# Graphic Design

by Ben Hannam

## Graphic Design For Dummies®

Published by: **John Wiley & Sons, Inc.**, 111 River Street, Hoboken, NJ 07030-5774, www.wiley.com

Copyright © 2025 by John Wiley & Sons, Inc. All rights reserved, including rights for text and data mining and training of artificial technologies or similar technologies.

Media and software compilation copyright © 2025 by John Wiley & Sons, Inc. All rights reserved, including rights for text and data mining and training of artificial technologies or similar technologies.

Published simultaneously in Canada

No part of this publication may be reproduced, stored in a retrieval system or transmitted in any form or by any means, electronic, mechanical, photocopying, recording, scanning or otherwise, except as permitted under Sections 107 or 108 of the 1976 United States Copyright Act, without the prior written permission of the Publisher. Requests to the Publisher for permission should be addressed to the Permissions Department, John Wiley & Sons, Inc., 111 River Street, Hoboken, NJ 07030, (201) 748-6011, fax (201) 748-6008, or online at http://www.wiley.com/go/permissions.

**Trademarks:** Wiley, For Dummies, the Dummies Man logo, Dummies.com, Making Everything Easier, and related trade dress are trademarks or registered trademarks of John Wiley & Sons, Inc. and may not be used without written permission. All other trademarks are the property of their respective owners. John Wiley & Sons, Inc. is not associated with any product or vendor mentioned in this book.

LIMIT OF LIABILITY/DISCLAIMER OF WARRANTY: THE PUBLISHER AND THE AUTHOR MAKE NO REPRESENTATIONS OR WARRANTIES WITH RESPECT TO THE ACCURACY OR COMPLETENESS OF THE CONTENTS OF THIS WORK AND SPECIFICALLY DISCLAIM ALL WARRANTIES, INCLUDING WITHOUT LIMITATION WARRANTIES OF FITNESS FOR A PARTICULAR PURPOSE. NO WARRANTY MAY BE CREATED OR EXTENDED BY SALES OR PROMOTIONAL MATERIALS. THE ADVICE AND STRATEGIES CONTAINED HEREIN MAY NOT BE SUITABLE FOR EVERY SITUATION. THIS WORK IS SOLD WITH THE UNDERSTANDING THAT THE PUBLISHER IS NOT ENGAGED IN RENDERING LEGAL, ACCOUNTING, OR OTHER PROFESSIONAL SERVICES. IF PROFESSIONAL ASSISTANCE IS REQUIRED, THE SERVICES OF A COMPETENT PROFESSIONAL PERSON SHOULD BE SOUGHT. NEITHER THE PUBLISHER NOR THE AUTHOR SHALL BE LIABLE FOR DAMAGES ARISING HEREFROM. THE FACT THAT AN ORGANIZATION OR WEBSITE IS REFERRED TO IN THIS WORK AS A CITATION AND/OR A POTENTIAL SOURCE OF FURTHER INFORMATION DOES NOT MEAN THAT THE AUTHOR OR THE PUBLISHER ENDORSES THE INFORMATION THE ORGANIZATION OR WEBSITE MAY PROVIDE OR RECOMMENDATIONS IT MAY MAKE. FURTHER, READERS SHOULD BE AWARE THAT INTERNET WEBSITES LISTED IN THIS WORK MAY HAVE CHANGED OR DISAPPEARED BETWEEN WHEN THIS WORK WAS WRITTEN AND WHEN IT IS READ.

For general information on our other products and services, please contact our Customer Care Department within the U.S. at 877-762-2974, outside the U.S. at 317-572-3993, or fax 317-572-4002. For technical support, please visit https://hub.wiley.com/community/support/dummies.

Wiley publishes in a variety of print and electronic formats and by print-on-demand. Some material included with standard print versions of this book may not be included in e-books or in print-on-demand. If this book refers to media that is not included in the version you purchased, you may download this material at http://booksupport.wiley.com. For more information about Wiley products, visit www.wiley.com.

Library of Congress Control Number: 2024950284

ISBN 978-1-394-26596-1 (pbk); ISBN 978-1-394-26598-5 (ebk); ISBN 978-1-394-26597-8 (ebk)

SKY10092406_112824

# Contents at a Glance

**Introduction** ........................................................ 1

**Part 1: What to Know Before You Start Designing** ........... 5

CHAPTER 1: What Is Graphic Design? ..................................... 7

CHAPTER 2: Developing Your Problem-Solving Skills ...................... 21

CHAPTER 3: Practices for Creating Better Design Solutions .............. 45

CHAPTER 4: Choosing the Right Tool for the Job......................... 59

CHAPTER 5: Design Is an Iterative Process............................... 91

**Part 2: Using the Principles of Design to Elevate Your Work** ...................................... 119

CHAPTER 6: The Principles of Design: Balance, Contrast, and Emphasis ......... 121

CHAPTER 7: The Principles of Design: Unity, Repetition, Rhythm, and Proportion ...................................... 143

CHAPTER 8: The Principles of Design: Movement, Hierarchy, Alignment, and Space............................................. 169

CHAPTER 9: Creating Grid Systems and Page Layouts...................... 181

CHAPTER 10: Constructing Color Systems ................................ 201

CHAPTER 11: Choosing Type and Creating a System ....................... 215

**Part 3: The Part of Tens** ...................................... 231

CHAPTER 12: Ten Things You Should Know When Putting Together Your Design Portfolio.................................... 233

CHAPTER 13: Ten Ways Artificial Intelligence May Change Graphic Design ........ 241

**Index** ............................................................ 247

# Table of Contents

**INTRODUCTION** . . . . . . . . . . . . . . . . . . . . . . . . . . . . . . . . . . . . 1
About This Book. . . . . . . . . . . . . . . . . . . . . . . . . . . . . . . . . . . . . 1
Foolish Assumptions. . . . . . . . . . . . . . . . . . . . . . . . . . . . . . . . . . 2
Icons Used in This Book . . . . . . . . . . . . . . . . . . . . . . . . . . . . . . . 3
Beyond the Book . . . . . . . . . . . . . . . . . . . . . . . . . . . . . . . . . . . . 3

**PART 1: WHAT TO KNOW BEFORE YOU START DESIGNING** . . . . . . . . . . . . . . . . . . . . . . . . . . . . . . . . . . . 5

CHAPTER 1: **What Is Graphic Design?**. . . . . . . . . . . . . . . . . . . . . . . . 7
Welcome to Graphic Design. . . . . . . . . . . . . . . . . . . . . . . . . . . . . 8
Specialization in Graphic Design . . . . . . . . . . . . . . . . . . . . . . . . . 9
Assessing Design Education and Training . . . . . . . . . . . . . . . . . . 10
Evaluating Freelance and Agency Experience . . . . . . . . . . . . . . . 11
Small, mid-sized, and large agencies . . . . . . . . . . . . . . . . . . . 11
Freelance work. . . . . . . . . . . . . . . . . . . . . . . . . . . . . . . . . . . 12
Use a contract . . . . . . . . . . . . . . . . . . . . . . . . . . . . . . . . . . . 13
Pricing Your Work . . . . . . . . . . . . . . . . . . . . . . . . . . . . . . . . . . . 16
Hourly rates . . . . . . . . . . . . . . . . . . . . . . . . . . . . . . . . . . . . . 16
Flat-rate pricing . . . . . . . . . . . . . . . . . . . . . . . . . . . . . . . . . . 17
Retainer agreement . . . . . . . . . . . . . . . . . . . . . . . . . . . . . . . 18
Rejecting Speculative Work . . . . . . . . . . . . . . . . . . . . . . . . . . . . 18

CHAPTER 2: **Developing Your Problem-Solving Skills** . . . . . . . . . . . . . 21
Identifying the Steps to Take Before Designing a Solution . . . . . . . . . 22
Understanding the problem . . . . . . . . . . . . . . . . . . . . . . . . . 23
Gathering inspiration and precedent. . . . . . . . . . . . . . . . . . . 25
Dialing in your target audience . . . . . . . . . . . . . . . . . . . . . . . 31
Defining the scope of your project . . . . . . . . . . . . . . . . . . . . 33
Taking a Macro-View to Tailor Fit Your Design Solution . . . . . . . . . . . 35
Conducting a competitor analysis. . . . . . . . . . . . . . . . . . . . . 35
Analyzing design trends and styles. . . . . . . . . . . . . . . . . . . . 36
Consider the technical requirements . . . . . . . . . . . . . . . . . . 41

CHAPTER 3: **Practices for Creating Better Design Solutions**. . . . . 45
Improving Your Empathy Skills to Help Reach Your Audience . . . . . . . 46
Generating an empathy map. . . . . . . . . . . . . . . . . . . . . . . . . 47
Developing a persona. . . . . . . . . . . . . . . . . . . . . . . . . . . . . . 48
Creating a mood board. . . . . . . . . . . . . . . . . . . . . . . . . . . . . 50

Building Better Collaboration Skills . . . . . . . . . . . . . . . . . . . . . . . . . . . . .51
   Seeking feedback makes you smarter . . . . . . . . . . . . . . . . . . . . . .52
   Conducting interviews, observations, and surveys . . . . . . . . . . . .53
Embracing Creativity (and Mistakes) . . . . . . . . . . . . . . . . . . . . . . . . . .55
   Identifying creative versus logical thinking . . . . . . . . . . . . . . . . . .56
   Learning from mistakes . . . . . . . . . . . . . . . . . . . . . . . . . . . . . . . . . .58

CHAPTER 4: **Choosing the Right Tool for the Job** . . . . . . . . . . . . . . . . . 59
Capturing Ideas with Pencil and Paper . . . . . . . . . . . . . . . . . . . . . . . .60
   Don't underestimate a tactile experience . . . . . . . . . . . . . . . . . . .61
Evaluating Electronic Pencils and Tablets . . . . . . . . . . . . . . . . . . . . . .62
   Comparing the feel and control of the Apple
   Pencil versus Wacom tablet . . . . . . . . . . . . . . . . . . . . . . . . . . . . . . .63
Appreciating the Adobe Creative Cloud . . . . . . . . . . . . . . . . . . . . . . . .65
   Working with Adobe Illustrator . . . . . . . . . . . . . . . . . . . . . . . . . . . .66
   Working with Adobe Photoshop . . . . . . . . . . . . . . . . . . . . . . . . . . .72
   Working with Adobe InDesign . . . . . . . . . . . . . . . . . . . . . . . . . . . . .79
Software for the Budget-Conscious . . . . . . . . . . . . . . . . . . . . . . . . . . .85
   Adobe CC alternatives . . . . . . . . . . . . . . . . . . . . . . . . . . . . . . . . . . .85
   Adobe Illustrator alternatives . . . . . . . . . . . . . . . . . . . . . . . . . . . . .86
   Adobe Photoshop alternatives . . . . . . . . . . . . . . . . . . . . . . . . . . . .87
   Adobe InDesign alternatives . . . . . . . . . . . . . . . . . . . . . . . . . . . . . .87
Using Mobile Apps for Some Tasks . . . . . . . . . . . . . . . . . . . . . . . . . . . .88

CHAPTER 5: **Design Is an Iterative Process** . . . . . . . . . . . . . . . . . . . . . . . 91
Phase 1: Project Brief and Goals . . . . . . . . . . . . . . . . . . . . . . . . . . . . . .93
Phase 2: Research and Planning . . . . . . . . . . . . . . . . . . . . . . . . . . . . . .94
   Understanding the problem, researching, and planning . . . . . . . .95
   Brainstorming, sketching, and refining your ideas . . . . . . . . . . . . .95
   Design development, feedback, and revision . . . . . . . . . . . . . . . . .96
Phase 3: Brainstorming . . . . . . . . . . . . . . . . . . . . . . . . . . . . . . . . . . . . .96
   Defining the goals of a brainstorming session . . . . . . . . . . . . . . . .97
   Fostering a nonjudgmental environment . . . . . . . . . . . . . . . . . . . .98
   Practicing divergent thinking . . . . . . . . . . . . . . . . . . . . . . . . . . . . . .98
   Value quantity over quality . . . . . . . . . . . . . . . . . . . . . . . . . . . . . . .98
   Reverse brainstorming . . . . . . . . . . . . . . . . . . . . . . . . . . . . . . . . . . .99
   Sorting and refining your ideas . . . . . . . . . . . . . . . . . . . . . . . . . . . .99
Phase 4: Sketching Out Your Ideas . . . . . . . . . . . . . . . . . . . . . . . . . . .100
   Thumbnail sketches . . . . . . . . . . . . . . . . . . . . . . . . . . . . . . . . . . . .100
   Iterative sketches . . . . . . . . . . . . . . . . . . . . . . . . . . . . . . . . . . . . . .101
   Collaborative sketching . . . . . . . . . . . . . . . . . . . . . . . . . . . . . . . . .102
   Exploring visual metaphors . . . . . . . . . . . . . . . . . . . . . . . . . . . . . .103
   Combining sketches . . . . . . . . . . . . . . . . . . . . . . . . . . . . . . . . . . . .104
Phase 5: Design Development . . . . . . . . . . . . . . . . . . . . . . . . . . . . . . .106

vi    Graphic Design For Dummies

Phase 6: Feedback and Revision . . . . . . . . . . . . . . . . . . . . . . . . . . . . . . .107
    Preparing to receive feedback . . . . . . . . . . . . . . . . . . . . . . . . . . . . . .107
    Shaping critique feedback . . . . . . . . . . . . . . . . . . . . . . . . . . . . . . . . .108
    Prioritizing feedback . . . . . . . . . . . . . . . . . . . . . . . . . . . . . . . . . . . . . .109
    Balancing feedback with design expertise . . . . . . . . . . . . . . . . . . . .109
    Use versioning to save time . . . . . . . . . . . . . . . . . . . . . . . . . . . . . . . .110
    Micro/macro . . . . . . . . . . . . . . . . . . . . . . . . . . . . . . . . . . . . . . . . . . . . .110
Phase 7: Finalization and Execution . . . . . . . . . . . . . . . . . . . . . . . . . . .111
    Tips for preparing printed work . . . . . . . . . . . . . . . . . . . . . . . . . . . .112
    Tips for preparing files for the web . . . . . . . . . . . . . . . . . . . . . . . . .114
    Tips for preparing files for mobile devices . . . . . . . . . . . . . . . . . . .116
Phase 8: Repeat . . . . . . . . . . . . . . . . . . . . . . . . . . . . . . . . . . . . . . . . . . . . . .116

## PART 2: USING THE PRINCIPLES OF DESIGN TO ELEVATE YOUR WORK . . . . . . . . . . . . . . . . . . . . . . . . . . . . . . . . . . . .119

CHAPTER 6: **The Principles of Design: Balance, Contrast, and Emphasis** . . . . . . . . . . . . . . . . . . . . . . . . . . . . . .121

Balance . . . . . . . . . . . . . . . . . . . . . . . . . . . . . . . . . . . . . . . . . . . . . . . . . . .123
    Symmetrical balance . . . . . . . . . . . . . . . . . . . . . . . . . . . . . . . . . . . . . .123
    Horizontal balance . . . . . . . . . . . . . . . . . . . . . . . . . . . . . . . . . . . . . . .123
    Vertical balance . . . . . . . . . . . . . . . . . . . . . . . . . . . . . . . . . . . . . . . . . .123
    Asymmetrical balance . . . . . . . . . . . . . . . . . . . . . . . . . . . . . . . . . . . . .124
    Radial balance . . . . . . . . . . . . . . . . . . . . . . . . . . . . . . . . . . . . . . . . . . .124
    Crystallographic balance . . . . . . . . . . . . . . . . . . . . . . . . . . . . . . . . . .126
Contrast . . . . . . . . . . . . . . . . . . . . . . . . . . . . . . . . . . . . . . . . . . . . . . . . . .127
    Color contrast . . . . . . . . . . . . . . . . . . . . . . . . . . . . . . . . . . . . . . . . . . .127
    Tonal contrast . . . . . . . . . . . . . . . . . . . . . . . . . . . . . . . . . . . . . . . . . . .128
    Textural contrast . . . . . . . . . . . . . . . . . . . . . . . . . . . . . . . . . . . . . . . . .129
    Size contrast . . . . . . . . . . . . . . . . . . . . . . . . . . . . . . . . . . . . . . . . . . . .129
    Shape contrast . . . . . . . . . . . . . . . . . . . . . . . . . . . . . . . . . . . . . . . . . .131
    Spatial contrast . . . . . . . . . . . . . . . . . . . . . . . . . . . . . . . . . . . . . . . . . .132
    Typographic contrast . . . . . . . . . . . . . . . . . . . . . . . . . . . . . . . . . . . . .133
Emphasis . . . . . . . . . . . . . . . . . . . . . . . . . . . . . . . . . . . . . . . . . . . . . . . . . .134
    Contrast emphasis . . . . . . . . . . . . . . . . . . . . . . . . . . . . . . . . . . . . . . .135
    Isolation emphasis . . . . . . . . . . . . . . . . . . . . . . . . . . . . . . . . . . . . . . .137
    Positional emphasis . . . . . . . . . . . . . . . . . . . . . . . . . . . . . . . . . . . . . .137
    Color emphasis . . . . . . . . . . . . . . . . . . . . . . . . . . . . . . . . . . . . . . . . . .138
    Typographic emphasis . . . . . . . . . . . . . . . . . . . . . . . . . . . . . . . . . . . .139
    White space emphasis . . . . . . . . . . . . . . . . . . . . . . . . . . . . . . . . . . . .140
    Directional emphasis . . . . . . . . . . . . . . . . . . . . . . . . . . . . . . . . . . . . .141
    Repetition and pattern emphasis . . . . . . . . . . . . . . . . . . . . . . . . . . .142

CHAPTER 7: **The Principles of Design: Unity, Repetition, Rhythm, and Proportion** ...................143

Unity ...................143
Gestalt unity ...................144
Visual unity ...................148
Repetition unity ...................149
Proximity unity ...................149
Color unity ...................150
Typographic unity ...................150
Spatial unity ...................151
Conceptual unity ...................151
Cultural unity ...................152
Repetition ...................153
Shape repetition ...................153
Color repetition ...................154
Pattern repetition ...................154
Texture repetition ...................154
Space repetition ...................156
Grid repetition ...................158
Conceptual repetition ...................160
Rhythm ...................161
Proportion and Scale ...................162
Hierarchy of scale ...................162
Sequential proportion ...................163
Harmonic proportion ...................164

CHAPTER 8: **The Principles of Design: Movement, Hierarchy, Alignment, and Space** ...................169

Movement ...................169
Hierarchy ...................175
Alignment ...................178
White space ...................179

CHAPTER 9: **Creating Grid Systems and Page Layouts** ...................181

Choosing a Grid Type ...................184
Column grid ...................184
Modular grid ...................186
Hierarchical grid ...................187
Baseline grid ...................188
Responsive grid ...................190
Working with Page Layout ...................192
Consider your content ...................192
Establish your layout hierarchy ...................192
Set margins, gutters, bleeds, and trim lines ...................194

viii   Graphic Design For Dummies

Group related elements . . . . . . . . . . . . . . . . . . . . . . . . . . . . . . . . . . .195
Be consistent . . . . . . . . . . . . . . . . . . . . . . . . . . . . . . . . . . . . . . . . . . .195
Align elements consistently . . . . . . . . . . . . . . . . . . . . . . . . . . . . . . .198
Incorporate white space . . . . . . . . . . . . . . . . . . . . . . . . . . . . . . . . . .198

CHAPTER 10: **Constructing Color Systems** . . . . . . . . . . . . . . . . . . . . . . . . .201
Defining the Brand Personality . . . . . . . . . . . . . . . . . . . . . . . . . . . . . .201
Exploring Color Psychology . . . . . . . . . . . . . . . . . . . . . . . . . . . . . . . . .203
Color hierarchy . . . . . . . . . . . . . . . . . . . . . . . . . . . . . . . . . . . . . . .205
Color Contrast . . . . . . . . . . . . . . . . . . . . . . . . . . . . . . . . . . . . . . . .206
Choosing Primary Colors . . . . . . . . . . . . . . . . . . . . . . . . . . . . . . . . . . .207
Creating Color Combinations . . . . . . . . . . . . . . . . . . . . . . . . . . . . . . .208
Addressing Color Accessibility . . . . . . . . . . . . . . . . . . . . . . . . . . . . . .210
Strategies for Making Charts and Graphs
More Colorblind Friendly . . . . . . . . . . . . . . . . . . . . . . . . . . . . . . . . . . .212

CHAPTER 11: **Choosing Type and Creating a System** . . . . . . . . . . .215
Purpose, Tone, and Message . . . . . . . . . . . . . . . . . . . . . . . . . . . . . . . .216
Staying Timeless or On-Trend . . . . . . . . . . . . . . . . . . . . . . . . . . . . . . .219
Considering Legibility . . . . . . . . . . . . . . . . . . . . . . . . . . . . . . . . . . . . .221
Establishing Typographic Hierarchy . . . . . . . . . . . . . . . . . . . . . . . . . .222
Limiting the Number of Typefaces . . . . . . . . . . . . . . . . . . . . . . . . . . .224
Working with type families . . . . . . . . . . . . . . . . . . . . . . . . . . . . . .224
Pairing complementary typefaces . . . . . . . . . . . . . . . . . . . . . . .225
The Importance of Font Size and Leading . . . . . . . . . . . . . . . . . . . . .226
Understanding Usage and Licensing . . . . . . . . . . . . . . . . . . . . . . . . .227
Avoiding Typographic Faux Pas . . . . . . . . . . . . . . . . . . . . . . . . . . . . . .228

## PART 3: THE PART OF TENS . . . . . . . . . . . . . . . . . . . . . . . . . . . . . . . . . . . .231

CHAPTER 12: **Ten Things You Should Know When Putting
Together Your Design Portfolio** . . . . . . . . . . . . . . . . . . . . . .233
Focus on Quality over Quantity . . . . . . . . . . . . . . . . . . . . . . . . . . . . . .234
Tailor Your Portfolio for Your Audience . . . . . . . . . . . . . . . . . . . . . . .234
Show a Range of Skills . . . . . . . . . . . . . . . . . . . . . . . . . . . . . . . . . . . . .235
Make Your Work Tell Your Story . . . . . . . . . . . . . . . . . . . . . . . . . . . . . .235
Put Your Best Work Above the Fold . . . . . . . . . . . . . . . . . . . . . . . . . . .236
Lean into Your Establishing Shots . . . . . . . . . . . . . . . . . . . . . . . . . . . .236
Include Sketches and Process Work . . . . . . . . . . . . . . . . . . . . . . . . . .237
Keyword Stuff Your Portfolio . . . . . . . . . . . . . . . . . . . . . . . . . . . . . . . .237
Meet with an External Reviewer . . . . . . . . . . . . . . . . . . . . . . . . . . . . .238
Keep Your Portfolio Up to Date . . . . . . . . . . . . . . . . . . . . . . . . . . . . . .239

Table of Contents **ix**

CHAPTER 13: **Ten Ways Artificial Intelligence May Change Graphic Design** . . . . . . . . . . . . . . . . . . . . . . . . . . . . . . . . . . . . . . . . . 241

Automated Tools . . . . . . . . . . . . . . . . . . . . . . . . . . . . . . . . . . . . . . . . 242
Improved Efficiency . . . . . . . . . . . . . . . . . . . . . . . . . . . . . . . . . . . . . . 242
Data-Driven Design . . . . . . . . . . . . . . . . . . . . . . . . . . . . . . . . . . . . . . 243
AI-Powered Design Assistants . . . . . . . . . . . . . . . . . . . . . . . . . . . . . . 243
Advanced Image Recognition . . . . . . . . . . . . . . . . . . . . . . . . . . . . . . 244
AI-Generated Assets . . . . . . . . . . . . . . . . . . . . . . . . . . . . . . . . . . . . . 244
Dynamic, Adaptive Design . . . . . . . . . . . . . . . . . . . . . . . . . . . . . . . . 245
Optimized Advertising . . . . . . . . . . . . . . . . . . . . . . . . . . . . . . . . . . . 245
Cost Reduction . . . . . . . . . . . . . . . . . . . . . . . . . . . . . . . . . . . . . . . . . 245
Creating New Design Roles . . . . . . . . . . . . . . . . . . . . . . . . . . . . . . . . 246

**INDEX** . . . . . . . . . . . . . . . . . . . . . . . . . . . . . . . . . . . . . . . . . . . . . . . . . . . . . 247

# Introduction

Maybe you picked up this book because you have a design problem you need help solving, or maybe it's because you're considering a career in graphic design. Either way, I'm glad you did.

Graphic design is for everyone, and we can all benefit from a set of problem-solving tools to help us respond to the complexity of everyday life. I've been teaching design skills and methodologies for over 20 years, and I love empowering people to create, edit, arrange, innovate, conceptualize, and execute their ideas.

Graphic design is the art and practice of creating visual content to communicate ideas to an audience. Design can be applied to a variety of mediums (for example, print, digital, and environmental) and seemingly appears all around us in a variety of contexts. Perhaps this is part of why I enjoy being a designer so much. I never know if I'm going to be working on a design solution for a bottlecap or a billboard, and the medium, message, concept, client, and audience change frequently. Every day presents a new puzzle to solve and an opportunity to learn, practice, and evolve.

My hope for you is that you enjoy the design process as much as I have, and whether you're solving a problem or researching a career path, that you enjoy the journey. Let your curiosity and imagination propel you forward to learn the principles of design to help guide your design decision-making. So, without further ado, I'm pleased to present *Graphic Design For Dummies* and to share some of my knowledge of graphic design with you.

## About This Book

It doesn't matter if you aren't artistic, have no prior graphic design experience, or if you're a seasoned designer. The point of this book is to empower you with a basis for making better design decisions.

Maybe you have a design problem that needs to be solved immediately; if so, jump into the chapter that is most applicable to your problem. Or perhaps you don't know much about graphic design and want to see if graphic design might be a good vocation for you; some of the earlier chapters can help you make this

determination. Or you may be enrolled in a graphic design program in high school or college and want a resource that breaks down the design process into steps to guide your own graphic design solutions. There is plenty of content included in this book for you, too.

No matter where on this spectrum you are, simply use the Table of Contents to help you jump right into the information you need. Each chapter begins with a brief description of the main topics, but don't be afraid to use the index at the back of the book to help you find the places where certain terms have been discussed.

# Foolish Assumptions

This book isn't (only) for graphic designers. It's for people with no graphic design background, too. I believe we are all lifelong learners, and some of us simply have a little more practice under our belts. Comparison can be the thief of a job, so I recommend that you don't be too hard on yourself — especially if you're first starting out or at the beginning of your journey.

I also feel the need to stress that if you're doing your job correctly, there are times when you will fail. Inspiration rarely strikes like a lightning bolt when you go from nothingness to awesomeness. Normally, there's a lot of hard work, feedback, reworking, testing, and other steps involved with making an awesome design solution. The thing I would stress to each and every one of you is to learn from your mistakes. Stop. Slow down. Think about your missteps. Why don't they work? Why did they fail? How could you pivot or alter them to be stronger? Don't be fooled into wadding them up and throwing them away as if they represent something shameful — because they totally aren't.

Creating something is always a messy, chaotic, and uneasy process. If you are creating something and reach a point where you aren't sure how you feel about it, then walk away for a couple of hours and come back to your work after you've eaten or rested and look at your solution with fresh eyes. Chances are good that this will help get you unstuck.

Finally, don't expect your first ideas to be your best ideas. When I create a logo, I might sketch somewhere between 50-150 thumbnail sketches before I begin working on the computer to create even more sketches. Stop treating graphic design like a cup of instant noodles, and know that a lot of the work that designers do involves thinking, playing with, deconstructing, discovering, and evolving ideas. If you rush the design process, you're likely to truncate your design solution's potential.

# Icons Used in This Book

This book contains icons that point to the type of information you're reading.

The Tip icon is a small piece of expert advice that will save you time and make your graphic design experience a little easier.

I cover a lot of details and information, and every now and then, I throw in a Remember icon to remind you of important details that might be advantageous to remember.

Who doesn't love a little technical jargon? I've pulled out these paragraphs so you can understand the technical aspects of graphic design without getting overwhelmed.

Yes, this book has a few warnings. When you see a Warning icon, please take heed. You're not going to blow up your computer or do anything irreparable, but I want to save you from as many headaches as I can.

# Beyond the Book

To learn even more about graphic design, check out this book's cheat sheet, which shows you helpful links to web pages containing information about graphic design. To get the cheat sheet, go to www.dummies.com and type **Graphic Design for Dummies Cheat Sheet** into the search box. You'll see not only the cheat sheet but any significant updates or changes that occur between editions of this book.

Also, on the dummies.com site, you'll find a ton of additional content I wrote that I just couldn't pack into the book. You'll find the following full chapters there:

>> Chapter 1: Designing Together
>> Chapter 2: Selected Strategies for a Successful Design Solution
>> Chapter 3: Avoiding Common Mistakes
>> Chapter 4: Testing Your Skills and Solving Design Problems
>> Chapter 5: Accepting Project Constraints and Feedback
>> Chapter 6: Practicing How to Critique

To start your graphic design career, all you need is a pencil. But be careful: Although all you need to start your career is a pencil, you might catch the graphic design bug and wind up with a fancy computer and software! Technology is great because it enables graphic designers to perform tasks a lot quicker than doing them by hand with a pencil. But here's a secret — always start your design projects with a pencil, not a computer — if you want to maximize your time. A simple pencil is enough to get ideas out of your head and down on paper, and a computer is fantastic when you already have a good idea of what you're trying to accomplish. Don't be fooled into thinking that ideas come from your computer or your software; they don't. . .they come from you. Computers are mostly helpful in executing your ideas, not generating them.

Don't believe me? Then imagine that your dad was a goat. Draw a picture of yourself (using a pencil) of what you would look like as a half-goat, half-human. You have 60 seconds to complete this task.

How does your drawing look? Sixty seconds isn't much time, is it? How long do you think it'd take you to draw your half-goat, half-person self-portrait on your computer? I'm willing to bet that it'd take a lot longer than 60 seconds. This example kind of proves a point, doesn't it? You don't have all the latest software in order to practice your design skills. A computer might help you make your ideas look professional, but it's just a tool. The really valuable design ideas — well, they come from you.

# 1

# What to Know Before You Start Designing

**IN THIS PART . . .**

Understanding the basics of graphic design

Sharpening your problem-solving skills

Learning how empathy can improve your design

Stocking up on the right hardware and software

Boiling down the phases of the design process

**IN THIS CHAPTER**

» **Getting your feet wet in graphic design**

» **Specializing in graphic design**

» **Setting hourly rates and flat fees and using retainer agreements**

# Chapter **1**

# What Is Graphic Design?

believe design is an instrument of organization, a means of relating objects to people, a medium for persuasion, and a way for humans to cope with the complexity of daily life. I believe there is no "right" way to solve a design problem because I've seen other designers solve design problems brilliantly in ways that I would have never thought of. Graphic design is a thinking person's game where you solve problems by creating a visual language from type, illustrations, images, and other elements.

My goal as a designer is to reach my audience with whatever medium is necessary in order to communicate most effectively. Call me an optimist, but I believe that graphic design can help make the world a better place because when people communicate effectively with one other, we build stronger relationships, reduce misunderstandings, resolve conflicts, and facilitate understanding and growth.

Graphic design is all around us, and we are immersed in its artifacts. As you sit there reading this page, I bet there are no less than ten things around you that a graphic designer has created. From the laundry logo inside your shirt to the operating system on your mobile phone and to the cover design on this book — design is all around us. Yet, for many people, the design and creation processes are opaque and often unappreciated. Sometimes, it isn't until graphic design fails — like the 2,000 "butterfly ballot" used in Palm Beach County, Florida, where presidential candidates' names were listed on both sides of the ballot and led some voters to vote for the wrong candidate — that people understand exactly how important good design is.

Fortunately, graphic design is not defined solely by its failures but is celebrated for its many successes. It has profoundly shaped the world by enhancing communication, influencing mass media, building powerful brands, and driving marketing strategies. Beyond these, graphic design plays a crucial role in cultural and social expression, contributes significantly to the economy, enriches education and learning, and champions environmental and social responsibility. Graphic design enhances how we understand and interact with the world around us.

Graphic design can be described as the art and practice of planning ideas and experiences using visuals and text. It can be used in branding, advertising, web design, print media, and other fields to convey information, evoke emotions, and guide visual interactions. Often, graphic designers specialize in a particular aspect of design and hone their skills to master their craft.

# Welcome to Graphic Design

Allow me to officially welcome you to the wonderful world of graphic design! It's a fascinating discipline where you are likely to take on the role of artist, hustler, risk-taker, mathematician, creator, innovator, collaborator, typographer, scientist, composer, iconographer, technology guru, social observer, businessman, and so much more.

I've been working as a graphic designer for more than 30 years, and I love the discipline as much today as I did when I first started. Graphic design is a career path that is flexible, constantly evolving, and necessary. The work we do is both beneficial and broad in so many ways. It's a journey that will require you to continually learn, grow, and adapt. For some, ever-present change can be frustrating, and for others, it embodies a spirit of freedom and personal expression.

I'm not going to lie; there will be moments when the road may get bumpy, but with each project, client, and experience, you will get stronger, faster, and conceptually deeper while navigating the terrain more confidently with less effort. There's likely not going to be a moment where you feel that you've arrived at the goal line, but the journey is amazing, and I highly recommend it to anyone.

No matter if you're reading this because you have a design problem you need to solve or if you're considering a career in graphic design, graphic design is an empowering process and discipline. You have the opportunity to create and communicate using visual language and connect with others. Not only that, but graphic design is damn fun.

So, allow me to be the first to welcome you and encourage you not to just dip your toe in. Jump on into the wonderful world of graphic design. I've been expecting you!

# Specialization in Graphic Design

There are many subsets in the graphic design discipline, though some graphic designers will often specialize in a particular area. Perhaps an area aligns with your specific interests, or maybe you will choose a higher-demand area that commands a higher salary.

TIP

If you're interested in researching graphic design salary ranges, then you might want to search for "design salary survey." One of my favorite design salary survey resources is Aquent, a staffing agency in Boston, Massachusetts, that specializes in placing employees in creative industries. Its salary survey can be found online at https://aquent.com/lp/salary-guide.

Specialization can help graphic designers stand out in a crowded market by offering unique skills and services and can help differentiate them from other designers in the field. Here are six areas of specialization within graphic design:

» **Branding and logo design:** Branding and logo designers often focus on creating visual elements to represent or promote a brand. This can include creating logos, color palettes, typography, and brand guidelines to create a cohesive and recognizable identity that resonates with a particular audience.

» **Web and digital design:** Web and digital designers often focus on creating websites, apps, and digital interfaces. This includes user experience (UX) design, user interface (UI) design, and creating layouts and graphics that are optimized for digital platforms.

» **Print design:** Print designers often focus on creating design solutions for physical media such as postcards, magazines, books, brochures, posters, and other printed media. Print designers pay particular attention to layout, typography, illustrations, and photography and work with printers to create their design solutions in a physical form.

» **Illustration and motion graphics:** Designers specializing in illustration create illustrations, create visual stories, and enhance communication for a variety of mediums, while motion designers create kinetic design solutions to create animations, animated graphics, video content, commercials, and advertising.

>> **Exhibition design:** Exhibition designers often focus on designing physical spaces, signage, wayfinding systems, exhibitions, and retail environments. Exhibition designers create visually engaging and functional spaces that enhance a user's experience.

>> **Packaging design:** Package designers often focus on designing packaging for products that are both aesthetic and functional. Package designers work to create attractive, protective, and informative packages that align with a company's brand guidelines.

Despite specialization in the design discipline, many of these areas share a common foundation, particularly with using the design principles (discussed in Chapters 6-8) to solve design problems. Also, many of these different areas of specialization use similar hardware and software but may use additional software to expedite certain workflows and tasks.

# Assessing Design Education and Training

Many people interested in graphic design struggle with understanding what education and training they need. If you want to work in the design profession, do you need to go to college and get a degree in graphic design?

The short answer is that while a degree in graphic design can be beneficial for a career in the field, it's not strictly necessary. I won't lie; there are some big advantages to going to college and majoring in graphic design, but you can have a successful career without a degree.

One of the biggest advantages of studying graphic design is that a credentialed program will offer structured learning in design principles, typography, theory, and software skills. A good design program may also offer students networking opportunities, access to design labs, software, printing, and other resources like graphic design critiques to help improve your work that can be difficult or expensive to pay for independently.

That said, there are a variety of online courses, tutorials, and books that someone who is motivated to do so could use to teach themselves about the art and practice of graphic design. Self-motivated individuals can also freelance and gain practical experience. Also, starting in an entry-level position can provide on-the-job learning.

REMEMBER

I'm a big fan of designers, no matter their level, using their skills to solve design problems. There are opportunities to help people who can't pay expensive design fees while growing their skills at the same time. For example, I designed a cookbook for my church to help raise money to upgrade their playground equipment. Members of the church shared their favorite recipes, and I designed the cookbook for them. The money we raised selling the cookbook was the primary source of funds used to upgrade their playground equipment. Opportunities to grow your skills as a designer and help someone out it the process are all around if you look for them.

All in all, a degree in graphic design offers a lot of advantages, but it's not the only path into the design discipline. Some really good designers have entered the discipline through other means, but majoring in graphic design in a credentialed program is likely to expedite your graphic design journey in some significant ways.

# Evaluating Freelance and Agency Experience

Almost all of my graphic design students get their degrees and either go to work at an agency, become entrepreneurs or freelancers, or go on to a graduate program. So, let's investigate some of these options.

## Small, mid-sized, and large agencies

Your experience working at an agency can differ, depending on the size of the organization.

» **Small agencies:** Small agencies are usually great at providing their clients with personalized service, lots of flexibility, and lower costs but may have more limited resources, leading them to focus on local or niche markets. Small design agencies sometimes ask their team to wear a number of hats, which can be great if you're interested in learning the ins and outs of the discipline. Many small agencies can produce high-quality work and are often flexible and adaptable enough to adapt to client needs quickly.

» **Mid-sized agencies:** Mid-sized agencies often have a larger team with more specialized roles. Mid-sized agencies strike a balance between personalized design services and organizational structure, like having a dedicated account

manager or a project lead. Mid-sized agencies generally have access to more tools, technologies, and resources or have dedicated departments for frequently used design services. Additionally, mid-sized agencies often strike a balance between structure and flexibility. While their prices may be higher than a small agency, they usually have competitive pricing compared to larger design agencies.

» **Large agencies:** Large agencies have extensive resources and specialized expertise in high-profile and complicated design projects. Large agencies usually have a large team with very specialized roles and may have multiple offices in various strategically chosen geographical areas. Large agencies often provide clients with more formalized interactions to complete long-term, complex design solutions on a large scale. Large agencies are often less flexible than small or mid-sized agencies but are highly efficient in how they handle large volumes of work. Large agencies have extensive resources but command higher prices for their work due to the scale of projects, their expertise, and the level of resources at their disposal.

## Freelance work

Working as a freelance graphic designer is an excellent way to control what projects you work on and when. For a lot of people, this flexibility allows for a better work-life balance. Also, choosing which clients you work with can lead to more satisfying and creatively rewarding work. Most of the clients that I've freelanced with were really cool clients, and I've largely found this work really interesting and engaging. In fact, the diversity of clients that I've worked with over the years has really helped me diversify the work in my portfolio and gain experiences in a variety of disciplines. I remember working with a scientific company on a website that hosted scientific datasets that scientists would use to run analyses. At one point, I had to talk with a Russian scientist living in Siberia about gene therapies and cloning. Needless to say, I did not have that on my beginning-of-the-week bingo card!

Aside from the niceties of freelance design, designers work temporarily or on specific projects or tasks for an agency or directly with a client. Typically, freelance designers charge an hourly rate, a flat rate, or a retainer fee and work for clients on an as-needed basis. Because of this, freelancers set their own rates and potentially earn more than they would in a traditional job at an hourly rate. Keep in mind that freelancers have to pay for their own healthcare and contribute to their own retirement savings because a company does not do this for them.

TIP

I encourage many of my graphic design students to freelance as a side hustle. One of the biggest tips I would give is to begin your freelance career by working with a few people that you know and trust first to get your freelancing legs underneath you before working with clients that you don't have some type of relationship

12   PART 1 What to Know Before You Start Designing

with. Start with small jobs for people you know and build up your network (and client list) slowly until you gain confidence.

I absolutely love working with clients in my community and helping them solve some of their graphic design issues. In fact, if you're not sure about what to charge a client, you can think about bartering for goods and services. I've worked with a number of my favorite restaurants, and instead of being paid in cash, we set up a tab so I can eat a certain number of meals for free. I've also bartered for hang gliding lessons, triathlon training, and scuba certifications. Freelancing is a great way to get to know the members of your community and to help them out! I promise you — nothing feels better than walking around your town and seeing your design work in the local storefronts and thinking to yourself, "I did that."

## Use a contract

Allow me to give you some of the best advice that you might receive if you're interested in freelancing — use a contract. A contract is crucial for freelance designers because a contract:

- Creates clarity by setting designer and client expectations
- Provides legal protection in case a dispute arises
- Sets key time frames and compensation terms
- Sets the scope of a project
- Demonstrates your commitment to professionalism
- Defines confidentiality and copyright/intellectual property terms
- Specifies how the agreement can be terminated

While I'm not an attorney and not qualified to offer legal advice, the following sidebar shows a simple contract I use for my own freelance agreements. If you adopt it, then you should show it to an attorney because local and state laws may require you to add or remove certain language to make the contract legally acceptable. That said, you can see how a contract can be used to create clarity between a freelance graphic designer, ABC Designs, and a fictitious client, XYZ Client.

Even if you're working with someone you know and trust, you should still use a contract. Contracts aren't traps; they are documents to help both parties know what the expectations are.

CHAPTER 1 What Is Graphic Design?  13

# SAMPLE FREELANCE DESIGN CONTRACT

**Today's Date:**

**Client's Name:**

**Client Email:**

**Client's Phone:**

**Client's Address:**

**PROJECT:** Give the project a name *(e.g., T-shirt Design for XYZ Client)*

**SCOPE OF THE PROJECT:** Describe the project in detail and make sure to indicate the scope of the project and what needs to be done to conclude the project. *(e.g., ABC Designs will create two-color vector artwork for XYZ Company to be screen printed on a light gray t-shirt. ABC Designs will deliver three concept sketches for XYZ Client to approve, along with two rounds of edits. The artwork will be created with Adobe Illustrator and the file will be delivered as an Illustrator EPS file and delivered to XYZ Client's screen-printing company on a USB drive.)*

**DETAILS:** Describe what the client is getting for their money. *(e.g., Proofs will be delivered to XYZ Client within seven days after ABC Designs receives a 50 percent payment and all associated content. This estimate includes the initial client meeting, research, sketching, concepts, design, and production, and one round of revisions.*

*This estimate is based on the scope of the project defined above. Changes to the scope of work may result in changes to delivery time and price. Additional expenses (such as illustration, photography, shipping expenses, etc.) will be itemized on the final invoice. This estimate is valid for 30 days from the date listed above. The fees for the project may vary as much as 15% from this estimate.)*

**ESTIMATE:** $325.00

Sketching & Concepts: 2½ Hours @ *$50.00*

Design Work: 4 Hours @ $50.00

**TERMS & CONDITIONS:**

- **Sketches:** The fee above includes three pages of concepts; additional sketched concepts may incur extra fees.

- **Final artwork:** The fee quoted includes one digital file of the final artwork. Any changes to the final artwork, once it has been approved, may incur an additional cost based on the extent of complexity.

- **Rights:** Upon full payment of all fees and costs, the rights to use this design transfer to the Client listed above. Until full payment is made, the Designer retains all rights to this work.

- **Credit:** The Designer retains the right to display this project on their portfolio website.

- **Overtime:** Fees quoted are based upon work performed during the course of regular working hours. Overtime, rush, holiday, and weekend work by the Client's directive will be billed at a rate of $100.00 per hour.

- **Billable Items:** In addition to the fees and costs estimated, costs incurred for additional services and shipping are billable to the Client. Whenever applicable, state and local sales taxes will be included. Travel expenses will be billed additionally, at cost.

- **Purchasing:** All purchases made on Client's behalf will be billed to the client. In all cases, prices may reflect a small markup of 5 percent. Charges for insurance, shipping and handling charges are additional. In the event the Client purchases materials, services, or any items other than those specified by the Designer, the Designer is not liable for the cost, quality, workmanship, condition, or appearance of such items.

- **Schedule of Payment:** 50 percent of the project estimate is due at the beginning of the project and the remaining 50 percent is due when the project has been approved and is delivered to the Client. Invoices are due upon 30 days of receipt. A 9.9% per month fee will be applied to payments that have not been received within 60 days of the project's delivery.

- **Termination Policy:** Client and Designer may terminate this project based upon mutually agreeable terms determined in writing. The termination of a project already underway by the client may be subjected to a "kill fee" and services rendered by the Designer will be invoiced and billed to the client.

- **Term of Proposal:** The information contained in this proposal is valid for 30 days. Proposals approved and signed by the Client are binding and begin on the date of Client's signature.

If the information in this proposal meets the Client's approval, the Client's signature must appear below to authorize the Designer to begin work. Please return a signed copy of this proposal to the Designer.

Designer / Date: _____

Client / Date: _____

# Pricing Your Work

Setting your rates involves several key factors to consider. If you're new to the graphic design profession, then focus on developing your graphic design skills first; once you're ready to work with a client, it's time to think about what these skills are worth.

## Hourly rates

Many freelance graphic designers charge by the hours they work on a project × their hourly rate, but how do you determine what your hourly rate should be? Too low and you'll feel taken advantage of and too high and you might price yourself out of jobs. In order to determine what your hourly rate should be you'll need to account for your experience and skill level. Beginners usually charge less than those with more advanced skill levels, and those with more experience are likely to demand higher prices than those without.

Your geographical location and market rates can also affect your hourly rate, so a freelance designer in Alabama is likely to charge less than a freelance designer in California just because there is a difference in the cost of living, competition for jobs, and expectations for what this work is likely to cost.

Along these same lines, the types of clients and their budgets can affect your hourly rate. For instance, if I were working for a health insurance company, then I'd charge them a higher rate than if I were working for a veteran's fundraising campaign to support local veterans with counseling needs. The health insurance company can afford my services, but I would likely reduce my fees when working with veterans since my dad was a veteran, and I want to help out veterans who are in need of counseling services.

TIP

When you set your rates, try to contact a peer who is working at the same level in your geographical area and talk with them about their hourly rates. I don't want to undercut them, but I want to make sure that my rates aren't too high or low. Also, as a freelance designer, sometimes you have to pass on certain jobs, so having a designer whose work you respect allows you to direct work their way in the event that it's not a good fit for you. As an informal agreement, you can ask your peer to return the favor if the situation is reversed.

Some might say that having a sliding hourly rate is unfair, but I don't think that's the case. I try to treat all of my clients fairly, and once I determine my hourly rate on a case-by-case basis, I'll stick with it and honor my agreement. I don't have any issues with discounting work in order to work with certain clients or projects that I might be particularly interested in working with or projects that I find highly fulfilling.

If you're a good designer and comfortable freelancing, then you may also want to reach out to local design agencies and let them know. I've been brought onto design teams temporarily when there is a lot of work to complete and have also been connected with clients when the jobs are too small for the design agency to complete at the specified budget.

## Flat-rate pricing

Flat-rate pricing is another common pricing strategy where clients are given a flat rate for a freelance designer to complete a project. Flat-rate pricing involves a fixed fee for the entire project — no matter how long it takes the designer to finish it.

Flat-rate pricing is ideal for projects with clearly defined deliverables and a narrow scope of work. A few common graphic design-related projects that you could assign a flat-rate fee for include logo design, business cards, posters, or brochures. If you have completed one of these types of projects previously, then you probably have a good idea about how long it will take you to complete the project and how large the project is likely to be.

Let's pretend that a client wants me to make a new business card for them. Since I've done a project like this before, I have a good idea about how much time this will take, but I want to give my client a solid number. I tell the client that I'll design a new business card for them for $100, plus the cost of having the business cards printed. If they agree to the deal, and it takes me 10 hours to complete the task, then I will have made $10/hour. If I hustle and it takes me one hour to complete the task, then I will have made $100/hour. Regardless of the amount of time it takes to complete the task, the customer will pay only $100, plus the cost to have the business cards printed. They don't have to worry about the time it takes to complete the project.

Flat-rate pricing is useful when the designer and the client benefit from the predictability and clarity of the project scope. It allows the client to budget for the project, and the cost they will pay is unlikely to change much during the course of the work.

Flat rate pricing can also be beneficial when the value of a project is greater than the number of hours put into it. Take designing a logo, for example. Let's pretend that it took you 10 hours to complete a logo from start to finish, and your hourly rate is $25/hour. First, charging $250 for a logo is incredibly low. Second, the value of a logo is significantly higher than $250. Logos are used on everything a company might produce, from business cards to signage and from apparel to promotional items. The value of a logo to a company is significantly higher than $250, so this is one example of how flat-rate pricing might be advantageous over an hourly rate for certain types of projects.

CHAPTER 1 What Is Graphic Design? 17

## Retainer agreement

A retainer agreement is a contract between a graphic designer and a client that states the client agrees to pay an upfront fee to reserve the designer's services over a set portion of time — basically retaining their services and availability.

This arrangement can benefit both the designer and the client by ensuring a designer's availability and time. The designer may agree to work for a slightly reduced rate since a retainer agreement provides a guaranteed income and a predictable workload. In return, the client is ensured that their work receives priority over other competing work the graphic designer may also be working on, and often receive these services at a better rate.

If you decide to use a retainer agreement, then clearly specify the retainer fees, the duration the agreement is in effect, and how either party can end the agreement. Once again, a good contract will make all of these expectations clear to both parties.

# Rejecting Speculative Work

Speculative work, or spec work, is work that a graphic designer does without guaranteed payment. Sometimes, a client may ask a designer to produce concepts as part of a pitch or submission, choose the best submission, and will only pay for this work if the designer's concept is selected.

You should be critical of speculative work because it increases the risk of exploitation, inequitable environments, and the chances that your concept will be ripped off.

Researching and refining concepts takes time, so asking a designer to do this for free is unrealistic. Also, what would prevent a client from stealing a good concept from one graphic designer and presenting the concept to a different designer to execute?

Let's pretend that I am an organization that holds conferences twice a year in different cities and I need someone to create a logo each time. Even though I charge each conference registrant $300 to attend my conference and hundreds of people attend, I don't want to pay for a graphic designer to create a logo. Instead, I'm going to get my logo by creating a logo design competition. This way, if I see a

logo I like, then I will declare this student the "winner" and give them $100. If 40 graphic design students enter the competition, then I'll be able to choose my favorite logo from the 40 entries, and there will be one "winner" and 39 losers. The student designer who's been chosen may feel like a winner, but the 39 other graphic designers never hear back and aren't compensated for their time and effort.

Speculative work doesn't guarantee payment or acknowledgment and may create situations where graphic designers take shortcuts or steal ideas from other designers because they know they are unlikely to receive compensation. The logo that looks amazing might be a concept that is ripped off from someone or something else rather than a solution that was developed from scratch. It might look good from afar, but it's far from good.

My two cents on speculative work are to simply not engage in these "opportunities" because they are unfair to graphic designers and the graphic design profession. Could you imagine asking 40 chefs to cook you a meal and only paying for the meal you like the best? Of course not! But for some reason, graphic designers are asked to produce and engage in speculative work more often than I care to admit, and it's simply an unhealthy and unfair practice that should simply be avoided.

**IN THIS CHAPTER**

» **Identifying the steps to take before designing a solution**

» **Taking a macro-view to tailor fit your design solution**

# Chapter **2**
# Developing Your Problem-Solving Skills

Over the years, I've learned that I will save a considerable amount of time and money by planning out my design projects ahead of time. Don't get me wrong: I love working on the computer and bringing my designs to life, but I've realized that understanding project goals, understanding my target audience, and gathering feedback makes my design work better. Working this way often makes me more efficient, too.

In this chapter, you will learn some strategies you can (and should) use to make sure your design solutions hit the mark. After all, how can you hit a bull's-eye without knowing what you're aiming at?

In my opinion, a lot of beginner designers rely too much on their intuition and personal tastes to guide their design solutions, but more seasoned designers understand that you first have to clearly define your goals, understand the needs of your target audience, trends, and explore other relevant factors to create a foundation for your design solution before you actually dive into making a design solution. While your own tastes are probably pretty awesome, your personal tastes may not align with your audience's.

There's nothing wrong with wanting something to look good, but graphic design doesn't always focus on the way something looks; it also includes how something

communicates, functions, and is received by the intended audience. If you design a poster for a kindergartener that looks identical to how you might design a poster for a college student, then you may have made some assumptions that aren't necessarily accurate.

Graphic designers create "visual language" by making decisions about the visual elements that appear in their design solutions. Not all audiences are the same, nor is the designer's personal aesthetic a trump card for determining what a good design solution should look like. The best design solutions take the needs of the client, the project, and the audience into consideration and communicate with focus, impact, and clarity.

Your design solutions shouldn't be for everyone. Think about who your primary audience will be and focus your design on communicating directly with them.

## Identifying the Steps to Take Before Designing a Solution

Every project will have its own set of constraints, limitations, and restrictions that the designer needs to work around. Clients working with a graphic designer might impose constraints on how long the designer has to complete the project or how much money can be spent on developing a solution. There could be technical constraints or regulatory considerations that a designer has to navigate. Or perhaps the client has already established their brand, so each design solution may have a unique set of constraints.

Each design project is different, and it's the designer's job to create a design solution that adequately addresses the project's needs and goals.

The clearer your understanding of your constraints, goals, message, and audience, the more likely you are to design a solution that hits that sweet spot and knocks the solution out of the park. This is why it's important to look at a design problem from multiple angles before jumping in and starting to push pixels around.

Even if you're working on a project for yourself (such as creating a portfolio website to show off your own work), you still have to think about the goals for the website, what it needs to communicate, and who's going to interact with the website.

You're unlikely to come up with a good design solution without doing your research first. Otherwise, you can make assumptions that aren't necessarily true or backed by data.

You've heard the expression, "Never judge a book by its cover," meaning you shouldn't judge something based on what you see on the outside without a deeper understanding. Graphic design functions similarly because you don't usually try to create a design solution without understanding the complexities and nuances of the problem you are attempting to solve. Understanding a problem well is a way to avoid designing something that is cliché or short-sighted.

There isn't a specific amount of time that you should devote to conducting research, but it's a crucial step in the design process. The complexity of the project, unique client constraints, researching the target audience, and being aware of relevant industry trends take time to discover and learn about. I would not be surprised at all if 15–30 percent of a project's entire timeline is spent on researching this information — it's that important!

You should plan on spending a reasonable amount of time to conduct your own research. This often involves a balancing act between the value of gaining important insights and meeting your project deadlines.

## Understanding the problem

In order to understand the problem, you are going to solve your need to define the goal, scope, and requirements of the project. Sometimes, clients think they have these clearly defined, but it never hurts to ask the client a few follow-up questions.

A client might say, "I need a poster," but you may want to ask a few questions like, "Why do you need a poster specifically?"

The client might reply, "Well, I need a poster to advertise my catering company."

A statement like this would make me scratch my head, so I might say, "Have many of your catering clients learned about your business through your posters? Is it possible that other types of advertising might work better? For example, a targeted postcard campaign that can be mailed to clients in your geographical area may work better. Are you open to exploring this idea?"

Clients want their problems solved and usually recognize that you are there to help. Don't be afraid to ask probing questions to learn about the challenges they face to get the most out of your time and design solutions.

### Communicating effectively with your client

The key is to not be afraid to talk with your clients, get to know them, ask questions, and fold the information you've learned into a carefully crafted strategy.

CHAPTER 2 **Developing Your Problem-Solving Skills** 23

Sometimes, clients will ask for exactly what they need, and other times, they may be open to alternative ideas. You never know until you talk with your client and assess the situation.

Asking questions isn't designed to talk the client out of working with you but to assist in better understanding the client's goals. Continuing with the previous example, you might want to ask your client, "Are there times when your business is particularly slow or serves fewer clients? Is there an advantage to reaching out to your catering clients at these times?" As you ponder the client's problem, you might discover that instead of designing a *poster* for them, you should design a *campaign* that will be mailed to clients at strategically chosen dates. Each of the postcards will have a strategic purpose with a strong call to action to encourage recipients to contact the caterer for their catering needs.

Redirecting the client from designing a *poster* to a *postcard campaign* is a change to the scope of the project and may benefit you both. Hopefully, you'll make more money designing a campaign than you would a single poster and your client will make more money through additional income that a postcard campaign brings in.

Look for win-win opportunities where you and the client can both benefit. You may have heard the phrase, "Good design is good business," which simply means a well-executed design solution can have a positive impact on a business in a variety of ways.

The exchange of alternative ideas usually works best at the beginning of a project before you or the client has invested resources into the project. However, don't be afraid to *respectfully* probe project goals throughout a project to identify constraints, and assumptions in order to look for opportunities that may have gone unnoticed. Remember, graphic design isn't just about aesthetics; it's also about functionality, thinking outside the box, developing creative solutions, and addressing the project goals.

### Using a sketchbook

One of the key indicators of a healthy design process is exploring a problem from many angles until a good strategy is revealed. Otherwise, the designer may create a superficial design solution rather than a strong solution to the problem they are being asked to solve.

Many designers like to keep a sketchbook and write down notes about their client interactions, concepts they are exploring, sketches, and other relevant information they discovered.

Keeping a sketchbook is a good way to organize your thoughts and, if need be, demonstrate that you are actively working on your client's project. I've found that

keeping a sketchbook can also be helpful in explaining how you arrived at a unique design solution by allowing you to look back at the steps you took that led you to your design solution. It's also a great way to demonstrate that your work is original and not copied from other sources. Figure 2-1 is an example of how designers use their sketchbooks to wrestle with a design problem until they identify a direction they are happy with.

FIGURE 2-1: This sketchbook shows how you can work out a design problem before you start working.

© Matt Newberry

WARNING

Many graphic designers don't share their design sketchbooks with their clients unless the situation calls for it to prevent clients from "Frankensteining" ideas together. "Frankensteining" simply means the client tries to put parts of different ideas and solutions together, stitching them into a solution that can usually be best described as a "graphic design monstrosity." However, if none of the ideas you present ideas to a client hits the mark, then you could share your sketchbook to see if any of your alternative ideas receive a more positive reaction.

## Gathering inspiration and precedent

There is so much good, free information and inspiration all around us, but we often can't see the forest for the trees, meaning we've become so accustomed to our routines that we sometimes fail to observe and reflect on the things that have been right in front of our faces our whole lives.

This is one of the many reasons why I love being a graphic designer. I can unabashedly borrow from architecture, fashion, biology, and so many other disciplines and fold what I learn and observe into my own design work.

We graphic designers know we're not the audience for most of our design solutions; we also know we have to achieve certain goals for our clients. However, we still need to have an informed point of view and may look for opportunities to incorporate our views, when appropriate, in our design solutions. Developing an informed point of view requires you to research or analyze examples of solutions that other designers, artists, scientists, and so forth have already done and synthesize (develop) a unique idea that is cohesive with the project's goals and needs.

The richness of the investigation is what's most important here. This is an opportunity to take a deep dive into learning and discovery and to make associations. Often, graphic designers begin to make associations and connections while collecting artifacts like images, type samples, textures, and color palettes. The designer may identify the beginning of a path in which to move forward but usually refrains from tackling the project directly at this point.

Sometimes, young graphic designers view the gathering of inspiration and precedent as a step that their professor made them do, so they hurriedly go through these steps, failing to realize that often, many of the insights about the project come from this process. My advice to these designers is to slow down and try to enjoy learning, discovering, and revealing the deeper insights that may eventually drive their concept later.

Thinking, outflanking, and wrestling with a problem you are trying to solve is a big part of the design process. While the Internet and AI offer tools the designer can and should use, it's not a substitute for good old-fashioned focused attention and brain power.

Of course, while you're out there looking for inspiration, you are likely to run into some direct comparisons or precedents. While it's good to see what solutions other designers have completed, you should be careful not to copy their work because it could expose you to copyright infringement. That said, there is plenty you can learn through observation. Often, seeing examples can help get you thinking, but when it's time to develop your own ideas, you might want to put the direct comparisons away to avoid making too many direct connections in your own design solution.

### Finding inspiration

Designers gather inspiration as a means of fueling their creativity. Every design project is unique, so it's not unreasonable to think that designers are constantly looking at the world around them to gather new sources of inspiration. What a wonderful way to look at the world! Each experience is a collection of miracles, magic, and discipline that can influence the ways in which you solve problems.

From the color and patterns found in nature, the many forms of art, the storytelling of literature, and the unfamiliarity of travel, inspiration is all around us. We simply have to look.

Designers look for inspiration in all kinds of places, but if you're just starting out, here are some suggestions for where you might want to begin:

- Art
- Books and literature
- Fashion
- History
- Nature
- Music
- Science
- Social media
- Technology
- Travel/Other cultures

Graphic designers often collect their inspiration as they go along and it might make an appearance in a mood board, which is discussed in greater detail later in this chapter.

When you expose yourself to other sources of inspiration, you are exploring a variety of design styles and concepts you can use to generate new and innovative pathways for your own work. You can also develop new problem-solving skills and methodologies, explore new techniques and applications, and, over time, develop your own unique design style — or visual voice.

Typically, your inspiration may share a reference point with the design problem you are looking to solve, but you might want to avoid a direct one-to-one comparison.

For example, if you are designing a label for a BBQ sauce, you may want to look at the visual language of top-shelf bourbon for inspiration instead of looking at other BBQ sauces. As you can see in Figure 2-2, the concept of something being "top shelf" is intriguing, the liquor packaging is often well-designed and visually appealing, and the liquor often has a "boutique, hand-crafted, artisan" message.

CHAPTER 2 Developing Your Problem-Solving Skills    27

The qualities that make liquor packaging unique may also support a concept for a BBQ sauce, so it might make sense to explore this niche to generate sources of inspiration. By looking for sources of inspiration beyond other BBQ sauces, you create new pathways to explore.

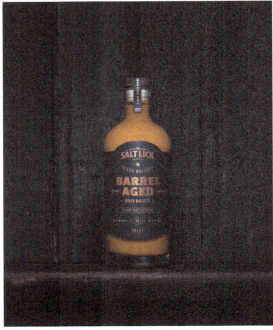

**FIGURE 2-2:** Finding inspiration in other products.

*The SaltLick BBQ*

North and South Carolina share a border, but they have wildly different tastes in BBQ, as do many other geographical areas. Again, if I wanted to look for sources of inspiration for a BBQ sauce, then I would probably investigate what makes a particular geographical area unique and include some of this information in my inspiration.

TIP

When gathering inspiration, you're not necessarily looking for direct comparisons as much as associations and/or connections that you may be able to leverage in more indirect ways in your design solution.

## Finding precedent and examples

Designers need to create unique design solutions. Each client, project, and target audience is unique, so it stands to reason that your design solution should

be unique, too. So, why should designers look at the work that other designers have produced as part of their design process? Well, it can be immensely helpful because you don't want to arrive at a solution that already exists, which may cause copyright issues. You may learn something from observing how others have solved similar problems, and you may gather inspiration from what you observe.

The goal for gathering precedent isn't to copy what you see but rather to familiarize yourself better with the landscape in which your design solution will live and compete.

If I were designing a label for a 12-ounce bottle of beer, I might look for examples or a precedent from a successful beer brand that helps me better understand the best size for a beer label. I don't know the exact measurements for a beer label, but I'm certain that I could use my observation skills to figure it out. I'm not copying the design solution, but I'm using my observations to estimate a good starting point for my own design solution that I will continue to develop. This is one example of how my precedent might inform my design. Similarly, if I were designing an app and I wasn't sure how big I should make the buttons in my interface, I would look at the examples I collected to help me make an informed decision. Again, I'm not copying a design solution, only referencing apps or operating systems that have accomplished similar goals.

So, how do you take something wonderful that you observed and fold it into your design solution? Well, you need to *synthesize* the idea. Synthesizing a design solution involves bringing together elements and insights to create a cohesive and effective design solution. Lean into the parts of the idea that accomplish similar goals and then explore how and why they work and test to see if incorporating similar strategies will help you overcome your problem, too.

Designers are generally curious people, willing to ask a lot of questions, and brave enough to explore solutions that are unlike those that already exist. We often seem to ask questions that can help our teams get unstuck and get the project moving forward again.

When you have a problem to solve, you need to look beyond the boundaries of your own limited knowledge for examples of how others have solved similar problems. Remember, Albert Einstein once said, "You cannot solve a problem with the same mind that created it."

Analysis (thinking, observing) and synthesis (combining ideas) are deeply entrenched components of graphic design, and it makes sense for you to gather inspiration and precedent from lots of sources to create a framework for solving a particular problem.

CHAPTER 2 Developing Your Problem-Solving Skills    29

**TIP**

## THE EGG-DROP ASSIGNMENT

In order to challenge students to synthesize ideas, college professors sometimes use an egg-drop assignment, where students are challenged to design packaging that allows an egg to be dropped from a height of at least 10 feet without breaking.

Often, the professor dictates some unique project constraints, such as the students can only use soda straws, popsicle sticks, and rubber bands to protect the egg. Then, students are left to design a contraption. The point of the assignment is to protect the egg from a fall, but the greater lesson is looking to nature for clues for solving this problem and synthesizing these observations into a means of protecting the egg.

Biomimicry is the practice of learning from and mimicking the strategies found in nature to solve human design challenges.

Students participating in the egg-drop assignment don't have to look too far to observe ways that nature protects, distributes, improves efficiency, heats, cools, or sticks — or any other number of examples — that could deliver fragile cargo to the ground safely. In Figure 2-3, you can see how a dandelion disperses its seeds into the wind. Each seed is tethered by a thin tube with about 100 bristles, forming parachute-like structures. These hairy parachutes close when the air is humid and the wind is weak; in drier, often windier conditions, these parachutes open to catch the wind so the seeds can fly freely.

Students are asked to observe nature, synthesize ideas, and use their observations to create solutions for protecting their egg from a 10-foot fall. So, if dandelion seeds can slow down how fast an egg drops, making me think about how some animals create protective elements, like nests, then I can begin to synthesize these two unrelated concepts to develop a unique solution to protect an egg from a fall of at least 10 feet.

There are usually some solutions that protect the egg and a few solutions that don't — but the real winners are those who learn to synthesize or take the concept of a solution, reinterpret it, and make it their own. They consider, observe, and break down big problems into smaller, more manageable problems and look for solutions beyond their own experiences. Often these are the students that I try to keep my eye on because they often have deep insights or unique solutions that are interesting, insightful, and complex.

**WARNING**

Don't strictly conduct research just from your own first-hand experiences. Otherwise, you may be guilty of confirmation bias — selectively gathering and interpreting information that confirms your preexisting beliefs or hypotheses.

30  PART 1 What to Know Before You Start Designing

**FIGURE 2-3:** What other ways might you be able to use nature to inspire a design solution?

James Thew/Adobe Stock Photos

## Dialing in your target audience

Graphic designers often gather information about their target audience. This is a strategy to align the visual language that you use in your solution with the preferences, lifestyles, and needs of the audience who will interact with your design solution. Following are some questions to help you think from your target audience's perspective:

- How does the audience feel about the product, service, or idea?
- Is the audience primarily male, female, or non-binary?
- What is the age range of your audience?
- What is the educational background of the audience?
- Does the audience have any strongly held beliefs?
- What is the audience passionate about?
- Where does the audience get their information?

Questions like these are important because they can help you tailor fit your design solutions for the people you are trying to reach. Different demographics, or the statistical data relating to populations and groups, can reveal trends and patterns

CHAPTER 2 Developing Your Problem-Solving Skills 31

that you can take advantage of to create more effective, compelling, and engaging interactions. In short, you want to tap into the visual language, choices, and style that your audience uses most often.

If I were at a party and I wanted to approach someone I didn't know, it might be smart to observe the individual and their body language. As I approached them, I might try to make them feel comfortable by mirroring their body language when introducing myself. Replicating their body language subtly indicates that I may hold similar beliefs and attitudes or perhaps that I hold the individual in high regard and want to emulate or appease them.

Designers often try to get to know the preferences of the target audience so they can create a design solution that mirrors the target audience's preferences so the message doesn't seem foreign, abrupt, or odd.

Learning about your target audience can also help prevent design fails where issues like cultural sensitivities, miscommunications, and biases toward a product or service have been overlooked.

Once you have analyzed the information about your users, their needs, and preferences, you can synthesize and incorporate this knowledge into your design solution to solve the problem in a way that meets the needs of your target audience and feels authentic.

It can be useful to create personas — fictional characters designed to represent a member of your target audience — to remind yourself that the design solution you are working on needs to meet their needs instead of your personal preferences. If you're working with a team, then creating a persona is also a quick way to remind the other members of your team who the design solution is for, which often speeds up the design process. Check out "Developing a persona" in Chapter 3 for detailed instructions on how to create a persona.

Focusing on understanding your target audience helps your design solution cut through the clutter and can help make your audience feel seen. Remember, different audiences have different preferences, cultural references, and communication styles that graphic designers need to consider.

This approach to design helps you tailor fit solutions to your target audience rather than providing a one-size-fits-all approach in which parts of your audience may feel left out or overlooked.

Think about it this way: The fast-food chain McDonald's sells billions of hamburgers each year, and if you order a McDonald's hamburger in one state, you can expect a similar experience as eating a McDonald's hamburger in another state.

This uniformity and control are part of what makes McDonald's burgers consistent and familiar. However, most people wouldn't rank McDonald's burgers as one of the best burgers they've ever eaten.

When you create design solutions for a specific targeted audience, you aren't mass-producing design solutions the way McDonald's mass produces its burgers. Instead, you are probably more like a local chef who knows what produce is ripe and who has knowledge of what the locals like to eat.

As a graphic designer, I always want to know who I'm designing for and what I need to do to move my target audience to action — just like a chef needs to know who they are cooking for and what type of food their patrons want. To me, this approach is far more satisfying and yields a superior design solution.

## Defining the scope of your project

Defining both the scope and the goals of a project are crucial steps in determining the boundaries and aims of a project. It can feel a little awkward to try to define these with your client for the first time, but this will become part of your normal project launch routine in no time.

The "scope" of a project is just a fancy way of saying a job begins here and ends there. Why is this important? Because you and the client may have different ideas about where a job begins and ends. You and the client need to be on the same page about where the finish line is located and what your goals are.

REMEMBER

Sometimes, words and phrases can be interpreted differently, so clearly defining the scope of the project is a way to head off miscommunications with your client.

### LEARNING TO DEFINE THE SCOPE THE HARD WAY

I was hired to create a small website for a client, and we agreed on a budget for the project. It was a fun project to work on, and my client was pleased with my progress. The client would make suggestions for the website, and I happily obliged. This continued for weeks, but slowly, I began to feel that the website would never be completed because the client always wanted "just one more thing," and I started to feel like there was no end in sight.

*(continued)*

CHAPTER 2 Developing Your Problem-Solving Skills    33

*(continued)*

> My last straw was when the client asked me if we could incorporate an e-commerce section on the website — something we never discussed and that would take considerable time to implement. I realized that I hadn't done my job articulating the scope of work and time I could devote to the project. What started as a fun project began to drag on and after months of work, I had to awkwardly work with the client to identify a point where the project would end. It would have been so much easier and less stressful to do this before the project began.
>
> Even though the client was happy with my work, my failure to define the scope of the project at the beginning created a less-than-ideal environment to work in. Clearly, I couldn't work on the website indefinitely, but the client and I hadn't discussed where the goal line was, so the client felt I was trying to end the project abruptly after catering to their needs for so long. Ending a project when someone feels "happy" isn't a very specific or well-defined goal. I learned that I needed to articulate the scope of a project better moving forward with other clients.

Changes to the scope of a project do occur and must be negotiated so both parties agree on what to expect as the project moves forward.

Sometimes, a project scope changes — it's no one's fault. When the scope of work changes, then you should immediately initiate a conversation with the client. If you're willing to do the work but need to adjust the deadline and/or fees, then let your client know immediately instead of waiting until the end of the project or assuming that they will approve additional fees.

Life is complex, and change is inevitable. It's not uncommon to have to redefine the boundaries of a project, but having clearly defined starting and ending points makes the entire process run more smoothly. If you run into a situation where the scope of a project needs to change, then it's better to discuss the changes with your client when they occur.

It's always a good idea to use a contract when you're working with clients. Contracts are beneficial for both graphic designers and clients alike and help the process go along smoothly.

Changes to the scope of a project can have a substantial effect on your profit margin, so it's worth taking time to define the scope of work clearly with all of the key stakeholders, including yourself. This way, everyone knows what to expect at the conclusion of a project, nobody is surprised, and everybody shares the same expectations.

# Taking a Macro-View to Tailor Fit Your Design Solution

It is helpful to gather specific, micro-targeted information about your project goals and target audience, but it can also be helpful to gather larger, broad, contextual information that relates to the design problem too. For instance, knowing what the competitive landscape is like where your design solution will compete, analyzing design trends, or considering the technical logistics can broaden your perspective and help you considerably.

## Conducting a competitor analysis

A competitor analysis (see Figure 2-4) is an evaluative process designed to capture and contemplate the strengths, weaknesses, and opportunities of the competitive landscape before you begin designing your solution. The market is constantly changing and evolving, so designers must understand where the market is currently to position the design solution strategically. Observing and learning about competitors and understanding trends in the industry can help me push my design solution in ways that are likely to benefit my client.

**FIGURE 2-4:** Use this competitive analysis framework to help you identify who might interact and compete with your design solution and why. Fill out this information for each competitor you compete with.

| COMPETITIVE ANALYSIS FRAMEWORK | |
| --- | --- |
| **Company Specific** | Number of Employees<br>Date Founded<br>Funding & Investors<br>Acquisitions<br>Number of Customers<br>Strengths and Weaknesses |
| **Target Audience/Message** | Products<br>Primary Purchaser<br>Secondary Purchaser<br>Target Audience<br>Messaging<br>Reviews<br>Engagement<br>Feedback & Comments |
| **Product/Service** | Product Features<br>Pricing<br>Experience Before Buying<br>Product Strength<br>Product Weaknesses<br>Customer Reviews |
| **Positioning** | How to Win?<br>Why Should Customers Choose Us? |

Conducting a competitor analysis is a step that young designers sometimes skip or gloss over because they've never been asked to do it before. Personally, I like to write down what my competitor analysis reveals and keep it handy when I talk to my clients. Often, they will have a competitor analysis of their own that I can reference. If it's beneficial to talk to the client about why I've made certain design decisions, then I'll pull out my sketchbook and share some of my competitor analysis with them and what aspects I'm attempting to address.

When I gather research for a competitor analysis, I often look for the following types of information:

- » **Industry trends:** Analyze competitor's design solutions and try to deconstruct and understand their concepts. Analyze how popular styles, colors, palettes, and other design elements relate to the audience.

- » **Unique selling points:** Analyze how the product or service uses selling points in their design solution (such as low-calorie, organic, doctor-approved, environmentally friendly, budget-conscious, and so forth).

- » **Identifying gaps and opportunities:** Analyze competitor's design solutions to see if there are either gaps or opportunities in the market that haven't been addressed yet.

- » **Audience perceptions:** Any information on how their target audience views their product, service, or idea and their online reputation and messaging, including engagement metrics, reviews, and feedback.

The purpose of a competitor analysis isn't to rip off competitors or take a shortcut when developing my own concept. Instead, it helps me understand where the crowded areas of the market are and guide me when creating a design solution that either aligns with or differentiates itself from the competition.

Sharing your insights from your competitor analysis can help your clients understand why you made the design decisions you did. Sharing this information may also help make your client feel that you understand how their market works and make them more comfortable putting their trust in you to help solve their problem.

### Analyzing design trends and styles

The first step of analyzing design trends is to familiarize yourself with how your audience interacts with the products, services, brands, and experiences they desire. I've covered this a bit already, but you'll want to gain insights about their behavior and use this information to guide your design decisions. However, there are a few steps I haven't identified yet that you might also want to consider.

### Follow the influencers and leaders

If you want to spot design trends and approaches, then you may want to follow and research the influencers and leaders in your industry. Usually, these are people or accounts that have a large following and shape the direction of the company. Names like Bill Gates, Elon Musk, and Tim Cook come to mind, and they often have social media accounts, blogs, podcasts, newsletters, interviews, and press releases where you can learn from them. These industry leaders are often asked, point blank, where they see their industries going and what new initiatives are beginning to break ground. You can consider ways to take large, grandiose ideas and scale them down so they are more easily digestible and easier to incorporate into your own design work.

TIP

Set up an account in the channels where relevant industry leaders are the most active and check in routinely to monitor industry trends. If possible, consider engaging with influencers/leaders or their communities for insight, feedback, advice, and opportunities to collaborate.

### SMOOTHIE KING

One of my students responded to a tweet from Diplo, an American DJ and music producer, when he tweeted about "Smoothie Wolf and feeding the streets since 1885," challenging his fans to create a logo for Smoothie Wolf.

My student quickly went to work, tweeted back some concepts, and asked if Diplo would like him to work up some ideas and bring them to him when he came to a nearby town for a concert. Diplo agreed, so the student finished designing the Smoothie Wolf logo and then screen-printed it on colorful tank tops.

On the day of the concert, the student found the backstage door and knocked on it. A bouncer poked his head out and said, "What?" The student explained why he was there, and the bouncer took the shirts and said, "Wait here," and locked the door behind him. After several minutes the bouncer reappeared with VIP passes to the show.

My student was pumped and couldn't believe his luck, and at one point during the concert, Diplo ripped off the shirt he was wearing and revealed one of the custom screen-printed shirts the student had created underneath. Diplo pulled the student onto the stage with him, and the student captured an amazing photograph to document the experience and include it in his design portfolio.

*(continued)*

CHAPTER 2 **Developing Your Problem-Solving Skills** 37

*(continued)*

While it's unlikely that all attempts to contact industry leaders will end up getting you pulled up on stage during a concert, you might be surprised to see how many influencers monitor their social media channels and interact with followers. While it's fine to monitor these channels passively, don't be afraid to throw your hat in the ring and engage if the opportunity presents itself. Part of the power of social media is being able to have access to industry leaders and influencers who are helping shape culture.

## Using tools and platforms

There are a number of helpful tools and platforms you can use to help you identify and analyze design trends. Here are a few of my favorites.

>> **Google Trends:** Google Trends provides access to search requests made to Google in the last seven days. Seeing what queries people are looking for on a variety of subjects can help you stay up to date on the latest trends, news, and pop-cultural references. Google Trends allows you to filter the data in a variety of ways (such as worldwide, by country, subregion, time, category, and trending now).

>> **Pinterest Trends:** Pinterest Trends allows you to search for keywords, breaks down the results into interests over time, and provides demographic insights like age and gender. It also provides popular Pinterest Pins (a bookmark people use to save content they love on Pinterest) and makes suggestions for related trends so you can compare the trends against one another. Pinterest Trends allows you to view search terms across different interests, regions, seasons, and more.

>> **Behance:** Behance is a large creative network for showcasing and discovering creative work, allowing you to search for projects, assets, images, and people in a variety of creative fields and locations. While the main reason for creators to use Behance is to create portfolios, it can also be used to showcase and search products and services easily. What Behance lacks in filtering trends, it makes up for in thumbnails and visuals that can be searched and referenced easily.

>> **Dribbble:** Dribbble is a self-promotion and social networking platform for artists and designers. Dribbble serves as a portfolio platform and a place where designers and companies from all over the world gain inspiration, gather feedback, and find work or hire other designers. Dribbble allows you to follow other designers' work and can be helpful for identifying design inspiration.

REMEMBER

Sometimes, new technology can be the catalyst for a design trend. As generative AI continues to enter the public domain, it will be interesting to see how its influence will affect workflows and image-making within the graphic design profession.

## Iterate and experiment

Designers experiment with design techniques and new trends to determine how easy it is to incorporate them and to judge whether the aesthetic is worth adopting into their own workflows. Many designers experiment with and modify trends that catch their eye and fuse their own visual voice or style into the mix. Often, the goal is to reference the trend, riffing on it like a jazz musician — not to copy the reference directly.

As you become more familiar with the body of work that is relevant to the problem you are attempting to solve, you may begin to notice themes in color palettes, typography, fonts, textures, techniques, and other design elements. Some trends are driven by hardware and software (such as iPad Pro, Apple Pen, and Procreate, which created an abundance of hand-drawn script letterforms). Alternatively, social factors like video game characters, sporting events, movies, and pop culture references can drive visual trends like the "Retro-Futurism" style of the movie *Blade Runner 2049* or the "Comic Book Aesthetic" of the movie *Scott Pilgrim vs. the World*.

As a tangential thought exercise, consider the healthcare industry. Have you ever noticed how many of the design solutions in this environment are a shade of blue? Blue is an extremely popular color among medical professionals, and it is a color that is well-liked by both male and female audiences. Depending on the color or shade of blue, blue can help communicate serenity and calmness, feelings of security and trust, and can even be used to create environments that feel safe, healing, and inspiring. When you put it all together, the decision to use blue makes a lot of sense, but its abundant use also creates a crowded environment for another blue design solution to exist.

Many designers test and probe the constraints, challenge conventions, and bend the rules because sometimes these are the areas where things are a bit more visually interesting. If I had a client in the healthcare industry, I'd talk with them about their goals, and if they expressed an interest in standing apart from others in the industry, I might encourage them to explore colors beyond blue as a means of differentiating their brand or service. I might start with an analogous color or a color that is close to blue on the color wheel, as seen in Figure 2-5, but still choose a cool color (green, blue, or purple) that evokes feelings of relaxation and calm.

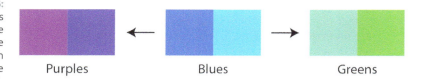

FIGURE 2-5:
Analogous colors are colors that are close to each other on the color wheel.

REMEMBER

Iteration and experimentation extend well beyond color and could include line, shape, form, texture, space, size, value, balance, contrast, harmony, movement, and composition as well. These are the elements of design and the building blocks that graphic designers use to create visual compositions.

When you look at design trends, try to notice what design elements are being used repeatedly and think about why these decisions may have been made. Assess your own design problem and lean into the parts that help you reinforce your message and abandon or reinvent the parts that don't help you achieve your communication goals. To be clear, I'm not saying "copy the good parts," but I'm saying take the time to understand what is working and attempt to understand why.

Let's pretend we want to create a logo for a start-up solar panel company, and we want to start by picking a general shape for the logo. Speaking broadly, here is some information about how we tend to interpret and react to certain shapes.

» **Squares and rectangles:** Squares and rectangles can be associated with order, stability, or reliability. Squares and rectangles can also seem boring and predictable.

» **Circles:** Circles may be associated with unity, eternity, completeness, or harmony. Circles can also be monotonous or lack excitement.

» **Triangles:** Triangles can communicate stability, balance, or progression. Triangles can also trigger associations of conflict, tension, or instability (such as an inverted triangle).

» **Spirals:** Spirals can elicit feelings of growth, evolution, or transformation. Spirals can also be associated with dizziness or confusion.

» **Curves:** Curves can communicate flow, grace, or beauty. Curves may also communicate feelings of confusion or unpredictability.

» **Organic shapes:** Organic shapes can be used to communicate nature, comfort, or familiarity. Organic shapes can also trigger associations of discomfort or unfamiliarity.

» **Symmetry:** Symmetry can trigger feelings of balance, order, or beauty. Symmetry can also feel sterile and lack creativity.

PART 1 What to Know Before You Start Designing

Of course, these perceptions may be influenced by culture, individual experiences, and personal preference, but they may help put the designer on a pathway of visual exploration that isn't arbitrary.

Supporting your rationale and decision-making for your design solution is to be expected. Be prepared to walk someone through your decision-making process.

When considering the shape of a logo for a start-up solar panel company, I would want to gather more information about the company, its pain points, how they are trying to position itself, and how the logo will be used before *fully* committing to a shape. However, my first impressions are to use the following shapes:

>> **Squares and rectangles:** These would be used if the company wants to express they are stable, reliable, and will be around for a long time.

>> **Triangles:** These would be used if the company wants to reinforce the benefits of solar energy over petroleum to communication progression.

>> **Organic shapes:** These would be used if the company wants to promote a lower environmental impact for their products and communicate that solar panels are more aligned with sentiments of nature and environmental sustainability.

Reliability, benefits, and environmental impact are three unique and different concepts, but you can see in this example how shape could play a role in what the company is trying to communicate and how the visual language could support this concept, as seen in Figure 2-6.

FIGURE 2-6: Simple shapes can be used to allude to different types of messages.

Reliable

Beneficial

Sustainable

## Consider the technical requirements

Design solutions often require the designer to be aware of the technical requirements of both print and digital forms to ensure a good final result. While this brief section can't cover every aspect of print and digital requirements, it can serve as an overview of some aspects you may want to consider and possibly discuss with your client at the beginning of your project.

If possible, stop by and talk with your local printer about your print job. They will work with you to make sure you get the best results and with no surprises.

## Print technical requirements

Following are some print technical requirements you should consider:

- **Bleed:** Bleed is the area outside of the design that will be cut off and discarded. Printers typically require a bleed area of 0.125 inch. Forgetting to include bleeds may result in undesirable white lines at the edge of your prints.

- **Color mode**: Most print design is created in the CMYK color mode which stands for Cyan, Magenta, Yellow, and Key (black).

- **File format:** Common print-ready formats include PDF, TIFF, and EMP files. Check with your printer for their preferred file format and specifications.

- **Fonts:** Embed or outline your fonts before going to print to avoid potential font issues. PDF documents embed fonts automatically by default.

- **Paper and print specifications:** Talk with your printer about the characteristics of the paper or material you'll be printing on, including the finish. Colors and varnishes can appear differently on different types of paper and finishes. Coated and uncoated papers can have dramatic effects on how the ink is absorbed into the paper fibers.

- **Resolution:** Images and graphics should have a high resolution of at least 300 dots per inch (dpi) or higher to avoid appearing pixelated or blurry.

- **Trim marks:** Trim marks indicate where the printer should cut the paper. Often, many copies of a file are printed simultaneously, and trim lines show where to cut the paper or substrate.

- **Vector vs. Raster:** Vector graphics can be scaled up or down without any loss of quality, while raster graphics that are based on pixel density can only be scaled down without sacrificing quality.

## Digital technical requirements

Following are some digital technical requirements you should consider:

- **Accessibility:** Follow accessibility guidelines to ensure that your design solution is usable by individuals with disabilities. The website www.w3.org covers a wide range of recommendations for making web content more accessible.

- **Color mode:** Use the RGB color mode for digital design. RGB is short for red, green, and blue and works better for screens and monitors because the color profile is built off of the primary colors of light used in digital displays.

>> **File format:** Use digital file formats such as PDF, PNG, JPG, GIF, or SVG for reduced file sizes, transparency options, and optimizing files to be viewed on screen.

>> **File size:** Be mindful of file sizes, especially for work on the Internet. Compress images to balance quality with load times. Large file sizes can slow the loading speed and negatively affect the user experience.

>> **Interactivity:** If designing for interactive platforms, think about the way your solution is designed to be interacted with. For example, buttons on a mobile device should be sized so they can be selected with a fingertip, whereas websites on a laptop are usually selected with a mouse or trackpad.

>> **Pixel density:** Consider pixel density when creating images for digital displays. High-density displays may require higher-resolution images to maintain visual clarity.

>> **Responsive design:** Use responsive design principles to create layouts that adapt to various screen sizes and orientations. `www.interaction-design.org` has a list of best practices in regard to responsive design.

>> **Typography:** Choose web-safe fonts that are readable across different types of devices, browsers, and operating systems. Web-safe fonts are stored locally and load faster than other typefaces, meaning you can take advantage of better speeds and performance when you choose web-safe fonts. The website `https://www.w3schools.com/cssref/css_websafe_fonts.php` is a good source for identifying web-safe fonts.

> **IN THIS CHAPTER**
>
> » **Improving your empathy skills to reach your audience**
>
> » **Building better collaboration skills**
>
> » **Embracing creativity (and mistakes)**

# Chapter 3
# Practices for Creating Better Design Solutions

Empathy allows us to understand how other people feel. This understanding fosters better communication and connections and allows us to relate to each other on a deeper level. Empathy is a crucial component for building trust, and when people feel supported and understood, the bonds between us are strengthened.

When we experience conflicts with others, being empathetic allows us to see our commonalities and differences in a new light and can help facilitate a more effective resolution.

We can also use empathy to learn about diverse perspectives and cultures and promote cross-cultural understanding by breaking down stereotypes, reducing prejudice, and building bridges between different stakeholders and communities.

Practicing empathy can contribute to your own personal growth by expanding your perspective, encouraging self-reflection, and fostering a greater sense of unity and cooperation with others.

I believe graphic designers are a naturally empathetic group because we often create and deliver messages to audiences with different abilities, backgrounds, and experiences. To do this successfully, you often have to learn about the challenges

and pain points that your audience faces in their lives and spend a lot of time *actively listening* and trying to see the situation from someone else's perspective to try to connect with them in meaningful ways.

# Improving Your Empathy Skills to Help Reach Your Audience

Empathy is seeing the world through other people's eyes, and when we can do this effectively, we are able to put aside our preconceived notions and understand the ideas, thoughts, and needs of others instead. When you approach a problem in an empathetic mindset and in the *context* of your target audience, you can often gain a completely different perspective and may identify a solution you may not have identified otherwise.

There are a variety of ways to grow your empathy skills, but one of the easiest steps you can take is to practice active listening. Active listening is giving your full attention to another. Avoid interruptions and demonstrate that you are listening by giving back non-verbal cues like nodding your head and maintaining good eye contact. It goes without saying that you need to remove your cell phone and other distractions from the equation and simply give the conversation your full focus.

Active listening allows you to focus on what someone is saying, which in turn helps position you for the next step — imagining what it would be like to experience a situation from someone else's point of view. Consider what the person you are talking with might be thinking or feeling in a particular situation. If you aren't sure what they are thinking or feeling, then ask them about it by using an open-ended question that requires more than a simple "yes" or "no" answer.

Try to develop a genuine interest in others and their lived experiences. Show a sincere interest in getting to know them better, and you'll be on your way to becoming a more empathetic person. Think about the information they shared with you and try to reflect on your own emotions and those of others you come in contact with. Reflecting on your own feelings may help you relate to the emotions of others more effectively.

Try to learn about different cultures and perspectives to better understand and appreciate other people's lived experiences, cultures, and backgrounds. Traveling, reading literature, and watching films that have been made by communities other than your own may give you an opportunity to practice developing your empathy skills in a controlled environment.

If you mess up and say something inappropriate, take responsibility for your mistake by not downplaying the significance of the remark. Apologize sincerely to anyone who may have been offended and then take the initiative to educate yourself and learn from the experience. We all make mistakes.

Empathy is sometimes confused with sympathy. *Empathy* allows you to experience the emotions, thoughts, or attitudes of others, while *sympathy* is your ability to show concern, sorrow, or compassion for others.

## Generating an empathy map

An empathy map helps describe aspects of a user's experience, what they see and hear, what they say and do, and both their pain points and goals. Creating an empathy map is usually a group project that typically begins by conducting interviews, distributing surveys and questionnaires, observing behavior, monitoring social media, and analyzing customer feedback.

Empathy maps work best when you gather the feedback first and fill out the empathy map afterward rather than the other way around.

Empathy maps are a document that a group of individuals create together in collaboration with one another. The map often provides a structure for the group to share information and creates a macro — or 40,000-foot view — of the target audience.

As you can see in Figure 3-1, empathy maps are a framework for better understanding how someone thinks and feels about an idea, product, or service. It considers the things a target audience sees and hears and helps designers better understand what the target audience's pain points and goals are.

Fill out your empathy map by starting with question one, "What do they think and feel?" and have the members of the group contribute to the discussion. A facilitator should write down the consensus from the group before moving on to the next question.

Empathy maps allow groups to sum up their learning from engagements with members of the target audience and can help lead to other strategies like customer journeys and personas. Empathy maps can be a valuable tool, but they require teams to interpret data, which can sometimes introduce errors, fail to capture broader contexts, and may not fully represent the fluid, dynamic nature of user emotions and sentiments. Empathy maps are a snapshot of a set of data at a particular moment in time, and teams must approach them as living documents that need to be monitored and updated for them to be helpful in the design process. Empathy maps can be used in conjunction with other tools like a customer journey or personas to help drive the design process.

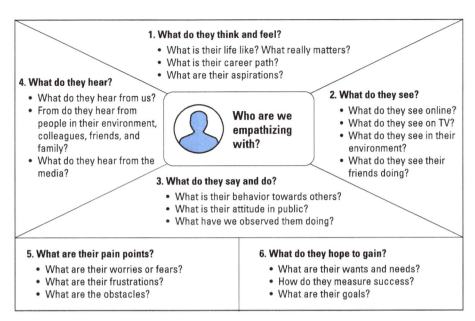

FIGURE 3-1: Empathy maps are a framework for understanding your target audience better.

# Developing a persona

While an empathy map might be considered a 40,000-foot view of the target audience, a persona takes a more granular approach. A persona is a fictional character that represents a user who might use a website, product, or service. Personas can be based on some of the research you collected in your empathy map and are designed to help design teams understand and empathize with their target audience. Typically, details like age, gender, job, personal interests, and goals are included in a persona. As you can see in Figure 3-2, the fictitious character, Justin, is a data analyst living in New York City.

The following list outlines some advantages of developing a persona:

» Focuses the design process on the needs of users
» Can help humanize the design process
» Can help designers empathize with their users
» Can serve as a reference point for decision-making
» Creates a shared understanding among team members
» Can help a team prioritize goals for a design solution
» Can be revised along the way as projects or goals change

48   PART 1  What to Know Before You Start Designing

TIP

Personas work best when you focus on key characteristics that are relevant to your project, which may include information like age, gender, education, location, career, interests, behaviors, goals, or challenges.

Try to leave out information that may not be relevant to the design project. For instance, the persona in Figure 3-2 appears to be a competent professional who is likely not interested in brands that use negativity to distinguish themselves from their competition. This persona is a busy professional and probably wants relevant information delivered quickly instead of through a monotonous style such as "We are having a sale! The sale is on Saturday, May 25. You can receive discounts up to 20 percent."

In this case, I might try to strike a positive, friendly, and competent message with a subtle hint of humor. To do so, I might create a word list that captures the vibe I'm trying to visually explore: Exceptional, superb, approachable, amiable, cheerful, competent, efficient, motivating, collaborative, engaging, reliable, and authentic. Now when I begin creating a design solution, I have a pretty well-defined target to try to hit with my visuals. After all, you can communicate with your graphic language and layout similar to how you can communicate with text on a page.

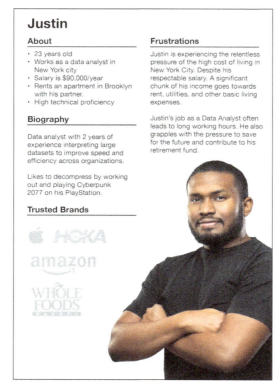

FIGURE 3-2: Creating a persona can help your team make better design decisions.

*Syda Productions/Adobe Stock Photos*

CHAPTER 3 **Practices for Creating Better Design Solutions** 49

## Creating a mood board

Mood boards are often useful in organizing the visual language and tone of a project. A mood board can include a collage of images, colors, textures, patterns, typography, and other visual elements. Mood boards can be relatively simple or more complex if a project is more intricate.

Mood boards can be helpful in coordinating a design team or as a low-stakes way of making sure the visual direction of the project is in line with client expectations. Imagine working on a project and finding out at the end after numerous hours have been invested that the client didn't like the visual language you used to communicate to the target audience. Mood boards can be a useful way to help understand your client's preferences before a project is started.

There's no "right way" to create a mood board, and they could be made from a collage of images mounted on a foam core board, created digitally using software like Adobe Illustrator or Photoshop, or online with tools like Canva and Milanote. Whether your mood board is physical or digital, it's created with the intention of serving as a visual reference and a source of information.

A few years ago, I was working on a package design project where the target audience was 8–10-year-old girls. Having a 10-year-old child myself, I took some photos of some of the objects she was actively playing with in her room and created the mood board you see in Figure 3-3. I used the Adobe Capture app on my mobile phone to develop a color palate and then I searched Adobe Fonts for typefaces that reflected informal, humanistic qualities. I needed my type to work hierarchically, so I included typographic weights and sizes in my mood board. I also found a text effect that could be easily applied to my typography in Adobe Photoshop to create three-dimensional letters with the click of a button. While I could have continued to work on the mood board and develop it further, this was enough to show my client and get the thumbs up to proceed.

Adobe Capture allows you to use your mobile device to capture audio, graphics, shapes, colors, types, patterns, materials, and brushes and bring these assets into your projects seamlessly. If you use Adobe Creative Cloud software, then you can access the design elements you created with Adobe Capture by opening the "Libraries" panel in your desktop application and looking for the graphic in the library you saved it to. Adobe Capture gives graphic designers a mobile tool for capturing elements that can be easily integrated into a mood board.

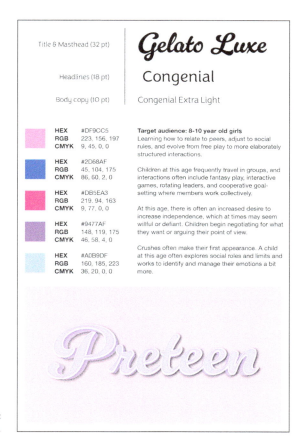

**FIGURE 3-3:** A mood board.

# Building Better Collaboration Skills

Graphic designers often collaborate with peers and other professionals like photographers, illustrators, copywriters, project managers, and so forth. Graphic design is an iterative process, meaning a designer will develop a concept, refine the idea, get feedback, and revise the concept until they are satisfied with the end result. The key to incredible collaboration is choosing good communicators who have relevant skill sets.

In my 20 years of experience as a professor teaching graphic design, getting feedback from peers is one of the most frequently skipped steps that young designers make. The idea of putting your work out there for others to react to can be terrifying for some, but it can also help you improve your work immensely.

Who you choose to get feedback from is an important consideration. Choose someone who understands your goals, the medium, and someone whose opinion you value.

Collaborations are designed to encourage an exchange of ideas and perspectives, and the purpose of the collaboration is to elevate the work and invite alternative points of view. This doesn't mean that you're surrendering your creative control, but that you should listen to other viewpoints and consider alternative angles for attacking the design problem instead.

Avoid claptraps, stickers, and refrigerator magnets. Don't just choose people who will praise your work, gush and tell you how amazing you are, or tell you that your work is perfect. This might make you feel great, but this won't actually improve the work.

While I love my mother dearly, I quickly discovered that she's an awful person to choose to collaborate with because she only wants to give feedback that is positive and encouraging. While this is an awesome trait for a mother, it's not a great trait for a collaborator. Instead, I try to seek out individuals whose feedback I trust and who aren't afraid to tell me when I've missed the mark.

## Seeking feedback makes you smarter

Design is a dynamic process, and every graphic designer has strengths and weaknesses. When you seek feedback from others — particularly in areas where you are weak — you can often learn strategies that may help you develop your weaknesses.

You've heard the phrase that two heads are better than one, and getting feedback on your work is no exception. It's easy to think that collaborating with others opens you up to criticism, but instead, it's actually a generative process rather than a reductive one. When someone gives you feedback on your work, it's a gift (although, admittedly, it may not feel like it sometimes). When you get feedback that helps you reframe your approach to solving a problem, it can really help you break free from your tried-and-true, established patterns and break through the glass ceiling that you may not have realized was there.

When I collaborate with others, I like to try to steer the conversation in a way that is most beneficial. For instance, I might show a colleague a web page that I'm designing and ask a question like, "What do you think of this color palette?" or some other aspect that I would like feedback on. This approach ensures that I'll get targeted feedback instead of a broad, sweeping reaction to my design solution, which may be likely to make me second-guess myself.

REMEMBER

At different stages of the design process, you'll need different types of feedback. It can be helpful to specify the type of feedback you're looking for. A statement like, "Can I get your reaction to this?" means "Can you give me broad feedback?" while a question like, "Can I get your reaction to my typographic hierarchy?" will generate a more targeted response.

Building a network of people whose opinions you trust takes time, but it's worth it. When I was in graduate school, there was an unwritten rule that when someone asked for help, you stopped what you were doing and gave it. Even 25 years later, I know I can call up my friend from graduate school and ask her for a critique. So, when you ask others for help, make sure you're willing to return the favor, too.

## Conducting interviews, observations, and surveys

Talking to other designers and professionals can be helpful, but talking with your target audience can be extremely valuable as well. Interviews, observations, and surveys can give you insights that can also help you improve your design solutions, too. The danger here is to avoid opinions rather than facts and to make sure you're not reacting to criticism that is too granular and represents the needs of an individual rather than the group. To avoid this, you need to prepare for your interviews and consider a few guiding principles.

» **Think like a beginner:** Treat each interview like it's the first time hearing the information that the individual is sharing. Listen carefully, or better yet, record the interview, and don't jump to conclusions too early. Avoid interpreting responses on the fly, and try to gather as much relevant information as possible.

» **Learn as much as you can:** If you are doing the talking, then you aren't learning. Listen to what the individual is saying and consider asking open-ended questions like, "Can you expand on this point?" Try to avoid sharing your own opinions and listen to their point of view instead.

» **Just the facts:** Ask questions that are aimed at gathering facts, not opinions. Avoid questions that start with "Would you. . .?" and ask a question like "When was the last time you. . .?" instead.

» **Ask why:** Ask the individual why a lot in order to dig down into deeper truths, attitudes, and behaviors. Why is this a pain point for you? Why do you feel this way?

» **Don't mention solutions:** At some point, you may in interested in sharing your approach to solving a problem, but don't do it. Your goal is to learn from the individual, not to have them confirm your approach.

CHAPTER 3 **Practices for Creating Better Design Solutions** 53

When you observe your audience, try to identify patterns of behavior, pain points, and areas where users struggle. These are all sources of valuable information and can help you identify where to focus your design efforts later, but for now, focus on learning as much as you can about your audience.

Try to put yourself in an empathetic mindset so you can experience what the issues and frustrations are in order to try to resolve them in your design solution.

If you decide to use a survey to gather data on your audience, then start with defining clear objectives. Think about the purpose of the survey and what you hope to learn. This may help you focus your survey on gathering the information that will help you the most and avoid wasting time on irrelevant information.

Surveys come in many mediums and budgets, so you could use an online platform like SurveyMonkey or a paper-based survey. Each method has its own advantages and disadvantages, like response rates, data quality, cost, and convenience. So, choose the tool that best fits your needs and budget and gets you the results you need.

When you write your survey questions, pay attention to how you ask questions. Are they open-ended, rating scales, multiple choice, and so forth? Each type of question has pros and cons, but you need to choose a question type that avoids leading, ambiguous, or confusing responses. Use a consistent, short, and clear question strategy to maximize the quality of the information you're looking for.

It can be a good idea to test your survey before you launch it to make sure there are no errors and to make sure your survey works as intended. Take a look at how long the survey takes to complete, and make sure to ask your most important questions first because survey participation may diminish over time.

Once you have collected your survey data, you'll need to analyze it to draw conclusions and insights from your data. There are a number of tools and techniques to organize and visualize data. From Google Sheets to software like SPSS, you can perform statistical analysis and testing to look for patterns and correlations in the data.

You can present the data clearly and concisely using graphics, charts, tables, and infographics to illustrate key points. It may also be beneficial to explain the methods, limitations, and implications of your survey if project constraints allow.

Interviews, observations, and surveys are a great way to develop and support a graphic design concept that goes beyond surface decorating and attempts to solve the problems that members of your target audience struggle with.

# Embracing Creativity (and Mistakes)

The design process is dynamic, and projects constantly evolve. The creative process does not follow the rules of logic, meaning if you're doing your job as a creative person, you're going to have to learn to be okay with making mistakes along the way. There isn't a single creative person alive, no matter how talented they are, who doesn't make mistakes.

In fact, I would offer that being afraid of making mistakes represents one of the biggest hurdles that graphic designers have to overcome. Being fearful of doing something "wrong" can mentally lock people up with what I call "paralysis by analysis."

If graphic design followed a logical pathway like math, then A+B=C and C+D=E. The only way that the answer for E can be correct is that A, B, C, and D also need to be correct. But graphic design and creative work isn't based on logic — it's based on perception, and often, human perception doesn't follow the rules of logic.

How you get to a graphic design solution isn't super important; only the quality of the design solution matters. The richness and depth of your exploration often matter more than the rightness of the steps you took along the way.

Think about it this way: In Figure 3-4, the order in which the archway stones were laid isn't particularly important. What's important is that once the supporting material is removed, the archway becomes self-supporting and stands the test of time.

This is a great metaphor for graphic design because it frees the designer up from the fear of making a mistake. It's okay to make mistakes, run into dead ends, or try an approach that is untested or may not work out. What matters most is that you explored, experimented, tested, evaluated, played, and looked at new angles for solving the problem. If you've done your job, then, of course, you'll have made mistakes along the way.

If you don't find yourself making mistakes along the way, then you've probably played it too safe. Does anything creative, unique, or inspired come from playing it safe? No, of course not.

Nobody is immune from mistakes, particularly graphic designers. Instead of being worried about making mistakes, graphic designers need to embrace them as a necessary part of the design process. Do graphic designers have to adhere to project constraints? Absolutely! Can you explore, experiment, test, evaluate, play, and look at new angles for solving the problem indefinitely? No, of course, you can't. But should graphic designers be asked to be creative on demand where the lightning bolts of inspiration fall from the heavens and immaculate concepts rain down upon you? Also, no.

CHAPTER 3 Practices for Creating Better Design Solutions 55

FIGURE 3-4:
A medieval gateway from Glendalough in Ireland.

Jennie/Adobe Stock Photos

Sometimes, graphic designers get lucky and can think and develop concepts and design solutions quickly, and sometimes, they need ample time to explore, develop ideas, get feedback, and assess ideas. Sometimes, this involves making a few mistakes along the way — that's perfectly okay. In fact, it's necessary.

## Identifying creative versus logical thinking

If I were to illustrate the differences between logical and creative thinking it would look something like what you see in Figure 3-5. When you are thinking logically, you take the available options and systematically remove options that don't meet the project requirements. The goal of logical thinking is to identify the best or right solution. Often, logical thinking is a *selective process* where constraints dictate certain outcomes, meaning options that are too costly or take too long to implement are eliminated from consideration.

Conversely, creativity is an *additive process* where the goal of creative thinking is to generate many options. This includes big options, bad options, red options, funny options, impractical options, inspiring options . . . you get the point. The breadth and depth, or the richness of the investigation, is more important than identifying the singularly best option.

56   PART 1  What to Know Before You Start Designing

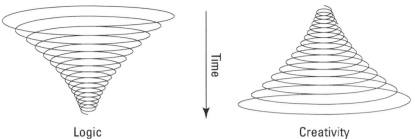

**FIGURE 3-5:** An illustration of logical thinking versus creative thinking.

**REMEMBER**

Approaching design solutions with *only* a logical mindset puts you on a course for creating uninspired work. Conversely, working *only* creatively leaves you unable to make certain decisions.

It can be tempting to think that graphic designers should strictly focus on creative thinking and approaches to problem-solving, but I have found that the best solution is to implement both creative and logical thinking. The key here is to know which tool to use (and when). The concept of using the right tool for this job is illustrated in Figure 3-6.

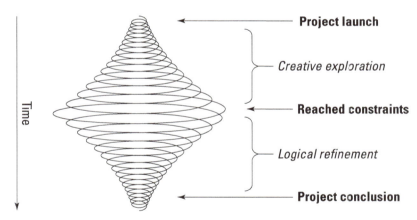

**FIGURE 3-6:** Using both creating and logical thinking together to solve a design problem.

In short, when the project launches, the creative exploration phase begins immediately, and the designer begins brainstorming and generating all kinds of solutions without judgment or self-editing the ideas. Then, when the project constraints are reached (such as time, cost, or other factors), the designer switches to a logical phase where all of the potential solutions are considered. During this phase, all the potential solutions are evaluated and narrowed down to the best solution and developed.

Approaching a design solution with just logical thinking can result in an uninspiring, mediocre solution. If you only use creating thinking, then picking and refining the best idea is almost impossible.

## Learning from mistakes

As mentioned earlier, if you're working creatively, then you're going to make mistakes. Learning from your mistakes is an important aspect of growing as a graphic designer. Here are some actions you can take to help you grow and to put your mistakes to work for you.

- **Reflect on how it went:** At the end of a project, reflect on how the project went and identify where mistakes were made. Think about how these mistakes impacted the project.
- **Consider the feedback you received:** Did you share your work with peers and other professionals? If so, think about the feedback you received and how it affected your trajectory.
- **Reflect on your assumptions:** Did the data you collected you're your interviews, observations, and surveys point you in the right direction? If not, document what happened so you can avoid falling into the same predicament in the future.
- **Reflect on the timeline:** Did you leave enough time to brainstorm? Did you leave enough time to develop and refine the concept? If not, document this so you'll be able to provide more accurate quotes for how long a similar project will take in the future.
- **Learn from others:** If possible, compare your results to those of other graphic designers. Did the project take you longer? Did it cost more? This information can help you hack your design process and identify areas, tools, and techniques you can use in the future.

Mistakes are simply opportunities for growth. Take the time to learn from your mistakes so you don't continue to make them again and again. Hopefully, the mistakes you make will be increasingly smaller and less important as you grow as a designer.

**IN THIS CHAPTER**

» Capturing your ideas using pencil and paper

» Evaluating electronic pencils and tablets

» Appreciating Adobe Creative Cloud

» Considering alternative software for the budget-conscious

» Using generative AI tools for graphic design

Chapter **4**
# Choosing the Right Tool for the Job

Graphic designers rely on tools to help them create their design solutions. Some tools are as inexpensive as pencil and paper, while other tools like laptops and software can be significantly more expensive. The goal of this chapter is to discuss some of the advantages and drawbacks of a few common tools in order to invest your money wisely.

Many of these tools are used to aid the designer in developing design solutions, experimenting, and refining their design solutions. A few years ago, I used to say that there was no "create dinosaur" button on the computer because this type of photographic or illustrative work had to be done manually, but with the improvements to generative AI, this is no longer the case. So, let's dive into the tools of design, take a look at what's good and what's cheap, and figure out where the "create dinosaur" button is.

Tools are just tools. They can be used well, or they can be used poorly. While it's true that some tools are easier to use, there's no tool more powerful than the human mind.

# Capturing Ideas with Pencil and Paper

Let's start by discussing the most prolific and cheapest tool around — a pencil and paper. It's hard to beat the flexibility and freedom that a pencil and a sheet of paper offer. Most designers will agree that a simple paper and pencil is a great option for sketching out ideas, testing concepts, and ideating. There's no annoying pop-up box that demands you to determine how big your document is or ask if you prefer to measure in inches or pixels — the barriers for getting your ideas out of your head and onto paper are quite low. Why is this important? I've seen young designers waste a lot of time setting up their digital documents only to realize that the concept they were contemplating just wasn't going to work that well. Had they grabbed a pencil and just started sketching from the beginning, they would have saved themselves so much time.

Don't get me wrong: I like working digitally too, but there's a lot of freedom using pencil and paper that digital tools just can't match. If you don't like how your sketch is working out, just move to a different spot and start again. There's such a low investment in time, and it's easy to sketch an idea and move on if you aren't feeling it. When it takes longer to test an idea out, we want our investment of time to work out, so we stick with bad ideas longer than we should — increasing the time it takes to get our ideas out once again.

Pencils and paper also offer immediate gratification. I can sketch out little rectangles where my type will be without having to pick a typeface, size, spacing, and so forth. There's no waiting. If I like the direction of the concept, I might invest a little more time into a particular sketch. If I'm not in love with the direction, then I'll move on.

REMEMBER

Pencil and paper are portable. This allows you to put your ideas down wherever inspiration strikes. There's no software to load, and you don't need batteries or electricity. You can work practically anywhere!

In Figure 4-1, this sketch of a business card took maybe 15 seconds to draw, but it contains a lot of information. The rectangle boxes represent the areas where my type will be placed but also hint at the size and weight of my type. For instance, the white rectangle represents the name of the company, and the dark box underneath is the employee's name in bold with the employee's job title to the right. The top of the business card will be a light color, and the bottom half will be a darker color. Flipping the card over reveals a company motto on the top with the employee contact information like phone number, email, and address on the bottom.

**FIGURE 4-1:** A quick thumbnail sketch of a business card layout in pencil and paper.

Thumbnail sketches aren't normally created to impress people; more often, they are used to explore an idea and to try to work out some of the design problems you are likely to face. A pencil and paper make the process of getting your ideas out quickly really easy. Because pencil and paper sketches can be created so quickly it's psychologically easy to eliminate ideas from consideration that are unlikely to work well.

I can share thumbnail sketches with a client or a colleague and get their thoughts on it before investing too much time developing the idea further by picking typefaces, colors, printing techniques, paper weight, and so forth. Working with pencil and paper allows me to focus on the ideas behind my design solution and work generatively rather than working in a linear path to identify a potential design solution. Since this sketch only took approximately 15 seconds to create, it's low risk to invest more time thinking about other layouts and approaches, too.

Sometimes when my students show me their sketches, I see something they didn't intend, and we can have a really interesting conversation and occasionally work together to develop a new idea that neither of us thought of. I mention this because this is part of the beauty of pencil and paper: You can be quick, loose, and fluid with your thinking because you aren't too concerned about logistics yet. Does it matter that the typical 2.5 x 3-inch dimensions of a business card in Figure 4-1 aren't accurate? No, not really. I would argue that the focus of the thumbnail sketch is to explore how the information on the business card could be laid out. This is one of many sketches that I should — and would — explore.

REMEMBER

You don't have to be great at drawing to use pencil and paper well. You only have to loosely capture a concept before moving on to investigate other concepts. Thumbnail sketches are just an artifact for preserving your ideas, concepts, or approaches.

## Don't underestimate a tactile experience

There's something visceral about holding paper in your hand and feeling the resistance of a pencil, pen, marker, or brush on the page. I didn't always think

CHAPTER 4 **Choosing the Right Tool for the Job** 61

so, but I had a design professor force me to do all of my sketches for a project in his course using watercolor paints. At the time, I thought it was one of the evilest requests I had heard, but I complied and was honestly surprised by how effective this was. Changing from sketching in pencil to watercolor is a massive shift in approaching the sketching process, but it got me out of a rut that I was unaware I had fallen into.

Through this professor's request, I learned that changing up the ways you work can also affect the direction of your problem-solving. Sketching in watercolor forced me not to be a stickler about how my sketches looked but forced me to think about the concepts driving them more deeply instead. The solution to my project was more whimsical and lighter than my tight sketches were leading me, and the experience forced me to rethink how I framed my concepts at the beginning of a project.

Starting your projects the same way each time and falling into a routine may create a roadblock in your design solutions. You may want to consider experimenting, sketching, and ideating off the computer, using fat markers, charcoal pencils, or scissors and glue sticks to create collaged thumbnail sketches. You might be surprised by this analog experience and realize that your solutions don't hit the same glass ceiling as when you approach the problems using your tried-and-true workflow. I was skeptical until I was forced to try it myself, and I hate to say it, but my design professor was right, and I would encourage you to experiment and try it, too.

## Evaluating Electronic Pencils and Tablets

Whenever I mention how valuable pencil and paper are to the design process someone almost immediately counters with, "What about electronic pencils and tablets? I like using my Apple Pencil and iPad way better than using a pencil and paper."

I get it; electronic pencils like the Apple Pencil are super cool. They are wireless, tilt, and pressure sensitive, and you can tap to change the pencil to a marker, highlighter, an airbrush, and so forth. But before we jettison the idea of using pencils and paper, let's crunch some numbers and take an objective look at two of the most popular options — the Apple Pencil and the Wacom tablet.

WARNING

The technologies and prices shown here are subject to rapid change, so don't be surprised to find your buying experience is more or less expensive. Don't focus too much on the prices, though. The point here is to show that you need to consider the financial cost before ditching old-school methods in favor of technology.

Let's begin by talking about price:

- **Apple Pencil:** The Apple Pencil retails for about $130, but you can't use an Apple Pencil by itself. You will also need an iPad to use the Apple Pencil; an iPad runs between about $500 to more than $1,000, depending on the iPad you choose. You'll also need to purchase a software application like Procreate that will cost you around $20, which brings the grand total to somewhere between $650 and $1,250. Many people don't stop there; they also want to experiment with Apple Pencil tips for about $25 and a textured screen protector for about $30. The Apple Pencil tips and textured screen protector make drawing on an iPad feel similar to what it's like to draw on a sheet of paper with a marker.

- **Wacom tablets:** Wacom tablets, on the other hand, are a bit less expensive, but instead of requiring an iPad, they require you to plug into a compatible computer. The Wacom drawing surface is textured and comes with a stylus that is similar to the Apple Pencil. The big difference is that instead of drawing on an iPad screen, you're drawing on the Wacom tablet while watching your computer screen. Wacom tablets range in price from $50 to $400, depending on the size of the tablet, features like wireless connectivity, and so forth. Just like the Apple Pencil, Wacom users often experiment with different types of nibs (tips) for the stylus, which usually run between $10 and $25. This brings the grand total for a Wacom tablet somewhere between $60 and $425.

REMEMBER

Tools are just objects that are designed to assist us in performing a particular task. Tools can make our jobs easier, but they typically don't solve problems by themselves.

Are there legitimate reasons for spending about $1,300 for an Apple Pencil and iPad or about $425 for a Wacom tablet? Yes, there are. Many of my graphic design students have purchased or received these tools as gifts and seem to be happy with them.

In my opinion, Apple and Wacom's tools are too pricey and overpowered for simple thumbnail sketches, but if your graphic design work has a heavy illustration component, you may want to consider investing in some of these tools to make your workflow more streamlined. But I would be remiss if I didn't stress that you don't need these tools to be an amazing graphic designer. A pencil and paper will still do the trick.

## Comparing the feel and control of the Apple Pencil versus Wacom tablet

Chances are good that you already know how it feels to draw with a pencil or other device like a Sharpie marker on regular paper. You can use your imagination to

mentally imagine how much pressure it takes to draw a thick, bold line versus a thin, light line on a sheet of paper. You can probably also imagine what the feeling of dragging a pencil over paper is like compared to the feeling of dragging a Sharpie market over paper.

If you want to imagine what the surface texture of an object is like, then imagine touching the object with your tongue. Think about touching your tongue to a piece of paper, a piece of glass, or other surfaces, and you'll quickly have a mental image of what that texture is like.

The Apple Pencil is designed to work with an iPad, while Wacom tablets are stand-alone devices that connect to a computer either through USB or wirelessly. Both the Apple Pencil and Wacom tablet offer pressure sensitivity, customizable buttons, tilt recognition, and programmable shortcuts.

However, providing users with options for tactile feedback with their Apple Pencil or Wacom stylus has opened the doors for third-party tips and nibs that fit over or replace the standard tip or nib in your Apple Pencil or Wacom stylus. For example, a fiber Apple Pencil tip fits directly over the end of an Apple Pencil and claims to provide more control and reduce the noise of tapping on the surface of an iPad. Users comment that this makes their Apple Pencil feel less "slippery" on the surface of the iPad and provides them with the resistance they are looking for. Similar products are available for Wacom users, too, and you can customize your stylus to have the feel of a Sharpie marker on paper by customizing your nib.

Both the Apple Pencil and Wacom tablet are highly portable, but the Apple Pencil edges out the Wacom tablet because the Apple Pencil is designed to work with an iPad versus a computer or laptop. While both options offer precision input for digital art and graphic design, the ultimate decision depends on your needs, budget, and workflows.

You can place a photograph on top of your iPad or Wacom tablet and trace your image to help expedite the illustration process.

Many designers want a familiar drawing experience with more traditional mediums like a pencil, marker, or brush, but they also want the convenience of a computer. Electronic pencil and tablet users can simply tap to "undo" mistakes; they can easily toggle through different design applications and select tools, brushes, textures, colors, and other options easily. There is a learning curve for both devices, but there are also workflow benefits that emerge as users gain familiarity with these tools.

# Appreciating the Adobe Creative Cloud

Adobe Creative Cloud, or Adobe CC for short, is a valuable tool that provides graphic designers with a suite of tools and resources to realize their design solutions and unleash their creativity. Adobe has become the *industry standard* for the graphic design profession. Being an industry standard means that this software package has been widely adopted and is the most common tool for carrying out graphic design tasks. It also means that Adobe has established a reputation for reliability, quality, and performance and sets the benchmark for other software platforms.

If you're interested in previewing Adobe Creative Cloud, you can sign up for a free trial at www.adobe.com.

The costs associated with Adobe Creative Cloud are pricy, but an Adobe CC subscription includes access to Photoshop, Illustrator, InDesign, Adobe XD, Adobe After Effects, and more. If you are unfamiliar with the software listed above, you should simply know that a subscription provides access to most of the software you will need to complete almost any type of graphic design solution. Also, Adobe's software is designed to work in unison and includes mobile applications that allow you to use your tablet and mobile device as an extension of your computer. A graphic made in Adobe Illustrator, along with a photograph edited in Adobe Photoshop, can be imported into Adobe InDesign to create a magazine ad and then exported with Adobe Acrobat and saved as a print-ready PDF file that can be printed easily.

Adobe Creative Cloud (CC) is a solid choice for graphic designers because it is nearly ubiquitous in the design profession, meaning almost every printer, vendor, and agency probably has a subscription. This also means that if you are interested in a career in graphic design, you should probably learn to use the Adobe CC tools right out of the gate because of how popular they are in the professional design community.

Adobe CC costs about $20/month if you are a student and approximately $60/month if you aren't. A subscription to Adobe CC includes all the software listed above plus 100GB of cloud storage, tutorials, Adobe Portfolio, Adobe Fonts, Behance, and a few other perks.

Software that is likely to cost a regular individual about $700 a year sounds insanely high, doesn't it? If you think so, too, then don't worry; I cover some alternative software for the budget-conscious later in this chapter. But if you're serious about learning graphic design, then this is simply the cost of the ticket to ride this ride.

TIP

If you only need access to Adobe Creative Cloud for a limited time, then consider signing up for a month-to-month plan where you can cancel at any time without fees.

If you are just trying to solve a design problem and you don't need Adobe CC anymore, you may want to look at Adobe's month-to-month options that cost a little more each month but allow you to cancel anytime. On a month-to-month plan, Adobe CC currently costs a little under $100 a month, but there's no year-long contract and you can cancel with no additional fees.

In the next few pages, you explore some of the main software programs in the Adobe CC package, investigating their purpose and how graphic designers typically use them.

## Working with Adobe Illustrator

Adobe Illustrator is a vector-based drawing and illustration program that can be used to create illustrations, graphics, logos, and more. One trait that makes Illustrator unique is that it is largely used to create *vector graphics,* which means that elements created in Illustrator can be enlarged or reduced in size without sacrificing image quality.

For example, a logo created in Adobe Illustrator has the same visual quality on a 2-inch business card as it would on a 48-foot-long billboard. This is because vector artwork is based on mathematical formulas that precisely calculate how an element looks and makes it easy to scale an element up and down without sacrificing a loss of image quality.

In Figure 4-2, take a look at how the zoomed-in portion of the letter "e" looks when saved as a vector element on the left, compared to how the same image looks when saved as a raster image on the right. Vector images are based on mathematical formulas, while raster images are based on pixel density.

So, what does this mean? It means that certain kinds of work, particularly work that may need to be scaled up (such as logos, artwork, graphics, and so forth), should probably be created in a vector format using software like Adobe Illustrator. Adobe Illustrator also provides precise command over shapes, lines, curves, and anchor points, allowing users to create designs with accuracy and control.

**FIGURE 4-2:** When part of the letter e is enlarged, look at the edge quality of the vector graphic (left) versus the same image saved as a raster graphic.

Vector          Raster

## Vector drawing tools

As mentioned earlier, Adobe Illustrator provides a comprehensive set of vector drawing tools that allow users to create and manipulate shapes, paths, and objects with ease and control. Novice designers sometimes struggle with learning to use the pen tool and Bézier curves initially, but once they master this tool, Illustrator unfolds itself, and almost every other task begins to make much more sense.

If you are struggling to learn Bézier curves and Illustrator's pen tool, then go to `https://bezier.method.ac` and play The Bézier Game, which teaches you steps to mastering the pen tool in Illustrator.

In the silhouette of the cat in Figure 4-3, you can just see the anchor points, Bézier curves, and pen tool path. I filled the shape with a black-and-white gradient to make some of the lines easier to see, but each of these anchor points and Bézier curves can be moved and adjusted until you're satisfied with the results.

Drawing in Adobe Illustrator can be challenging. Many graphic designers like to place a pencil-and-paper sketch into Illustrator and trace it with the pen tool rather than creating a drawing in Illustrator with no visual references.

Adobe Illustrator allows you to trace sketches quite easily and if you take your time, learn to add, delete, and modify your Bézier curves and anchor points, you'll be just fine. It takes a little practice to begin to feel confident, so don't be too hard on yourself if it doesn't come easily to you immediately.

CHAPTER 4 **Choosing the Right Tool for the Job** 67

**FIGURE 4-3:** Silhouette of a cat to illustrate the use of Bézier curves, anchor points, and pen tool path.

## Typography and text tools

Adobe Illustrator does a great job of handling type. Because Illustrator is vector-based, it offers a range of typographic tools for working with type, including size, spacing, leading, alignments, paragraph and character styles, tab stops, and glyphs.

Illustrator also offers a wide range of effects and styles that can be applied to text to allow for eye-catching typography. Some of these effects include drop shadows, glows, gradients, warping, and more. In Figure 4-4, you can see how a text effect can be applied to type to change the appearance and give it a soft drop shadow.

**FIGURE 4-4:** An example of a text effect that has been applied to type using Adobe Illustrator.

Not all software handles type well. Being able to control how your typography looks, aligns, and renders is really important. Make sure you're using the right tool for the job.

While Illustrator handles type well, it wouldn't be my first choice for working with documents that are primarily text or documents that are multiple pages of text (such as a magazine). Adobe InDesign would be my preferred tool in instances like this. The drawings, artwork, and text you create in InDesign can easily be placed into an InDesign document, allowing you to capitalize on the features of each software package.

Learn to use the text tools in Adobe Illustrator well so you don't have to rely on creating lots of text boxes. You can control alignments, tab stops, leading, margins, gutters, and other elements within a single text box. This approach may help you avoid spacing errors often associated with aligning and spacing numerous independent text boxes.

## Drawing and editing capabilities

When it comes to vector drawing and illustration, Adobe Illustrator is widely considered to be the king of the hill. Illustrator offers users amazing control with quality features that cannot be beaten. Almost every graphic designer and illustrator has established a workflow that works best for them, and once you get under the hood, you'll establish a pattern of working that works for you, too.

Illustrator allows you to design and illustrate with control and precision. You can build and modify complex shapes easily, draw expressive lines, create your own brushes for a custom look, and create freeform sketches with ease.

Adobe Illustrator is heavily documented software, and it's extremely easy to find YouTube videos, tutorials, communities, and resources to help you learn how to achieve the visual results you are looking for.

Creating items like logos, illustrations, customized type, infographics, charts, background patterns, and so forth are right in the middle of Adobe Illustrator's sweet spot. You can use Illustrator's drawing and editing capabilities to chart your own path forward or modify rudimentary lines and shapes to achieve the results you are looking for. You can see how Adobe Illustrator can be used to refine an idea from a sketch to a computer illustration, as seen in Figure 4-5.

See *Adobe Illustrator For Dummies* for help raising your Illustrator game and streamlining your workflows.

CHAPTER 4 **Choosing the Right Tool for the Job** 69

**FIGURE 4-5:** A sketch and refinement of an owl with Adobe Illustrator.

© Hadley Kaeyer

## Generative AI in Illustrator

One of the newer Adobe Illustration tools is Adobe's Text to Vector Graphic feature, where you can create prompts for Adobe Illustrator, and the software will create an editable vector file. You can choose between a subject, scene, icon, or pattern, and Adobe Illustrator will generate three vector graphics for you to preview. If you don't like the results, you can edit the prompt or simply click the Generate button again.

In Figure 4-6, I used the text prompt "Tyrannosaurus Rex in the jungle with mouth open and teeth showing" to generate an editable vector file using Adobe Illustrator's Text to Vector Graphic feature. I set the detail level to complex, but I did not edit the image so you could see the level of detail and what the prompt produced.

I'm happy with the results of the prompt, which look less than a minute to render three options. I thought the second option was the strongest, so that's what I selected for Illustrator to render. I would definitely want to tweak and modify this image if I were going to use it in a design solution, but the Text to Vector Graphic tool might be helpful if I wanted to get out of the gate quickly or if I wanted to show a client an idea and get feedback on it. Some parts of the illustration are a bit off with proportion, line work, and color that I'd want to finesse, but overall, Text to Vector Graphic is a tool that could help shorten workflows and improve results.

FIGURE 4-6:
A demonstration of Adobe Illustrator's Text to Vector Graphic tool.

WARNING

Some artists, graphic designers, and illustrators may feel threatened by generative AI. There are legitimate concerns about copyright and authorship, the quality and uniqueness of the work, and other legitimate concerns. Some creatives embrace AI tools, while others may view them as a threat or be cautious about their use. I embrace the tools and workflows that generative AI offers, but I don't want them to come at the expense of my artist, illustrator, and designer friends' work. In my opinion, generative AI still needs well-defined guidelines and enforcement mechanisms.

The Graphic Artists Guild is a guild of graphic designers, illustrators, and photographers, and it has shared its position on generative AI, which can be found at `https://graphicartistsguild.org/graphic-artists-guild-position-on-ai-image-generative-technologies`. This web page is a short read, but it is a good primer on where generative AI could cross the line and infringe on a graphic designer's, illustrator's, or photographer's work. It's clear that additional legislation is needed to make sure the rights of the artist are protected in this emerging technology.

So, with tools like Illustrator's Text to Vector Graphic, Adobe is making me rethink my "there's no create dinosaur button on the keyboard" statement because now I can simply type in what I want, and I've got a good starting point to begin working with. If you look at the dinosaur's hand in Figure 4-6, you'll see this part of the illustration will need to be cleaned up or redrawn.

CHAPTER 4 **Choosing the Right Tool for the Job** 71

# Working with Adobe Photoshop

Adobe Photoshop is a raster-based photo editing program that can be used to retouch, edit, and create photo artwork. The trait that makes Photoshop unique is that it is used to create *raster graphics* — images that are made up of tiny pixels arranged in a grid to represent an image.

REMEMBER

Vector graphics can be scaled up or down with no loss of quality, while raster graphics may only be scaled down without sacrificing image quality.

The density —the number of pixels contained in an image — affects the image quality and file size. As you can see in Figure 4-7, the pixel density on the black circles increases from left to right.

**FIGURE 4-7:** Black circles illustrating pixel density.

So, not only does the circle with a pixel density of 30 pixels/inch look a little fuzzy around the edges, but its file size is a mere 20KB. The circle on the far right with a pixel density of 600 pixels/inch is the circle with the most pixels/inch, but its file size is almost 180 percent larger (360KB) because more pixels have been packed into it.

REMEMBER

Photoshop is a raster graphics editing program, so pixel density and file sizes always play a role in the quality of your results.

Did you notice in Figure 4-7 how the 300-pixel-inch circle almost looks the same as the 600-pixel circle? Well, that's because our eyes have a hard time distinguishing the differences in the pixel density somewhere around 300 pixels/inch, so increasing your pixel density beyond 300 pixels/inch is likely to have diminishing returns.

With regard to pixel density, following are a few rules of thumb:

- » 72 pixels per inch is a good pixel density for the Internet
- » 218 pixels per inch is a good pixel density for retina displays
- » 300 pixels per inch is a good pixel density for printed materials

The pixel density rules of thumb make a lot of sense when you stop to think about it. Images that appear on websites have lower pixel densities — and, more importantly, smaller file sizes — so images on websites load quickly. Items that appear on retina screens, like an app on your phone, only need to be downloaded once, so the pixel density and image quality can be increased for a better viewing experience. And finally, the pixel density for printed materials is largely determined by the specifications of printers and printing equipment.

This leads us to a fundamental truth about Adobe Photoshop: You can create files and scale your files down, but generally speaking, you shouldn't create files and try to scale them up because you'll sacrifice image quality. Remember, artwork in Adobe Illustrator can be scaled up and down without sacrificing image quality, but artwork in Adobe Photoshop is usually created at the appropriate resolution for the medium you're working in, including both the horizontal and vertical dimensions, as well as the pixel density for the particular medium.

Now that image resolution and pixel density are out of the way, let's talk about why Adobe Photoshop is an absolute beast in the raster graphics software category. Photoshop, like Illustrator, is an industry-standard in the graphic design profession, and knowing how to use this program is not only expected but often necessary. Photoshop can be used for a wide range of tasks, including photo editing, digital painting, web design, and so much more.

TIP

If Adobe Illustrator's crux is the Bézier curves and the pen tool, then Adobe Photoshop's Mount Everest has to be control of layers, masking, and blend modes. Once these techniques are understood, Photoshop probably won't look so intimidating.

Graphic designers use Photoshop to retouch photos, adjust colors, apply effects, create masks, and collage images together with impressive results. Like Adobe Illustrator, there are numerous resources dedicated to learning new Photoshop techniques, connecting with various Photoshop communities, establishing workflows, finding resources, and posting in forums where you can ask questions and learn.

REMEMBER

See *Adobe Photoshop For Dummies* to help raise your Photoshop game, get you started quickly, and streamline your processes and workflows.

Let's take a look at five aspects of Adobe Photoshop that make it such a powerful tool for graphic designers. You'll be impressed with the level of control that Adobe Photoshop provides. Just remember that each tool in the Adobe Creative Cloud arsenal excels at a particular design-related task, and it's important to understand these differences and choose the right tool for the job.

## Image editing and retouching

Photoshop excels at editing and retouching images and has many tools to help you adjust either part of a photograph or the entire image, including altering an image's brightness/contrast, levels, curves, hue/saturation, color balance, shadows/highlights, and much more.

For those who are new to Photoshop, here are a few definitions to help you wrap your head around some of Photoshop's image editing features:

- » **Brightness/contrast:** This adjustment allows you to change the number of shades between the lightest and darkest areas of an image. In other words, you can adjust the tonal range of an image.
- » **Levels:** This tool allows you to adjust the color balance, tone, and exposure of an image.
- » **Curves:** Curves are similar to levels but provide more customized control by allowing you to edit shadows, highlights, and midtones separately.
- » **Hue/saturation:** The hue/saturation tool allows you to adjust the hue (color) and saturation (purity) and an image's lightness.
- » **Color balance:** Color balance allows you to adjust the intensity of the primary and secondary colors in an image.
- » **Shadow/highlight:** This tool allows you to correct dark or dull images due to strong backlighting or correcting subjects that have been washed out.

In addition, Photoshop has numerous tools to help retouch and edit portions of images. In Figure 4-8, you can see how I used Photoshop's clone stamp tool to remove the brown spots from the flower petal on the left.

Photoshop's image editing and retouching tools are extremely powerful and help designers fine-tune their images and give them the results they are looking for. Numerous YouTube channels — including Pixiperfect, Plearn, Photoshop Training Channel, as well as many others — teach various aspects of Photoshop.

Some of the best image editing tools in Photoshop include:

- » **Layers:** Layers are likes stacked, transparent sheets on which you can work. You can work on each layer independently, experimenting to create the effect you want and then combine or merge the layers after you're happy with the results.

**FIGURE 4-8:** A retouched image of a flower. The black arrow points to the dark dots that were removed using Adobe Photoshop's clone stamp tool.

- **Selection tool:** The selection tool can help you isolate parts of an image so you can work on that area without affecting the rest of the image.

- **Clone stamp tool:** A tool that copies pixels from one area and applies them to another area.

- **Healing brush tool:** A tool that removes unwanted spots, marks, or small objects in your image.

- **Content-aware fill:** A feature that tries to seamlessly fill a selected portion of an image with similar-looking content based on the surrounding parts of the image.

- **Adjustment layers:** A special type of layer that allows you to manipulate the color or tone of the layers beneath them.

- **Filters and effects:** Digital effects that allow you to modify or repair images or create visual effects.

- **Masking:** A nondestructive way for you to hide parts of an image or a layer without erasing or removing pixels.

- **Blend modes:** A way to change the look of one or more layers without changing your original image. A blend mode simply tells two layers how to work together to create a combined image. Photoshops checks each layer for overlapping pixels and then, depending on the blend mode, decides how those overlapping pixels will be blended.

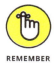

REMEMBER

Don't feel discouraged if it takes you a while to master Adobe Photoshop. It's a complicated but powerful program and many users find starting with the basics and slowly building up their skills is the most effective way to learn the program.

CHAPTER 4 **Choosing the Right Tool for the Job** 75

## Photoshop's layer-based editing

One of the primary advantages of using layers when editing images is that you can edit and adjust layers individually. Layers are the key to building a nondestructive workflow because they allow you to isolate and control components independently.

Being able to work nondestructively is important because it allows you to work in a way where the original image is preserved. In order to understand this concept better, consider the following scenario. I've taken a photo of a flamingo at the zoo, and I want to erase the background to isolate the flamingo. If I grab the eraser tool and start removing the background, then the original image will be altered because the eraser tool deletes pixels from the original image.

However, if I use a layer mask to isolate the flamingo instead (see Figure 4-9), the original image will not be destroyed because I'm creating a new layer that essentially masks the background instead of permanently deleting pixels. I can save my file, make changes, and re-edit the image easily because layer masks are nondestructive, making layer masks a better choice than the eraser tool for this type of task.

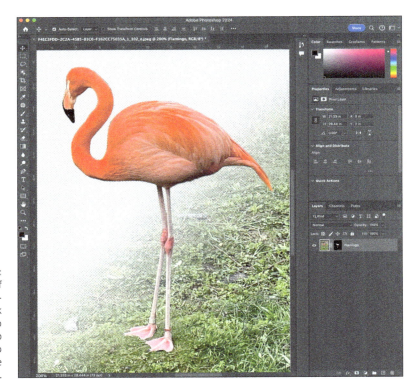

**FIGURE 4-9:** An example of a nondestructive layer mask being used to isolate (clip out) a flamingo from the background.

Always work nondestructively whenever you can. Being able to go back and make changes at a later date provides designers with a lot of flexibility.

Each layer can include blend modes and instructions for how one layer should interact with and blend with other layers. Adjustment layers can include the following:

- » The information to set the brightness and contrast, adjust levels, curves, exposure, vibrance, hue/saturation, and color balance
- » Change color images to grayscale
- » Emulate photo filters
- » Adjust tints and color
- » Set color lookup preset colors
- » Invert color values
- » Reduce the number of brightness values
- » Control the number of pixels that are black and white
- » Map different colors to different tones in your image
- » Modify specific colors in your image

## Color correction

As mentioned previously, Photoshop allows users a high degree of control over their images. When correcting an image, here is a general workflow that Adobe recommends on its website.

1. Use the histogram to check the quality and tonal range of the image.
2. Make sure the Adjustments panel is open to access color and tonal adjustments. Apply corrections using an adjustment layer, which is a nondestructive way of working.
3. Adjust the color balance to remove unwanted color casts or to correct oversaturated or undersaturated colors.
4. Adjust the tonal range using either Levels or Curves.
5. Sharpen the edges in the image using the Unsharp Mask or the Smart Sharpen filter to sharpen the clarity of edges in the image.

You can use the Eyedropper tool to sample color from one area and use it to correct the color of another area by using the Match Color tool by going to Image > Adjustments > Match Color.

CHAPTER 4 Choosing the Right Tool for the Job      77

Take a look at the underwater photo in Figure 4-10. Often, underwater photos tend to look more blue/green because when light waves travel through water, the higher wavelength colors (red, orange, and yellow) tend to diminish more rapidly than lower wavelength colors (purple, blue, and green).

TIP

If you're planning to shoot images underwater, then you may want to consider using artificial lights or a flash, using a red filter to help correct for the greenish tint underwater, or using a custom white balance in your camera settings to adjust the white balance to make your images look more color-balanced.

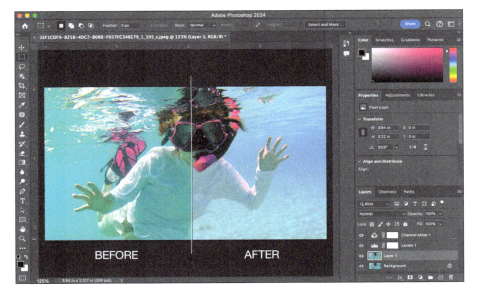

FIGURE 4-10: Amplifying the red channel in an underwater shot may help make the image appear less green and slightly more natural.

I used an adjustment layer in Photoshop to amplify the red channel, and as a result, the "after" image on the right-hand side looks less green and more natural. What this demonstrates is how control over the colors in your images can be used to adjust the quality of your images.

TIP

If you find yourself repeating the same task in any of Adobe CC's software applications, then you can create an action that allows the computer to record and save the steps you took and then apply these same actions again at the push of a button.

## Generative AI in Photoshop

Adobe has included some impressive AI tools in Photoshop. Tasks like expanding images, editing images, and removing backgrounds can be automated with powerful AI tools.

78   PART 1  What to Know Before You Start Designing

Generative AI tools have taken a process that was traditionally much more involved and simplified into an embarrassingly easy process. In Figure 4-11, I took an image of a rooster, selected an area with my marquee tool, typed "baby chick" into the generative AI tool, and selected my favorite of three generative AI prompts.

**FIGURE 4-11:** Adding generative AI is an extremely easy process. Simply select the area you want AI to focus on, type in the generative AI prompt, and choose your favorite solution.

**TIP**

If you want Photoshop's AI tool to try to remove something from a photograph, then don't enter anything into the text prompt and Photoshop will remove the selected element and use generative AI to replace the element.

Adobe Photoshop's versatility, extensive capabilities, and support make it an invaluable tool for graphic designers. Photoshop is compatible with a variety of file formats like GIF, JPG, PNG, PDF, PSD, and TIFF files. Adobe Photoshop is capable of producing high-quality images for both print and digital media.

## Working with Adobe InDesign

Adobe InDesign is a desktop publishing and layout application that can be used to create books, magazines, brochures, and both print and digital publications. InDesign allows you to arrange text, images, and other elements to make them look professional and polished. You can think of InDesign as the design software that allows you to bring all of your content together and make it look awesome before printing or publishing it online.

Adobe InDesign is perfect for handling multipage documents, and it is extremely easy to place both vector and raster documents together in an InDesign document. InDesign also allows you to set up "styles" that are like shortcuts for formatting

text, paragraphs, and objects consistently throughout your document instead of manually adjusting elements individually. You often see repeated elements in publication design, which graphic designers use to create a feeling of cohesiveness and unity, see Figure 4-12.

FIGURE 4-12: Outside magazine design solution by Shelby Bryant.

© Shelby Bryant

TIP

Adobe Illustrator's crux is the Bézier curves and the pen tool, Photoshop's Mount Everest is layers, masking, and blend modes, and Adobe InDesign's foundation is learning how to effectively control text, images, and other design elements and parent pages.

## Layout and page design

When you first create a new document in InDesign, one of the first screens that appears (see Figure 4-13), is a screen that prompts you to make decisions about the document you are creating. Of course, these settings can be changed later, but it's easiest to enter any information you know at the beginning of the project to take advantage of InDesign's semi-automated workflow.

REMEMBER

Adobe InDesign handles text and grid systems extremely well, which makes designing layouts and compositions easy. Most people say InDesign is easier to learn than Illustrator or Photoshop.

80   PART 1   What to Know Before You Start Designing

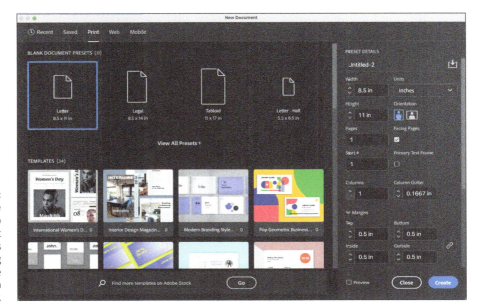

FIGURE 4-13: You'll be prompted to enter project parameters when creating a new Adobe InDesign document.

When you create a new InDesign file, you'll be asked to define the size of the document, the number of pages, and whether you intend to have the pages face each other (like a magazine or book). You'll also be asked to specify the number of columns, bleed, and slug settings. If this sounds like technical jargon, don't worry; it's not too difficult to wrap your head around. Please refer to the location of the letters in Figure 4-14 to help you visualize these Adobe InDesign settings they are prompting you to enter.

A. **Outside margin:** The outside margin provides visual breathing room around the outside of a page. It also provides room for a reader to hold a book or magazine without placing their thumbs over the content in the spread.

B. **Inside margin:** The inside margin is designed to include space to accommodate the binding of a printed book. Some ways in which a book or a magazine is bound can take more room than others. For instance, a spiral-bound book needs approximately 1/2-inch of space to bind the book, while a perfect bind (used to bind many magazines) requires approximately 3/4-inch to bind the book.

C. **Top margin:** The top margin is designed to serve as a unified starting point for content to align to. The top margin can often include a running head or section information. For example, in an article that appears in the "gardening" section of a magazine, a graphic design may include a visual element in the top margin to help readers understand and orient what section of the magazine they are currently viewing. Occasionally this type of information can appear in the bottom margin instead.

**D. Bottom margin:** The bottom margin often includes page numbers and other information like a folio. Folios generally contain the magazine's name, issue date, and section (if it doesn't appear in the top margin). Generally speaking, odd page numbers appear on the right-hand side of the page, while even number pages appear on the left-hand side of the page.

**E&F. Columns:** Columns grids are used to organize elements vertically and two- or three-column grid systems are often used for magazine design. Mathematically speaking, six-column grids are extremely beneficial because six columns can be divided into 2 three-column (E) grids or 3 two-column grids (F). Columns of text can sometimes be easier for users to read than long lines of text that span an entire page.

**G. Document edge:** This area represents where the printer would normally trim a document. Sometimes, a printer will print files on a larger sheet of paper and the trim lines indicate where the page should be cut in the production of a book or magazine.

**H. Bleed line:** The bleed refers to the area in a document that the printer will trim off. Many printers find 1/8-inch bleeds perfectly acceptable. If a design element is designed to go right to the edge of a document, you should extend a portion of this element 1/8-inch farther (to the bleed line) so the printer can trim part of this element off when trimming out the book or magazine.

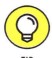
**TIP**

Grid systems aren't just for printed publications! You can (and should) use a grid system for designing digital layouts for websites, tablets, and mobile devices, too.

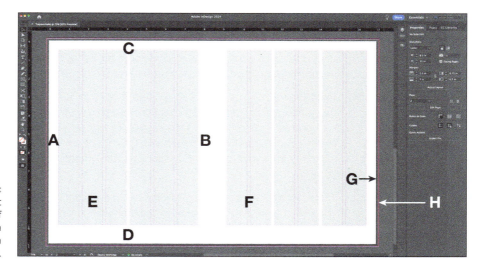

**FIGURE 4-14:** The basic anatomy of an InDesign document with facing pages.

82    PART 1  What to Know Before You Start Designing

## InDesign parent pages

InDesign has a feature called parent pages, formerly called master pages, that serve as master templates that you can apply to multiple pages within your document. These parent pages often contain elements such as headers, footers, page numbers, grid systems, and background images that you want to appear consistently across multiple pages in your document. Figure 4-15 show three sets of parent pages (A) and three document pages (B). Parent pages are a powerful tool for streamlining the design process, ensuring consistency, and making your workflow more efficient.

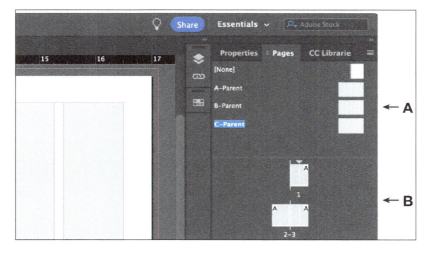

FIGURE 4-15: Adobe InDesign parent pages (A) and document pages (B).

In order to apply a parent page to a document page, you simply drag the parent page (A) on top of the document page (B). Parent pages save time by allowing you to create and apply common elements like headers, footers, page numbers, and so forth to document pages easily. Conversely, if you change an element on a parent page, then it will change that element on every document page where that parent page has been used.

TIP

Make sure you don't mistakenly put your entire design on parent pages. Parent pages are only for elements that are designed to be repeated on document pages as a way of eliminating repetitive tasks.

## Handling typographic elements like a pro

Adobe InDesign is renowned for its ability to handle type and apply styles to text. The importance of these features depends on the project and graphic designer's

workflow, but the power and control that these features provide are significant. Following are some InDesign features for handling typographic elements:

>> **Handling Type:** InDesign offers powerful tools that let graphic designers control typographic settings such as

- Font selection

- Kerning (the space between individual letters or characters)

- Leading (the vertical space between multiple lines of type)

- Tracking (the space between characters in a block of text)

InDesign also allows control over paragraph alignments, hyphenation, glyphs, and tab stops.

>> **Applying Styles:** InDesign's ability to apply styles can help streamline your workflow and allow you to create and apply typographic and visual styles across multiple elements within a document. To put this in context, styles allow you to tag content and then adjust the color, spacing, size, and so forth with a single click. This speeds up the design process and helps maintain consistency across the entire document, regardless of its page count.

>> **Baseline grid:** InDesign's baseline grid helps designers align text to a baseline grid to create a clean and professional-looking layout. This is especially helpful when designing with multiple columns and images that are meant to be aligned with typographic elements.

>> **Text wraps and text frames:** InDesign allows graphic designers to control how their text interacts with other elements on a page, such as images or shapes. This allows the designer to control how text is positioned and flows around other elements in the composition.

>> **Text on a path:** InDesign allows users to draw a path and have text follow that path. Text can be placed on a path, even if it's a simple curve, a complex shape, or a closed loop. Instead of being restricted to horizontal and vertical layouts, this feature allows designers to experiment and experiment with their typography.

## Creating PDF and interactive documents

Any document created in InDesign can be saved in a PDF format, but Adobe InDesign has a set of interactive tools that allow you to create PDFs that can include animations, bookmarks, buttons, forms, hyperlinks, page transitions, and other features. This means that you can create interactive slideshows with multimedia elements making InDesign a great choice for creating both print and digital publications.

InDesign can also be used to create eBooks and e-magazines meant to be consumed on mobile devices and tablets. InDesign can be used to create fixed layouts, reflowable documents that allow readers to optimize content, and e-magazines, which are digital magazines that have been optimized for onscreen viewing.

Most people don't think of Adobe InDesign as a tool for creating interactive content, but Adobe InDesign offers a great set of interactive design tools.

# Software for the Budget-Conscious

One of the biggest complaints I hear about Adobe CC is that it's expensive. Not everyone can afford to spend up to $60/month on software, so are these budget-conscious users locked out of graphic design? No, of course not. There are some really great alternatives to Adobe out there, so let's dive in and take a look at some less expensive options.

## Adobe CC alternatives

The following two solutions are some of the best Adobe CC alternatives that are currently on the market. This software offers lower-priced options that may be attractive to small business owners or budget-conscious graphic designers. One of the benefits is that users can purchase this software outright (rather than subscription-based software), which can either be good or bad depending on the needs of the user.

### Affinity

Affinity has positioned itself as a lower-cost alternative to Adobe Creative Cloud's three main software packages (Illustrator, Photoshop, and InDesign) and offers photo editing, vector graphics, and page layout software for Mac, Windows, and iPad. The approximately $165 price includes access to Affinity Designer, Affinity, and Affinity Publisher.

I tested Affinity's software and was pleasantly surprised by the depth of its documentation and support. The software interface was user-friendly, and I felt comfortable with the performance of all three of its software packages. The software seemed to follow a similar structure as Adobe, but there were clear differences in where certain tools and windows were located and how certain tasks were performed.

See `https://affinity.serif.com`.

CHAPTER 4 **Choosing the Right Tool for the Job** 85

Affinity offers new users a 7-day trial, so users can test-drive the software before making a purchase.

Affinity's software is an affordable alternative to Adobe Creative Cloud and a good option for budget-conscious individuals who don't have to be as familiar with and nuanced in Adobe Creative Cloud workflows. Canva, a popular online template editor application, announced in early 2024 that it will be purchasing Affinity, so it will be interesting to watch how Affinity users will be supported as more details on this acquisition emerge.

### CorelDRAW Graphics Suite

CorelDRAW Graphics Suite is designed to handle vector and raster graphics as well creating multipage documents. The two key components of the CorelDRAW Graphics Suite consist of CorelDRAW, which is used for vector graphics and page layout, and Corel PHOTO-PAINT, which is used for image editing and pixel-based design. CorelDRAW Graphics Suite also includes the Corel Font Manager application that helps organize and manage your font library.

CorelDRAW Graphics Suite offers users the option of either a monthly plan or an option to purchase the software at a one-time price that is roughly twice as much as a two-year subscription.

See `https://www.coreldraw.com`.

CorelDRAW offers new users a 15-day trial, so users can test-drive the software before making a purchase.

I am familiar with CorelDraw and feel it's a professional-level software solution, but the CorelDRAW Graphics Suite is priced around a $270/year for a subscription. CorelDRAW Graphic Suite can also be purchased outright for a one-time fee for around $550.

### Adobe Illustrator alternatives

As you know, Adobe Illustrator is software designed to edit, modify, and create vector graphics. So, with this in mind, here is a list of some popular alternative software that can perform similar tasks.

>> **Inkscape:** Inkscape is a free and open-source vector graphics editor for GNU/Linux, Windows, and macOS. Inkscape can import and export various file formats, including SVG, AI, EPS, PDS, PS, and PNG files. Inkscape can found at `https://inkscape.org`.

- **Vectr:** Vectr is a free in-browser application that has basic vector editing features. While the software is free, users will be prompted to pay for a subscription to remove ads, increase storage, and add credits to their accounts to access AI tools and new features. Vector can import and export SVG, PNG, JPG, and Vectr files (with a Premium subscription). Vectr can be found at https://vectr.com.

Vectr offers Chromebook users a good vector graphics option. This is because Chromebooks rely heavily on cloud and Internet storage solutions.

## Adobe Photoshop alternatives

Adobe Photoshop is raster software used to create and edit pixel-based artwork. Here is a list of some alternative software programs that can perform similar tasks.

- **GIMP:** GIMP is a free and open-source image editor that works on GNU/Linux, Windows, and macOS. GIMP provides a large number of features and functions and is quite robust. GIMP can handle BMP, GIF, JPEG, MNG, PCX, PDF, PNG, PS, PSD, SVG, TIFF, TGA, XPM and other file formats. GIMP can be found online at https://www.gimp.org.
- **Pixlr:** Pixlr is a free in-browser application that has basic raster editing features. While the software is free, users will be prompted to pay for a subscription to remove ads, have unlimited saves, and add credits to their accounts to access AI tools, fonts, templates, elements, and animations. Pixlr can import and export JPEG, PNG, WEBP, GIF, PSD, and RXZ file types. Pixlr can be found at https://pixlr.com.

Pixlr offers Chromebook users a good raster graphics option because the application is an in-browser application.

## Adobe InDesign alternatives

- **Scribus:** Scribus is a free, open-source desktop publishing application that offers numerous tools for layout, typesetting, and preparation of files for printing. Scribus works on GNU/Linux, Windows, and macOS. One drawback to Scribus is that it cannot open or save the files of other desktop publishing applications; however, if cross-compatibility isn't a concern, then Scribus is a capable alternative. Scribus can be found at https://www.scribus.net.
- **Canva:** Canva is an online template editor application that allows users to create and modify templates. Canva also offers a desktop application for

Windows, macOS, iOS, and Android devices. Canva can import JPEG, PNG, HEIC, WEBP, MOV, GIF, MP4, MPEG, MKV, PDF, Word, PowerPoint, Excel, and Illustrator files and export GIF, JPG, MP4, PDF, PNG, PPTX, SVG file types. A free version of Canva is available, but you can upgrade to Canva Pro to unlock premium content, more powerful design tools, and AI features for about $15/month or $120/year. Canva can be found at `https://www.canva.com`.

» **Adobe Express:** Adobe Express is similar to Canva and is also an online template editor that allows users to create and modify templates. Adobe Express can seamlessly connect to other Adobe web apps and services. Adobe Express can import a wide variety of file types that need to be loaded into a Creative Cloud Library and can be exported to PNG, JPG, and PDF file formats. An Adobe Express Premium Plan is included with an Adobe CC subscription or can be purchased for around $10/month, which unlocks premium content, more generative AI tools, and more templates. Adobe Express can be found at `https://www.adobe.com/express`.

Canva and Adobe Express are similar tools. You may want to test-drive both of these tools and then choose the tool that fits your workflow the best.

# Using Mobile Apps for Some Tasks

Don't sleep on mobile apps. There are some great apps available on tablet and mobile devices that you can work into your workflow. Most of these mobile applications help improve the efficiency of your graphic design workflow rather than offering solutions to design problems.

Think about where you spend your time or struggle and look for applications to help you specifically in these areas. I struggle with picking colors, so an application like Coolors makes the process of generating color palettes less daunting. Coolors can be found at `https://coolors.co`.

» **Adobe Capture:** Adobe Capture turns your phone or tablet into a theme, pattern, vector-based shapes, 3D materials, typography, or custom brush generator. If you have an Adobe CC account, then the assets you create will be imported into Adobe CC.

» **Behance:** Behance is part of Adobe CC and allows artists and designers to showcase their work online. You do not have to have an Adobe CC account to use Behance.

>> **Coolors:** Coolors is a color palette generator that allows you to generate random color palettes or color palettes that can be extrapolated by taking and uploading a photo.

>> **Paper by WeTransfer:** Paper is a mobile sketching app that allows you to sketch, collage, paint, and draw on your mobile device. The app is free, but you can upgrade your account to send, store, and receive larger files.

>> **Procreate and Procreate Pocket:** Procreate is a raster graphics app for digital painting, sketches, and illustrations on an iPad, while Procreate Pocket allows you to work on your mobile device. Procreate offers over 200 brushes, and it can be customized with Quick Actions to create specialized menus. Procreate allows you to create animations and can be a fun way to create animated GIFs and MP4 videos from your drawings.

>> **Scanner Pro and CamScanner:** Both of these applications make it easy to use your mobile device to scan, edit, and create PDF documents. These apps can be helpful for scanning agreements, receipts, articles, and more and convert these files into PDFs easily.

>> **Sketchbook:** Sketchbook is a sketching, painting, and drawing app. Sketchbook contains a wide array of customizable brushes, layer controls, and blend modes.

> **IN THIS CHAPTER**
>
> » Understanding the cyclical and iterative nature of graphic design
>
> » Breaking down the different phases of the design process
>
> » Preparing your files with these helpful tips

# Chapter 5
# Design Is an Iterative Process

At its core, graphic design is a *cyclical process*, and while the exact steps in this process may vary from designer to designer, several stages loop as a design solution evolves. This is important because approaching graphic design as a *linear process* with a beginning, middle, and end can truncate or shorten several important phases of the design process that are often important to developing a successful solution.

There's no agreed-upon approach for solving a design problem, and we could argue about what to call the steps in this process, but generally speaking, the models all follow a pretty similar pattern. Sometimes, specific types of problems or mediums will dictate certain steps in this process, but you should be aware that a cyclical process seems to be an approach to generating design solutions that have emerged as being particularly helpful.

REMEMBER

You can customize your own design process, but it can be beneficial to talk with other graphic designers to understand the process they use to design their solutions.

When I start a new design project, I mentally walk through the different design phases and estimate how long each step in this process will take. Some projects require additional time in a particular phase, so this process helps me break a large project down into manageable parts and gives me a sense of where my time will need to be spent. For example, if I'm working on an advertising campaign, then I will probably spend more time in research and planning, trying to visualize how all of the parts of a campaign will work together cohesively. If I'm working on a mobile app, then I'll spend additional time on feedback and revision by gathering information from user testing. Figure 5-1 shows the seven phases of my design process. Don't forget that this process is cyclical, so even when I reach Step 7, I'm going back to Step 1 to verify that I've met the goals of my project brief and to see if I can continue to improve the piece further. This cyclical approach allows me to ideate and experiment while still making progress on my design solution and pushing my solution further.

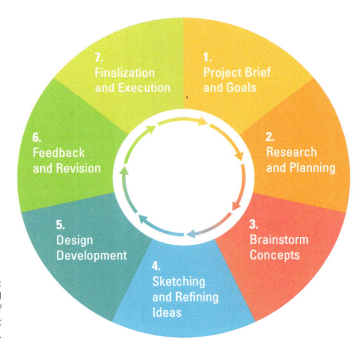

**FIGURE 5-1:** Cyclical diagram of the seven-part design process.

REMEMBER

Graphic design is an iterative process, meaning it involves constantly thinking, making, refining, and improving a solution until it reaches a point where you have solved the problem sufficiently or have reached the limits of a design constraint (such as a deadline, budget, and so forth).

92   PART 1  What to Know Before You Start Designing

Let's talk about some of the parts that go into each of these seven phases so you can understand how you might adapt this model to design projects that you're working on.

# Phase 1: Project Brief and Goals

Whether the client hands me a project brief or I'm writing a project brief up myself there is some information that is invaluable to include. Project briefs should provide a brief summary of the project and include the purpose, scope, and goals of the project. I want to know what the goals of the project are and what outcomes my client is expecting. I want to know who my target audience is and what their preferences, attitudes, and behaviors are.

Sometimes, some of this information is incomplete, so I'll talk with my clients and try to learn as much as I can from them, and I'll jot down notes from our conversation to refer back to later. Other times, the client doesn't know the answers to the questions I'm asking, and they want me to research and share the information I learn with them.

I always try to ask if they have any inspiration or examples of similar projects that have caught their attention. Sometimes, the client has examples they collected or have seen, so I talk with them to learn more about why these examples appeal to them. I'm often surprised by what I learn from simply talking with my clients and asking, "Why do you like this solution?" I like to think of the time (and stress) I save myself by simply talking with my clients and learning what aspects they value most.

**TIP** Taking notes is critically important for me. Sometimes, I work late at night when it'd be inappropriate to send a text or email to a client. Taking notes lets me refer back to a conversation when I can't remember specific details off the top of my head.

A good project brief also specifies the scope of work and the deliverables that the client is expecting to receive. This changes from project to project and one client will expect you to deliver a finished product (such as a box of printed brochures) while another client will want you to deliver files so they can handle printing the brochures themselves to save a little money.

Arguably, some of the most important pieces of information in a project brief are information about timelines and deadlines. A timeline is a sequence of events with start and end dates, while a deadline is the date a project needs to be completed. A timeline might say that I have two days to develop a concept for a project and

present it to the client for approval, while a deadline specifies the entire project needs to be completed no later than July 21.

A good design brief should include information like the following:

- » Project summary
- » Project goals and objectives
- » Information about the target audience
- » Description of the scope of work
- » Client examples and inspiration
- » Information about project deliverables
- » Project timelines and deadlines

TIP

Do you need some graphic design prompts for inspiration? Search for "project brief generator" or check out https://goodbrief.io or https://fakeclients.com for an abbreviated project brief that you can use to create work from fictitious clients for your design portfolio.

# Phase 2: Research and Planning

In Chapter 2, you took a look at areas where designers can draw inspiration and talked about finding examples of precedent and examples of design solutions that are similar to the types of problems you are attempting to solve. This is a great start to research and planning, but let's try to go a little deeper into research and planning because a lack of planning is often a cause for failure.

Everybody will approach this problem a little differently, but I try to break my design process down into thirds — and try to spend approximately one-third of my time on each of the following steps. This serves as a guide to help me estimate how much time it will take me to complete the project and also help me estimate how much time I have to spend on each phase of the project.

TIP

If you want to get better at estimating how much time it will take you to complete design projects, keep track of your time with a timesheet and review what phases took you the most time to complete. This will allow you to hack your design process and look for strategies to speed up the time you spend on these phases.

94   PART 1   What to Know Before You Start Designing

## Understanding the problem, researching, and planning

The first third of my time is spent understanding what the goals and needs of the project are and putting the problem into context. I will often look for precedent, sources of inspiration, examples of how others have solved similar problems, who the major competitors are, and gather information about the target audience.

I try not to make too many assumptions based on my own understanding of a problem but try to use my research as a means of discovering unexpected facts or approaches to solving the problem in a new or interesting way.

I seem to have less success with design solutions where I try to force fit pieces of information together, so researching the problem is a way to process this information rather than imposing my will onto the solution. Instead, I often try to use the momentum and direction that my research uncovers to amplify, redirect, and create in a way that is beneficial to the client. This is similar to how a martial arts Aikido master redirects the momentum of an attacker and uses this energy to throw the attacker off balance. A surfer can't fight the power of a wave but harnesses the energy to manifest a composition to reflect their timing, balance, and imagination.

TIP

As a graphic design professor for more than 20 years, this is a step that many of my students will skip if given a chance, but slowing down and thinking critically before entering a "making" phase is important because this is the step where your concept is born.

Unless you're willing to spend time thinking before creating, your design solutions are likely to hit a glass ceiling because the solutions will be rooted in your own limited understanding of the problem.

## Brainstorming, sketching, and refining your ideas

The next part of this process, where I spend the next third of my time, is when my thinking phase begins to become visual. This is where you, the designer, will begin to wrestle with how to visually articulate the most important parts of your research.

Graphic design is visual language, so it's important to create a visual language that is meaningful, authentic, and can be understood by your target audience. Before we can get to a visual solution, we need time to experiment, play, develop, conceptualize, and refine how we might visualize our design solution. Leaving

time for this step is important because it is often an underappreciated aspect of the design process.

I'll often contact my client at the end of this phase and show them my top three ideas and get their feedback on my idea before I spend time perfecting the idea on my computer. This way, I have client buy-in, and it can also help them feel as if they are part of my design process. If there are any changes or adjustments that need to happen, this is a perfect time to address them. This also takes time, so I make sure to include this step when estimating the amount of time that brainstorming, sketching, and refining my ideas will take.

## Design development, feedback, and revision

The last third of my time is spent working on the computer to develop the solution, seeking feedback from my client and target audience, and revising the design solution based on the feedback I receive.

Most of this time will be spent working on the computer to finalize the solution, but it also includes spending time to gather feedback and make any necessary revisions. I also want to make sure that I account for any time investigating technical requirements for the project. For example, preparing artwork for printing, writing compliant code, or exporting files can take time, so I want to make sure I manage my time accordingly.

# Phase 3: Brainstorming

Brainstorming is a technique to help generate ideas in response to a prompt. The goal of brainstorming is usually to create a large volume and variety of ideas — including ideas that are a bit fringe or off-the-wall. When you brainstorm you aren't necessarily looking for the "best" answers, as much as you are looking for interesting, unique, or alternative ideas.

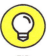

It's extremely easy to get to this step and to hone in on a solution early in the process, and I constantly have to remind myself of the following:

>> Don't fixate on a solution too early in this process.

>> Do not self-edit my ideas.

Both of these may cause the brainstorming session to stop, so try to maintain a headspace where you will evaluate the potential of the ideas later. For now, the goal is to generate lots of ideas and lots of variety.

Figure 5-2 is a visual comparison of tackling a problem using the standard, logical approach on the left, compared to trying to outflank the problem by testing the edges of the problem in a brainstorming session. The goal isn't to find the perfect solution as much to explore angles for investigating and exploring different facets of the problem.

FIGURE 5-2: Illustration of tackling a problem using the standard approach (left) versus outflanking a problem using a brainstorming technique (right).

Just like a military strategy, sometimes a direct attack on an enemy's fortified position may be held off. Moving around an enemy and flanking them may reveal a weakness in their defense. Brainstorming is a way of exploring a problem from a variety of angles to see what we can learn. So, generating ideas quickly and "outside-the-box" thinking should be encouraged.

## Defining the goals of a brainstorming session

A good brainstorming session has project-specific goals and constraints in mind. For example, you may want to set a time limit for the time you will spend brainstorming. If you are brainstorming with multiple people, let them know that there will be a time when the group will discuss, merge, and refine the ideas, but they should avoid doing this at the outset of the brainstorming session.

All ideas, not just the good ones, should be recorded. Sometimes, individuals will try to dominate the session, so your brainstorming session may need to be managed so everyone can equally participate in the process and all voices and ideas can be heard. In addition, having a rule of "only one person can talk at a time" is also helpful because it keeps dominant individuals in the group from verbally stepping on other members' ideas.

 It is extremely helpful to provide a clearly defined question or goal for a group of people participating in a brainstorming session. Wordsmith your question or goal in advance before holding the brainstorming session.

## Fostering a nonjudgmental environment

When holding a brainstorming session, try not to allow critical comments to be voiced but to encourage the quantity and variety of ideas. If you are managing the brainstorming session, you may find it helpful to ring a bell whenever someone critiques another member's idea or talks over someone else when they are sharing an idea to remind the group that the goal is to generate lots of ideas — including non-traditional and crazy ideas! It's not only important to monitor people's words, but don't forget to monitor body language and facial expressions as well.

## Practicing divergent thinking

A lot of solutions in a brainstorming session aren't going to pan out, a lot of solutions will be fairly uninspired, a few solutions will be passable, and a precious few ideas have potential. This is perfectly normal; in fact, one could argue that this is a hallmark of a good brainstorming session.

Divergent thinking often occurs in free-flowing and non-linear manners of thinking. If you're working in a group, one member's idea might become the spark of a new idea for another member. The more variety, perspectives, associations, and interpretations, the better! Even though certain ideas may seem too unconventional or unrelated, don't self-edit these ideas or allow other group members to judge them. There will be a time when the group will evaluate the ideas, but the free flow of ideas relies on freedom from the fear of rejection or failure.

## Value quantity over quality

In the early stages of a brainstorming session, the focus should be on increasing the pool of ideas. It doesn't matter, at this stage, how realistic the ideas are. All ideas at this stage should be written down and evaluated later. Evaluating ideas comes later in the brainstorming process when all of your ideas will get merged, sorted, filtered, and refined.

Often, ideas are sorted into "good" and "bad" ideas without much thought, but collecting a large number of ideas can actually increase the chances of reaching a new solution than following a more traditional approach of finding a solution through a logical, rational approach.

## Reverse brainstorming

Reverse brainstorming is a technique to solve an idea in reverse, so instead of focusing on ideas that will lead you to a solution, you focus on ideas of how to make the problem worse. Instead of fighting the chaotic tendency to make things worse, this technique allows you to embrace your inner chaos maker.

You start by identifying the problem and reversing it, collect all of your "make the problem worse" ideas, and then reverse the "bad" ideas — turning them back to "good" ideas for the group to evaluate, sort, and refine.

An initial prompt like, "How can we gain more customers?" would become "How can we drive customers away?" which, when the answers are flipped back to positives, can help a group identify improvements, strategies, and innovative ideas more easily.

## Sorting and refining your ideas

Once your brainstorming session has concluded, the group should take the ideas and identify the most promising ideas.

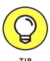
TIP

When I hold a brainstorming session, I like to ask members of the group to write down their ideas on Post-it notes. This way, when the group begins sorting through the ideas, we can categorize and refine them quickly.

One strategy for identifying ideas is to create an *affinity diagram* where all of the brainstorming ideas are physically sorted into clusters based on their relationships. This relationship of the ideas to the problem can help identify new pathways to explore and outflank the problem. Another strategy is *theme mapping* where the group identifies overarching themes or categories that have emerged from the brainstorming session. Sometimes, these themes allow the group to see the bigger picture better and identify commonalities between the groups and the problem. Some brainstorming activities result in a *prioritization matrix* that is similar to a graph and x- and y-axes representing two criteria, such as feasibility and impact. Ideas are placed in the matrix to sort and identify the ones that are both feasible and impactful.

There are a number of great methods and strategies for sorting through and thinking about the results of a brainstorming session. If you're new to the brainstorming process, I would encourage you to look up "brainstorming" on the Internet or YouTube and watch a short video to familiarize yourself with the process before leading a group of people through a brainstorming session.

Don't have a brainstorming group to work with? That's okay; you can work through many of the same processes yourself before you begin sketching out your ideas and choosing a direction to explore visually.

# Phase 4: Sketching Out Your Ideas

Sketching is a valuable part of the graphic design process that can make your work more creative, aid in problem-solving, and foster visual thinking. Often, the design process begins with thinking and writing, and it isn't until this phase that the designer begins to experiment with how their ideas might actually look.

## Thumbnail sketches

Sketching is a great way to get your ideas out of your head and test their viability before committing to a direction. Each sketch is designed to explore the problem from a slightly different angle, and you should try and work quickly, moving from idea to idea. Your drawings don't necessarily have to be well-rendered, but there does need to be thought behind the sketch; otherwise, it would have no value in relation to the problem you are exploring.

To put this into context, one of the projects that I give my Introduction to Graphic Design class to complete is to illustrate the meaning of a word in a creative way where they do not simply illustrate the meaning of the word itself, meaning the word "popcorn" shouldn't literally look like popcorn.

It's natural to be quite literal at first, so I have my students sketch 150 thumbnail sketches to explore ideas before they are allowed to work on the computer. The drawings are quick and gestural, and sketching is a way for them to visually experiment and test the waters for viable solutions.

It's almost impossible to sit down and come up with 150 awesome ideas, but typically, I see the breakdown of 150 sketches look something like this:

- **100 sketches:** Ideas that aren't likely to solve the problem
- **45 sketches:** Ideas that aren't bad but aren't terribly inspired, exciting, or unique
- **5 sketches:** Ideas that have the potential to be developed into a really good design solution that is new, unique, or insightful

I've seen this ratio of sketches to good ideas play out year after year, and it translates to approximately 3 percent of the sketches hitting the sweet spot. Sketching is a way for you to get better, deeper, and more unique ideas. Iterating through sketches is a way for you to look for angles to explore, be more contemplative, and refine your message visually. In Figure 5-3, you can see how quick and loose my thumbnail sketches look. My goal is to capture ideas quickly as I think about the problem I'm attempting to solve.

TIP

Keep your initial ideas loose. There's no need for realism or shading. Just sketch enough to get the ideas down on paper for now.

I try to keep my ideas and thinking loose and fluid, and I try not to use my pencil eraser or to get too detailed in my thumbnail drawing. I simply want to explore a concept to see if there's anything there I like or that I can take advantage of in a design solution. My advice is to not get hung up with how your thumbnail sketches look; you're simply exploring ideas.

FIGURE 5-3: Iterative sketches don't need to look good. They are often used to explore ideas rapidly. Don't get hung up on how your thumbnail sketches look. Go for volume!

## Iterative sketches

Iterative sketches are used to refine and develop an idea through successive versions, making improvements and elaborating on the idea through iteration. Refining a thumbnail sketch through iterative sketches is similar to the way a painter

might start covering the canvas with a big brush at first and then use smaller, more detailed brushes as they get further into their painting.

In Figure 5-4, I took an idea that I liked, and I created a few tighter iterative sketches to explore further the idea of drowning or sinking under the water. I probably sketched out 20 iterative sketches in total, where I just explored an idea that I thought had potential.

FIGURE 5-4:
Iterative sketching can help you dig down on an idea and develop it a bit more than a thumbnail sketch. Can you see how I tightened up the way I sketched my iterative sketches versus my thumbnail sketches in Figure 5-3?

TIP

It can be helpful to take one or two variables at a time and experiment with them to see if there's anything there worth considering.

Typically, there are fewer iterative sketches than thumbnail sketches because they are more deliberate and aimed at solving a specific design problem or improving a concept. Iterative sketches are a way to work on finer details before moving on to the computer.

## Collaborative sketching

Collaborative sketching is a way to sketch with others that takes advantage of differences in perspectives and approaches to a problem. Typically, collaborative sketching may include several team members and someone who acts as a facilitator.

The facilitator will explain the structure, time frames, activities, and expected outcomes, as well as any rules for participation. The group sketches together for a specific length of time and then shares and discusses their sketches with the

group, allowing other members to ask questions and share feedback. Once everyone has shared their ideas, the group identifies a few promising ideas to refine further, and the group digs into the next level of refinement, similar to iterative sketching. Once again, the group reviews the refined sketches, and everyone is encouraged to provide feedback. Working together, the group then summarizes the key outcomes and decisions, and the facilitator collects all of the sketches, notes, and key takeaways from the team as the sketching exercise concludes.

Collaborative sketching can be helpful because it makes the sketching process feel like a lighter lift; they don't rely on one person's perspective or abilities to generate ideas quickly. Having a skilled facilitator guiding the session and keeping members focused is an essential part of this exercise.

## Exploring visual metaphors

Visual metaphors use the pictorial representation of an object to suggest an association or similarity. Visual metaphors use similarities to create an association with one another. Sketching with visual metaphors in mind can help take the attributes of one thing and project meaning to another.

For example, in Figure 5-5, note how Captain America's suit and shield make use of red, white, and blue, as well as stars. Captain America's persona and costume are the epitome of American patriotism.

FIGURE 5-5: Captain America is the epitome of American patriotism, appropriating stars, a red, white, and blue color scheme, and stripes.

Willrow Hood/Adobe Stock Photos

In order to explore visual metaphors, you need to fully understand what the concept you are borrowing from encapsulates. Break down the metaphor into its basic elements and test the parts by sketching how they can be manipulated and visually represented.

It's often helpful to utilize symbols and imagery that are widely recognized and have some sort of association with your own concept.

While visual metaphors can be powerful additions, they can also make your concept a cliché if you aren't careful. Some visual metaphors have been used so many times that they are no longer interesting or unique. For example, a light bulb representing a new idea or a heart representing love are visual metaphors that have lost their impact, predictable, and often uninspired. However, there are still lots of powerful visual metaphors out there that are interesting, clever, and original.

You'll need to understand the visual symbol, combine the elements creatively, simplify the metaphor for clarity, and test your idea with others to make sure you've communicated the right message.

Keeping visual metaphors simple is a key step in creating quality visual metaphors. Overcomplicating the metaphor tends to muddy the waters, so aim for a solution that is both simple and direct.

## Combining sketches

Once you have a collection of sketches it may be worth taking some time to go through your sketches to look for opportunities to combine sketches or borrow ideas from one sketch and apply it to another sketch. By carefully selecting, integrating, and refining elements from multiple sketches, you can leverage the strengths of each sketch to create a stronger design solution.

Begin by identifying the strongest element of a sketch and look for another sketch with features that might complement this direction. Try to avoid overcomplicating the sketch because it's easy to "Frankenstein" ideas and end up with an abomination. To avoid this, prioritize the most important elements and work to refine the sketch — working toward a solution with a cohesive and unified approach.

The key to combining sketches is not to be heavy-handed with this process. Sketches aren't like LEGOs that can be stuck together. It will take some time to combine the sketches into a cohesive goal without losing focus on what you are trying to communicate visually. My advice when combining sketches is to take your time and not try to force-fit sketches together. Look for ideas that are likely to work together the same way a chef might point to ingredients and say if it "grows together, it goes together" when cooking.

In Figure 5-6, I took two of my iterative sketches and combined them to create the solution to illustrate "drowning." I created a grid system where the top quarter is the sky, and the remaining three-quarters is water. I chose to illustrate the word "gasp" instead of "drowning" because I didn't want to be so literal and felt the association between the two words would be easy for my audience to interpret.

My next step was to take each of the letters of the word "gasp" and add scale and rotation to them as if they were kicking and struggling to get back to the surface to breathe. As the viewer reads the word "gasp" from left to right, you'll notice that the letter "p" begins to succumb to his fate and starts to slip into the darkness of the water. Finally, I added three small bubbles to help emphasize the concept of drowning one last time so there could be no doubt about what I was trying to communicate.

FIGURE 5-6: An example of combining iterative sketches together to create a new concept to illustrate the concept of drowning.

Layering meaning and context clues into your design solutions often requires you to slow down and think about what you can accomplish with small visual tweaks here and align all the elements with your goal. You wouldn't drive your car down the road pressing on the gas and the brake pedal simultaneously, would you? One pedal is to make the car go, and the other pedal is to stop the car. Similarly, testing ideas by sketching allows you to make sure all of your elements are working together toward a common goal. If there's an element that isn't working, then it's probably an element that needs to be further refined, replaced, or removed.

CHAPTER 5  Design Is an Iterative Process    105

# Phase 5: Design Development

Once you have a sketch that you're happy with, it's a good time to meet with your client or key stakeholders and discuss the direction you should go before taking your next steps. Getting approval from an external source at this point helps prevent you from getting lost in your own ideas and thinking that you've got a winning idea when, in reality, the solution only makes sense to you. So, before you begin working hard to develop your favorite solution it's a really good practice to gather some external feedback. You're not trying to answer the question, "How should I?" as much as you're trying to answer, "This makes sense to you, right? Do you agree with this direction?"

Seeking feedback at this point is important because you don't want to put in the time to take a sketch, import the sketch to your computer, and work on developing the sketch, only to realize afterward that your client never liked this idea from the very beginning, and it was dead on arrival. It's much easier to pivot and/or make a correction than to invest the time to develop an idea and immediately get sent back to the drawing board.

So, after a direction has been confirmed, it's time to transition from sketches to working on the computer and fine-tuning your composition, selecting typography, building color palates, and selecting imagery and other visual elements.

TIP

I like to keep track of the time it takes me to complete each phase of the design process. This way, I can identify patterns, look for tools and techniques to move through phases more quickly and estimate the time it will take me to complete a job more accurately.

In my 20 years of teaching graphic design, design development is a phase that many young designers have expressed feeling self-conscious about, so let me share the same advice that I share with them with you, too. It's okay if you don't know every software feature, trick, and key command right now. You just need to know the software well enough so that you can execute your idea. New software features are included in almost every software update, and you'll learn the tricks and key commands as you continue to use the software. There's no need to stress that you don't know everything there is to know about the software you're using — just begin by making sure you're using the right tool for the job.

I wouldn't design a logo or a résumé with Adobe Photoshop. It's simply not the right tool for the job in either case, but as long as you're using the right tool for the job then you can develop a lot of the technical skills as you go along.

TIP

LinkedIn Learning, Skillshare, Adobe, and YouTube videos are some of my favorite ways to pick up new graphic design techniques and software skills.

Don't be afraid or embarrassed to do a little research, watch a tutorial video, or ask another graphic designer how you can solve the problem more efficiently. In my previous role as a creative director, I had no problem with my graphic designers doing research or watching tutorial videos to learn to solve a particular problem more efficiently. More times than not, these individuals were my rising stars because they wanted to improve their skills, and so did I. So, don't feel like you can't deliver a good design solution with adequate software skills. It might take you a little time to work more efficiently, but everyone learns and picks up new tricks as they go along.

That said, you can't let your lack of software knowledge get in the way of executing your idea either. So, while you don't need to know every trick in the book with regard to your software skills, you need to have enough software skills to execute your idea well. However, there are so many online resources available that there is a software tutorial for almost every scenario.

# Phase 6: Feedback and Revision

Receiving feedback and revision can be a tricky process for some people, but how do you turn the feedback that some view as a critique into a gift? Well, here are some strategies for thinking about and receiving feedback about your work.

## Preparing to receive feedback

Mentally, you need to be in a good headspace to receive feedback about your work and one of the best ways I know to do this is to avoid positioning yourself as a "me versus them" type of scenario. The person giving you feedback isn't your enemy; they are more likely an ally. However, there are some steps you can take to make the feedback you receive less dramatic.

This includes setting expectations at the start of the project as to when receiving feedback would be most helpful. So, when you get to the point when you need feedback, then it's not a surprise to anyone. You'll also want to set some expectations as to how much feedback you want and the number of revisions you are prepared to make.

You may also need to educate your clients and help them understand what type of feedback is most useful to you. This may be the first time the client has worked with a graphic designer before, and they may not know what kind of information you're looking for. So, you may want to lead them through a critique instead of leaving them to their own devices.

I like to begin a feedback session with a client by summarizing the project and goals and then follow this up with a brief recap of the steps I've completed up until this point. I'll remind them of conversations or emails where I've solicited their opinions.

## Shaping critique feedback

I want to emphasize to my client that this is a partnership and that I have listened to what they contributed and folded these considerations into the solution. This isn't *my solution*; this is *our solution*. If something about the design is out of alignment, then it isn't necessarily *my* fault but instead, something that *we will* identify and react to. I want to make sure my client hears me being proactive and feels that I am engaged in the feedback process.

Teaching a client how to critique and share feedback isn't extra work; it's just part of the job. Not everyone is versed in giving critique feedback, so it's perfectly normal to lead a client through this process.

I want to remind the client of our goals of the project and how my research led me in a particular direction. I'll usually spend a bit of time walking them through my thinking and then ask them for targeted feedback, such as

- Do you think these colors have enough contrast?
- Do you think this typeface reflects the right tone and intensity of the message?

These questions are designed to shape the feedback I receive. Receiving vague feedback like, "I like the direction, but maybe work on it a bit more," isn't particularly helpful to me, so I want to try to shape the feedback I receive by running through some of my design decisions and checking that we are both in alignment.

However, if I'm talking with my target audience, then I am not going to lead them through my design decisions, and I'm going to quit talking and start listening. I don't want to bias their reaction to the piece by explaining how clever my solution is or how I want them to interpret my solution. I want to be in more of a listening posture than an explaining posture.

If the feedback is unclear, then I'll ask a clarifying question to make sure I'm understanding correctly. I'll take notes as the critique goes along, and then I'll try to summarize and repeat what I've heard back to the target audience to make sure nothing has been overlooked.

## Prioritizing feedback

Everybody has an opinion, and you can count on receiving feedback. I don't care if you're Michelangelo and you're working on his famous David sculpture; somebody will be there to offer their two cents. But here's the thing: That's perfectly okay!

After receiving feedback, you need to sort through and analyze it. Put the suggestions into categories such as "design elements," "functions," or "preferences" to see what categories you're getting the most feedback on. Are there any feedback themes that repeat? Was there something your client emphasized?

You're looking for ways to prioritize the feedback you received and to evaluate which changes are likely to affect the impact the most. Everybody has an opinion and things they might do differently, but your job is to determine which of these suggestions you need to react to.

REMEMBER

Any errors need to be fixed. Did you make a spelling error? Fix it. Did you use the wrong shade of blue in the company logo? Fix it with no questions asked. Preferences and alternative approaches to solving the problem are in a completely different category, though. These are worth prioritizing and evaluating their impact toward achieving the goals of the project.

## Balancing feedback with design expertise

I always try to learn from the feedback that a client or target audience provides, but I don't always agree with their design suggestions. Sometimes, clients make decisions that don't align with what my experience tells me is a bad decision.

Even though I may be working for a client, there are times when I will argue — politely, of course — for my point of view. There are times when the designer may have the upper hand in determining how a decision may affect what a piece communicates and will need to stick to their guns. When this has happened to me in the past, I'll try to quickly mockup two directions and use them to make my point. The reason I do this is to show the client that I'm listening to them but that there is a better way of moving forward.

CHAPTER 5  Design Is an Iterative Process    109

When situations like this arise, I try not to be heavy-handed with my objections as if I were some type of design prima donna, but I position myself as more of a graphic design sherpa who is helping my client cross difficult terrain by assisting with their project as best I can.

## Use versioning to save time

As you begin making changes that your client or target audience has suggested, it's a good idea to use versioning to track the changes you make. Versioning simply means that you save your work using a file naming system such as "Logo v1.0," and when you make a change to the logo, you resave the file as "Logo v2.0" instead.

Inevitably, I've made the changes that a client has requested (such as making a logo purple), and they've later said, "Never mind, I like your original version better." If I've made changes to my original file, I will need to go back and undo everything I just did; however, if I've used versioning, then I can simply open Logo v1.0, and I'm instantly rolled back to where I started.

Versioning can also be helpful in showing where you've spent your time when the project is over, and you bill your client for your work. Sometimes, clients forget that they asked you to show more sketches or try out an idea that they didn't ultimately end up using. Versioning is a good way to capture where your time and effort have gone. Make sure to save all your versions, even after the choice is made!

## Micro/macro

Last but certainly not least, think about the feedback and suggestions you received through a micro/macro lens. Which suggestions are subjective, and which are likely to make the biggest impact on how the design solution functions?

You'll likely receive comments that are more granular (such as, "Can we move this element over here instead?" and comments that are larger or more substantial changes (such as, "Let's switch from a horizontal navigation bar to a vertical navigation bar"). Framing these comments in terms of micro and macro suggestions may help you tackle some of the most important ideas first, which may aid in resolving some of the smaller issues as you work through your list of suggestions.

REMEMBER

If you don't make a change, be sure to address the reason why you didn't with your client at some point to let them know how the issue will be resolved.

# DESIGNING A UROLOGY LOGO

I was asked to help a local urologist create a logo for their business. I started by sketching all my sophomoric logos, which was fueled by my inner-middle school sense of humor, and then went to work thinking deeply about the shapes and colors that might work best.

As far as shapes were concerned, I determined it was important to stay away from sharp shapes like zigzags, triangles, and pointed starts and instead steered toward organic, fluid, and calming shapes. Along these same lines, I wanted to stay away from warm colors yellow, orange, red, and some purples because I didn't want the logo to be associated with pain, blood, or bruising.

I worked up a few ideas and met with the urologist to show him a few of my favorite ideas before choosing a direction and finalizing the logo. I presented my logos and the doctor looked completely lost. In fact, he asked me to give him a minute and asked if he could take my sketches with him to think about for a few minutes and left the room.

When he returned, he said that he liked one logo in particular, but he wanted it to be purple instead of a sky or medium blue. I was intrigued by his sudden ability to make design decisions after looking so lost moments before. He confessed that he walked into the other room and asked his secretary which design she liked best, and she pointed to the logo and commented, "But purple is my favorite color."

That was his entire decision-making process. I mentally kicked myself in the rear for not doing a better job of explaining why I thought this logo was a good fit for him in my presentation. I had assumed he was knowledgeable about visual communication and that he understood that my design decisions were purposeful and what I was trying to visually communicate.

To this day, I try to slow down and talk all of my clients through my decision-making process to help them better understand how the elements in my design solution support the goals of the project. This approach has helped me tremendously over the years and might be a tactic that will work for you, too. Otherwise, the secretary might decide for you!

# Phase 7: Finalization and Execution

After all the changes have been made and the client is happy, it's time to do two things. First, I have my client sign a Proof Approval form (see Figure 5-7) that states the client has reviewed and approved the project. It also states that the graphic designer has made a good faith effort and that the client has had a chance

to review the document and takes responsibility for any mistakes that may be found from this point forward.

The other option that the client can select is the option to make additional changes, and the graphic designer will present the client with another proof and a clean copy of the Proof Approval form with the understanding that once the final edits have been made, the client should be able to sign off on the project, bringing the project to its completion.

Using a Proof Approval form may help you avoid comments from clients that are vague and ambiguous. The form can be a tool for designers to move the project forward at a time when clients tend to drag their feet or hem and haw.

Once the client has signed off on Option 1, authorizing the project to go into production, then it's time to finalize the design and prepare files for the next steps in the distribution process.

## Tips for preparing printed work

When you prepare files to go to print, one of your first steps should be to find out from the printer how they want you to prepare your files. Each printer you work with may be using different kinds of printing presses, have different workflows, or may have specific settings they would like you to use. That said, there are some commonalities between printers, and unless instructed otherwise, the files you create should follow these guidelines:

- » All raster images should be at least 300 DPI (dots per inch) to avoid looking blurry or pixelated when printed.
- » Convert your design to a CMYK (cyan, magenta, yellow, and black) color mode. Files with an RGB (red, green, blue) color mode may shift in how they look when printed.
- » Use a ⅛-inch bleed and ensure that any design elements that extend beyond the document's borders are extended out to the bleed line.
- » Use rich black for large black areas to create a deep, solid black that is free from little white imperfections called a "hickey," which is caused by a printing error, dust or debris, or paper defect. Rich black is created by making the color using 40 percent cyan, 40 percent magenta, 40 percent yellow, and 100 percent black.

# PROOF APPROVAL FORM

**Client Name:**
**Client Address:**
**City, State Zip:**
**Date:**

**Project name:** [Name of the project]

This proof is provided for you, the client, to check the design and accuracy of your project before it is put into production. Please review all aspects of the project, including layout, design, spelling, colors, and your contact information. After reviewing, please complete one of the options below and return this form to [Graphic Designer's Name] with the proof by [Date] to make these final changes and begin production. Please choose *one* of the following options below.

**Option 1:**
I verify that I, as an authorized representative of the client named above, have reviewed and approved this project. I understand that any changes requested after this project is put into production, whether due to mistakes or preferences, may incur an additional charge. I also acknowledge that mistakes or preferences not discovered and specified at this time are not the responsibility of [Graphic Designer's Name]. I accept full responsibility and authorize [Graphic Designer's Name] to put this project into production.

**Signature:** _____

**Date:** _____

**Option 2:**
I would like the following items to be changed and request that [Graphic Designer's Name] makes the changes below and submits a new proof. *Note: Please write directly on the mock-up or describe your changes below.*

FIGURE 5-7:
An example of a Proof Approval Form that your client will sign to move a project into production.

» Export your files in the format specified by your printer. These can often be PDF files. PDF/X1-a and PDF/X-4 are some common high-quality PDF print settings.

» Provide a detailed print specification sheet or notes to the printer with instructions about which type of paper to use, special printing requests (such as UV varnish), folding or binding requirements, or any other information the printer might need to handle your job successfully.

TIP

If you're using an online printer, be sure to look at the printing guidelines, templates, and FAQ's for information about how to prepare your files for print.

## Tips for preparing files for the web

When preparing files for the web, there is often a balancing act between compression and image quality that must be considered. It's considered a best practice to optimize images so they are exactly the size that's needed at an appropriate resolution.

Take a look at Figure 5-8; notice anything different about the two images? While they might look identical, the files may act very differently when they are viewed on a website or cellphone. The file size of the image on the left is 34MB, while the file size of the image on the right is a mere 253KB after the image has been sized and compressed.

**FIGURE 5-8:** These images might look similar, but they may act very differently when they are viewed on a website or mobile phone.

114    PART 1  What to Know Before You Start Designing

What does that mean? It means the image on the right is about 99 percent smaller in size and will load exceptionally fast on a website, while the image on the left will take extra time to load. Both images can be the same physical size, but their file sizes can be wildly different.

Do you know anyone who wants to wait for their web pages to load? Probably not. This is why preparing your files properly is time well spent.

In addition, if there are other images on the website, it may take even longer for the webpage to load. File size, file formats, compression, and resolution can all affect the user's experience. Here are a few more considerations for preparing files for the web:

>> **Choose the right file format:** JPGs are ideal for photographs, PNGs are great for when you need parts of an image (like a background) to be transparent, SVGs are the correct file format for vector graphics, and GIFs are great for making smaller animated files.

>> **Compression is paramount:** I love Adobe Photoshop's Save for Web (Legacy) tool that allows you to see and adjust your image compression settings. Simply go to File > Export > Save for Web (Legacy) to see how compression will affect both your image quality and file sizes.

Simply making a file a PDF is not necessarily a good solution for reducing your file sizes. There are often more efficient and effective ways to reduce your file sizes that should be considered as a first step.

>> **Resolution also affects file sizes and image sizes:** Standard web images usually have a resolution of 72 dpi, but higher resolutions (like what you would find on a retina display) are around 144 dpi to provide these users with a sharper image.

>> **Use descriptive names:** Use descriptive file names and use a hyphen in lieu of a space. For example, "Frank-Lloyd-Wright-Fallingwater.jpg" can make search engine optimization (SEO) easier; the file name will be read as "Frank Lloyd Wright Fallingwater."

>> **Use alt text:** Use alt text to provide meaningful descriptions for individuals with visual impairments using screen readers as well as providing additional SEO benefits.

## Tips for preparing files for mobile devices

Similar to preparing files for the web, using appropriate file formats, compression, and image sizes and resolutions are equally important. Here are some additional tips for preparing files for mobile devices:

- » Optimize video using MP4 (H.264 codec) for compatibility and compression.
- » Use responsive video containers and images to ensure that videos and images appear as intended on mobile devices. Many mobile devices have different screen sizes, so responsive design strategies like video containers and srcset attributes help content scale and take full advantage of various screen sizes.
- » Use efficient file formats like WebP for images and SVG file formats for better compression on mobile devices.
- » Use "lazy loading" to preload off-screen images and videos so they are downloaded and ready to go until they are needed.

REMEMBER

Mobile devices aren't just miniature computers. How we use our mobile devices is often drastically different than how we use a computer. If I look up Walmart on my cellphone, chances are good I'm looking for store hours or which Walmart is closest to my location. If I look up Walmart on my computer, I'm probably looking at product reviews or if they have the thing I'm looking for in stock. Mobile sites are often used to answer different questions than their computer counterparts.

# Phase 8: Repeat

Graphic design is an iterative process, and as the design process is followed, the graphic designers, key stakeholders, and clients learn more about their strategies, methods, and tools. As a project progresses, new insights and ideas can emerge, and further iteration can enhance the results.

This isn't to say that the entire project needs to be thrown out and started over, but certain phases or decisions can — and should — be revisited under the premise that the new information a graphic designer has learned may require a component of the project to be updated or reworked.

Additionally, the first iterations of a design project are rarely perfect. In fact, there's no design solution that I've ever created that couldn't be improved in some way! Revisiting the phases of a design project again after the bulk of the work has been completed is a way to further experiment and push ideas further, fostering greater innovation and creativity.

Clients often have their ideas for a project evolve as a project goes along. It's not uncommon for a client to have some additional requests at this point in time.

As a project enters the "Repeat" phase of the design process, it ensures that the design solution is tested, improved, and refined to fully meet the client's goals and effectively communicate with the intended audience. This process typically continues until the project runs into a time, financial, or other type of constraint that requires the design process to end.

It's one thing to know the graphic design processes academically and another to actually walk through this process yourself.

# Using the Principles of Design to Elevate Your Work

**IN THIS PART . . .**

Understanding contrast, visual emphasis, and hierarchy

Putting unity, Gestalt psychology principles, and rhythm to work

Using movement, alignment, and white space

Learning how to use a grid structure

Exploring color psychology

Choosing the right typography

## IN THIS CHAPTER

» **Introducing the principles of design**

» **Recognizing balance and how it's used**

» **Using contrast effectively in a design solution**

» **Creating visual emphasis and hierarchy**

# Chapter **6**

# The Principles of Design: Balance, Contrast, and Emphasis

Have you heard of the principles of design? If not, then prepare to be amazed because the principles of design are the building blocks of graphic design. The principles of design are often used to create visually pleasing and functional design solutions.

It's important for graphic designers to recognize and utilize the principles of design because they are often a fundamental tool in a graphic designer's toolkit. In fact, it's not just graphic designers that use the principles of design, but artists, architects, interior designers, and many other disciplines lean into the principles of design, too.

The principles of design have evolved over time through the contributions of many artists and disciplines, so when you understand and use the principles of design,

you can think of it as standing on the shoulders of giants and taking advantage of the many lessons that various artists and designers have spent their careers investigating and defining.

REMEMBER

Using the principles of design doesn't guarantee that your work will be good, but it can significantly enhance its quality.

There are parts of the principles of design where there is consensus and parts that are more likely to be interpreted by the designer's style — often called *visual voice* — as well as cultural context and other factors. One area that is largely agreed upon is the core principles such as balance, contrast, emphasis, movement, pattern, rhythm, and unity, though some designers may prioritize certain design principles over others. This doesn't mean that the design principles are flawed, but you can think of it as being more of a recognition of how artists and designers develop their own style, which in turn influences how they apply the design principles in their work.

Cultural context can also play a role in how the design principles are applied. For example, different cultures may have different aesthetic preferences and interpretations of certain colors, may use different symbols, different visual hierarchy structures (like reading from right to left), or have different approaches to design.

TIP

Graphic designers should avoid using cultural elements from other cultures without a deep understanding and respect for those elements and their significance.

That said, the ways in which the design principles are used allow for a wide range of creative expression from which we can all benefit. The principles of design serve as guidelines to help the artist or designer visually communicate through their work. Of course, there are always design solutions that don't follow the principles of design and still function well, but the principles of design can be extremely helpful and worth the investment in time to understand how they function. They are a fundamental tool in the graphic designer's toolkit for a good reason.

TIP

You don't need to try to use *every* design principle in your design solution, but you can use the design principles together *in coordination* with other design principles in a design solution. You can use the principles of design to effectively guide a graphic design critique, too.

I'm a big believer in "seeing is believing," so I've created a series of simple graphics to help visually communicate some ways in which many of the design

principles could be executed. This is designed to help you understand the concept better, but shouldn't be interpreted as the only, or best practice, for utilizing the design principle in your own work.

# Balance

Balance refers to the distribution of visual elements to achieve a sense of stability and often ensures that no single part of a design solution overpowers the other parts. Balance is often used to create a sense of harmony and stability. When the balance is off in a composition, it can create a feeling of tension, anxiety, or discord.

There are several types of balance, including symmetrical, asymmetrical, and radial balance, as well as crystallographic balance, a less familiar term that involves the visually even distribution of similar elements without a specific focal point.

## Symmetrical balance

Symmetrical balance is achieved when elements are arranged evenly around a central axis, creating a mirror image. Symmetrical balance is often associated with feelings of formality, stability, and order. Symmetrical balance can be further broken down into horizontal balance and vertical balance.

## Horizontal balance

Horizontal balance refers to elements that are arranged around a central axis and create a mirror image on the left- and right-hand side. In Figure 6-1, the red dashed line represents the central axis, and the elements are reflected horizontally.

## Vertical balance

Similar to horizontal balance, vertical balance is when elements are arranged around a central axis but create a mirror image on the top and bottom instead. The central axis divides the composition into top and bottom halves instead of left- and right-hand sides.

CHAPTER 6 The Principles of Design: Balance, Contrast, and Emphasis 123

FIGURE 6-1: An example of both symmetrical balance and horizontal balance. The design elements mirror each other on the left- and right-hand side.

## Asymmetrical balance

Asymmetrical balance is achieved when elements of different sizes, shapes, or colors are arranged in a way that creates a sense of balance (see Figure 6-2). Asymmetrical balance relies on visual weight rather than mirroring elements.

Asymmetrical balance can be used to create a sense of energy and movement, and many modern design solutions may use asymmetrical balance to create a fresh and innovative aesthetic. Unlike symmetrical balance, asymmetrical balance can evoke a feeling of informality because it can be more organic and unpredictable. Sometimes, asymmetrical balance can evoke feelings of imbalance or unease if the viewer interprets the balance differently than the designer intends.

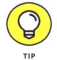

Whenever I take photographs of the work in my portfolio using asymmetrical balance, I find the compositions are more engaging for viewers to look at than symmetrically balanced compositions.

## Radial balance

Radial balance occurs when the elements radiate outward from a central point. This type of balance creates a sense of movement and dynamism (see Figure 6-3).

**FIGURE 6-2:** Four examples of asymmetrical balance that experiment with shape, color, and balance. The key to asymmetrical balance is balancing the visual weight of the elements.

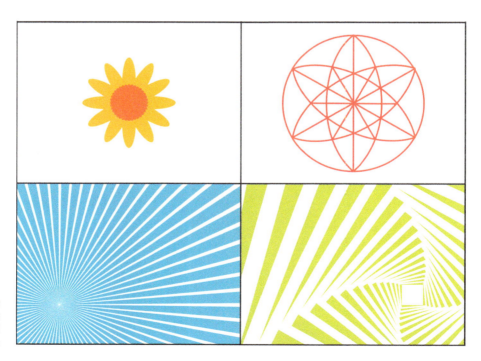

**FIGURE 6-3:** Four examples of radial balance.

CHAPTER 6  The Principles of Design: Balance, Contrast, and Emphasis    125

## Crystallographic balance

Crystallographic — or mosaic — balance is achieved by giving equal visual weight to a number of elements. The results aren't a symmetrical pattern but balanced chaos in which several elements are combined to make a unified whole. Please see Figure 6-4 to view examples of crystallographic balance.

Crystallographic balance can evoke a number of emotional responses in people due to the infinite number of visual elements that can be used to create this type of balance or mosaic-like pattern. Feelings of calm, orderliness, stability, and reliability can be evoked depending on the visual elements that are used in this variety of balance.

The response to crystallography can vary because of individual preferences and cultural factors. The overarching effect is sentiments of structure and harmony.

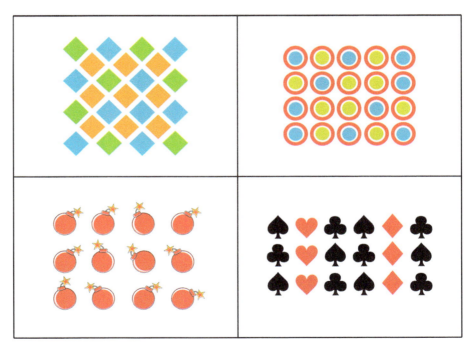

FIGURE 6-4:
Four examples of crystallographic balance.

Crystallographic balance can be found in both natural and human-made design. One example in nature is the symmetrical arrangement of snowflakes and patterns seen in crystals and mineral formation. Crystallographic balance is

also used in art, architecture, and textiles. Islamic art and mosaic art often use this technique to create geometric patterns and mosaics where repeated design elements come together to form a cohesive and balanced design.

# Contrast

Contrast refers to the differences between visual elements that make them stand out or blend together in the viewer's eye. Contrast can be used to create visual interest, make elements easier or more difficult to see, and as a means of creating emphasis in a design solution.

Contrast is a fundamental principle of design and is often used by graphic designers, so recognizing, understanding, and controlling contrast is a paramount skill set in a designer's toolkit.

Graphic designers often use contrast to help highlight the most important elements in a graphic design solution. Designers may increase the contrast of a key point or a call to action to make sure there is little ambiguity in the viewer's mind about the importance of these elements.

Contrast can also be used to improve the legibility of text and must also be considered when designing for visually impaired individuals.

Contrast is often used to establish visual hierarchy and can be used to guide the viewer's eye through a design solution in a controlled way. Contrast can be affected by color, tone, texture, size, shape, and white space, as well as other strategies.

Contrast isn't just used to emphasize design elements; it can be used to deemphasize design elements, too.

## Color contrast

Color contrast is the differences in the color of an object that make it distinguishable from other elements. In the example shown in Figure 6-5, you can see how the differences in type and background colors affect the dominance of the message.

**FIGURE 6-5:** Color contrast can be used to draw or diminish attention and be used to help create emphasis. The joke on the left seems less funny because the contrast between the setup and the punchline emphasizes calling a cab if you've been drinking. The joke on the right has less color contrast and leans into the punchline because camouflage is notoriously difficult to see.

> What do you call a guy who's had too much to drink?
> A cab.

> I went to buy camouflage pants, but I couldn't find any.

Following are some of the key aspects of color contrast:

- **Hue:** The difference between colors on the color wheel
- **Lightness:** The difference between how light or dark a color appears
- **Saturation:** The purity of a color
- **Temperature:** The difference between warm colors (yellow, orange, and red) and cool colors (purple, blue, and green)

## Tonal contrast

Tonal contrast is the difference between how bright and tonally different design elements are. The brightness is the measure of a color's lightness or darkness, and high tonal contrast means there's a relatively large range between the lightest and darkest areas. A low tonal contrast means there is more subtlety in this range.

TIP

Tonal contrast can be achieved without colors by using various states of gray. In fact, if you squint your eyes at a composition, you can sometimes view the tonal contrast more effectively.

Like other types of contrast, tonal contrast can be used to improve legibility, define hierarchy and emphasis, and create visual emphasis. In Figure 6-6, tonal emphasis has been used to create a composition that plays with a high degree (left) and low degree (right) of tonal contrast.

**FIGURE 6-6:** If you wanted to create a funny t-shirt, would it be better to use a high degree or low degree of tonal contrast?

If you can read this, your glasses are doing their job.

If you can read this, your glasses are doing their job.

## Textural contrast

Textural contrast, as you may expect, involves the difference in surface qualities or textures within a design solution. Sometimes, this effect can be artistically created, and other times, textural contrast can be created through material selection, printing, finishing, or processing techniques. An example of this would be printing a glossy UV varnish on a matte paper. The contrast between a glossy varnish and a dull paper creates a high degree of textural contrast and may help create visual interest within the piece. See Figure 6-7.

One thing that's interesting about textural contrast is that you're evoking another sense other than your vision — your sense of touch, which can be used to make a design solution more memorable or impactful.

In architecture, the architect might create textural contrast through the use of stone and glass or concrete and metal, while a graphic designer might use a foil stamp on a contrasting background or UV varnish on a matte paper.

## Size contrast

There's a reason why they say, "If you can't make it good, make it big." Size contrast is a technique that is proven to work and can be used to establish a visual hierarchy to lead the viewer's eyes through the piece. Often, larger elements convey a sense of importance, and smaller elements may suggest tertiary or subordinate information.

CHAPTER 6 **The Principles of Design: Balance, Contrast, and Emphasis** 129

**FIGURE 6-7:** Creating textural contrast is a way of mixing different textures and creating depth, interest, or visual hierarchy in a composition.

Aliimran/Adobe Stock Photos

TIP

When determining what the size of different elements might be, sometimes it can be helpful to think about what a viewer might be able to see from far away, what they will see as they approach the piece, and what information they will see when they are in front of the piece as a strategy for determining the size of various design elements.

In Figure 6-8, think about what information you might see as you approach this poster from a distance. What information are you likely to see, and how might this impact you? Consider how size contrast affects the visual hierarchy of the poster.

**FIGURE 6-8:** How might size contrast affect how the information on this poster is seen from various distances?

130　PART 2 **Using the Principles of Design to Elevate Your Work**

Take a look at the poster for a film festival in Figure 6-8, and think about the answers to the following questions:

- » Which elements are the largest elements, and why do you think these elements were sized this way?
- » Which elements are the medium-sized elements? Why do you think these elements are medium-sized?
- » Which elements are the smallest? Why do you think these elements are the smallest?
- » What would the poster look better or worse if all of the elements were sized similarly? Why?
- » How does your eye move through this piece? Where do your eyes start, and where do they end up?

Size contrast is a great way to control where viewers look and how their eyes flow through a composition, but it's not the only way. There are a number of strategies for leading a viewer's eyes through a piece. Balance, color, layout, and a variety of other strategies can also be used to accomplish a similar effect. Sometimes, the effect can be subtle or suggestive, and sometimes, the effect can be made more direct by combining multiple visual cues to leave little room for doubt.

## Shape contrast

Shape contrast can be used to create visual interest and direct a viewer's attention to a particular area. Different shapes can be used to draw attention to key elements in a composition. For example, a website designer might use square and rectangular elements to designate areas for written content but then use round elements for buttons and calls to action. A logo designer may consider shape contrast to distinguish one logo from its competitors.

Shapes, either in whole or in part, can be used to draw attention to key parts of a composition. Shapes may also carry psychological connections, like circles being associated with sentiments of friendship or inclusiveness, while triangles may be associated with balance or dynamism.

The connotations of different shapes are implied and are not absolute. Individual preferences and cultural associations may impact how different shapes are perceived. However, thinking about shapes and what they communicate can be beneficial for graphic designers to consider.

CHAPTER 6 **The Principles of Design: Balance, Contrast, and Emphasis** 131

Some associations that may be linked with particular shapes:

- **Circles:** Friendship, harmony, inclusiveness, infinity, protection, safety, or unity
- **Hexagons:** Cooperation, efficiency, or order
- **Ovals:** Continuity, flexibility, grace, movement, or mystery
- **Polygons:** Complexity, modernity, organization, or versatility
- **Rectangles:** Comfort, discipline, formality, reliability, strength, or tradition
- **Spirals:** Calmness, energy, evolution, growth, or intelligence
- **Squares:** Balance, familiarity, order, reliability, security, or stability
- **Stars:** Achievement, aspiration, excellence, or fame
- **Triangles:** Action, balance, direction, dynamism, energy, excitement, movement, risk, or tension

## Spatial contrast

Spatial contrast is the difference *between* elements within a design composition. This includes the position, spacing, and alignments of elements and is often used to create a sense of hierarchy, functionality, and emphasis. A generous use of space might evoke feelings of luxury and calm, while tight spacing may create feelings of urgency, frustration, or intensity.

Spatial contrast can help guide the viewer's eyes, establish areas of visual rest, or isolate elements like calls to action so they stand out as focal points within a composition.

Often, spatial contrast can be used to differentiate between different types of content. A website designer may insert more space around a positive quote from a user that supports the product, service, or brand as a way of emphasizing its importance or impact.

TIP

The pacing of information is important for how the audience perceives the information. The pacing of stock prices can be dense because they are raw data, while the narrative of a company's annual report may spaced more openly to make this content more concise, compelling, and clear.

Consider the image in Figure 6-9. How might the spatial considerations in the label designs be interpreted? The design elements do not feel tightly spaced and

well distributed. What might the designer be trying to communicate visually? Perhaps they are trying to communicate that this is a luxury or high-end product, or perhaps that this is not a product to be scared of or feared. Perhaps the visual language suggests that this is a natural, organic product. The visual language does not seem to suggest that this product is targeting recreational cannabis users.

FIGURE 6-9: An example of cannabis packaging. What might we infer from the designer's open use of spatial contrast?

*createvil/Adobe Stock Photos*

## Typographic contrast

Typographic contrast is using different typefaces, sizes, weights, and styles of text to create differences in how typographic elements look and function. It's important to create a hierarchy with type to give the viewer a sense of where to begin consuming typographic content.

One of the biggest things I see younger designers struggle with is creating a system with a clear typographic hierarchy. Some common mistakes that are easy to make include:

>> Using too many typefaces in a design solution

>> Using typefaces that are too similar in appearance

>> Setting text using only capital letters or lowercase letters

- » Using too many sizes of type in a single design solution
- » Choosing a typeface that is either too bold or too light
- » Using too many typographic alignments in a design solution

All of the issues in this list were created by situations that were created by decisions that used too little typographic contrast or too much typographic contrast.

It's important to establish a hierarchy with your type. Choose fonts, weights, and styles that allow you to set headlines, subheadings, and body copy in a way that is clear, logical, and easily understood.

Some factors that can affect typographic contrast can include:

- » **Font size:** Use larger-sized type for headlines and smaller sizes for body copy to create typographic contrast.
- » **Font weight:** Use different font weights (bold, regular, or light) to create typographic contrast.
- » **Font style:** Use italics, underlining, small caps, and so forth in certain words to establish typographic emphasis within a selection of text.
- » **Typefaces:** Use a combination of typefaces to create contrast. This involves combining a bold typeface with a lighter typeface or a serif and sans-serif typeface to create a typographic contrast.
- » **Spacing:** Adjust the space between letters (kerning), word spacing (tracking), and vertical lines of type (leading).
- » **Background color:** Place typographic elements on different colored backgrounds (such as light text on a dark background, and vice versa) can be a way of creating areas of typographic contrast.

# Emphasis

Emphasis is a technique for creating a focal point in a design solution that is designed to draw the viewer's eye to a certain element. Being able to guide or control where a viewer's eyes land is often linked to the effectiveness of a design solution. Leading the viewer's eyes through a design ensures the most critical information is noticed first.

There are numerous ways of creating visual emphasis, so a graphic designer may experiment with different techniques as project constraints allow. Often, a designer may utilize more than one technique at a time to ensure success, but this is a balancing act as using too many visual cues may make the work look amateurish — the way explaining a punchline makes a joke less effective.

Emphasis is a way for design elements to stand out.

## Contrast emphasis

Earlier in this chapter, I talked about different types of *contrast* (color, tone, texture, size, shape, spatial, and typography). If you recall, contrast refers to the *differences* between visual elements that make them stand out, so it makes sense that contrast can also be used to emphasize a particular design element. Contrast is a way of creating emphasis in a design solution.

Take a look at Figure 6-10 and think about what elements are being emphasized and how. Clearly, the name of the product on any beverage is an important piece of information, so the designer made the product's name, Raskel, the biggest element on the can but also made it white so it would contrast her very colorful background on each of the cans.

There are four flavors of Raskel, so the designer used four contrasting colors to differentiate between Lime Uprising, Raspberry Riot, Orange Craze, and Berry Risky. This was a smart move because it makes choosing your favorite flavor extremely easy.

In order to make the collection of beverages feel cohesive, the designer repeated several visual elements like the monkey, the swirl in the background, the typefaces they used, and the location of information like fluid ounces, alcohol by volume, and other required information.

In order to achieve contrast emphasis, some elements have to be cohesive or fall into a system in order to make other strategically chosen elements stand out and benefit from contrast emphasis.

Think about the different types of contrast the designer is achieving in the Raskel images above and how the brand guidelines might be used to extend this visual language to other mediums (such as ads, social media, or a website).

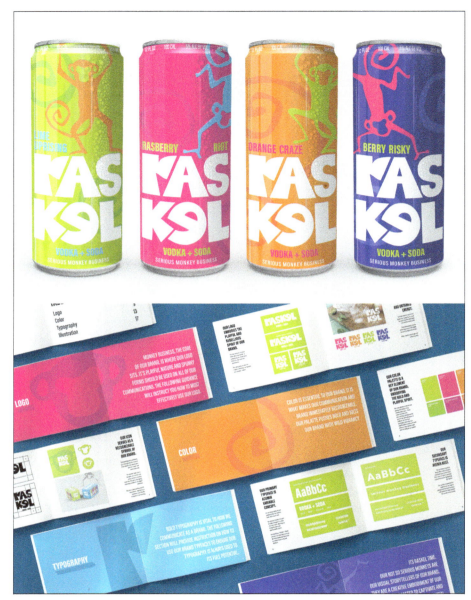

**FIGURE 6-10:** Raskel packaging and brand guidelines by Ryan Margaret Lee.

© Ryan Margaret Lee

136  PART 2  Using the Principles of Design to Elevate Your Work

## Isolation emphasis

Isolation emphasis refers to making a design element stand out by surrounding it with white space — isolating it from other elements. The white space has the effect of drawing the viewer's attention directly to the isolated element, making it a focal point. Take a look at the examples in Figure 6-11.

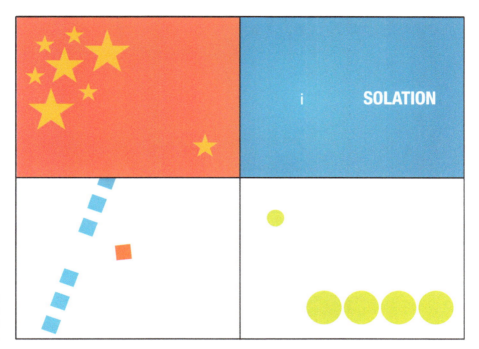

FIGURE 6-11: Four examples of isolation emphasis.

## Positional emphasis

Positional emphasis takes advantage of areas within a composition that tend to draw the viewer's attention. These areas are learned and may have a cultural component. For example, in the United States, we read from left to right and from the top to bottom. Placing important content on the top left-hand side of a composition helps ensure that American viewers will notice it. However, this positioning may be less effective in China. Positional emphasis takes advantage of the audience's tendency to go to certain areas to look for information. Figure 6-12 demonstrates several positional emphasis concepts.

Positional emphasis is particularly effective in mediums like magazines, books, posters, websites, and social media, where users have learned where to look for key pieces of information.

**FIGURE 6-12:** Four examples of positional emphasis.

## Color emphasis

Color emphasis is the strategy of using color to draw attention to a particular area or element in a composition. The human brain has to process a lot of sensory information quickly, and it has to prioritize what information is the most relevant in an instant. Color is a visual cue that our brains prioritize, so using strategically chosen colors is a way of helping your audience process your message more quickly.

Color can be used to help you establish hierarchy, it can be used to convey a mood or emotion, it can be used to highlight key elements, or create a focal point to direct the viewer's eye to a particular location in a composition.

REMEMBER

Using color effectively can direct your audience's attention, receive your message more quickly, and enhance the impact of your design solution.

Think about how you might use color to draw attention to the categories in your résumé (see Figure 6-13) or highlight a button on a website to make the signup process more intuitive. Even small amounts of color can be used to direct a viewer's attention to the areas that are most important or help establish hierarchy.

138  PART 2 Using the Principles of Design to Elevate Your Work

**FIGURE 6-13:** Using color to help create typographic hierarchy.

REMEMBER

Color emphasis can impact perception and behavior. Some colors cause a physical reaction and have been shown to increase heart rates, while other colors can have a calming effect. If you'd like to know more about color emphasis, be sure to check out *Color Theory For Dummies*.

## Typographic emphasis

Typographic emphasis is when a designer uses various typographic elements to highlight and draw attention to specific parts of a composition with text. There are a number of typographic variables that a designer can use to create emphasis.

Typographic emphasis is used to signify different levels of importance or urgency through a combination of size, weight, style, and spacing to help guide the audience through a composition. Graphic designers often use variables like weight (light, book, bold, or black), styles (such as Roman, condensed, extended), spacing (leading, tracking, and kerning), and other aesthetics like color, proximity, and alignment to create emphasis.

REMEMBER

Many people try to communicate through photographs, illustrations, and artwork, but you can, and should, communicate with typographic elements too. Don't forget to use your typography to help you convey your message. Typography is often the difference between a good design solution and a great design solution.

CHAPTER 6 **The Principles of Design: Balance, Contrast, and Emphasis** 139

## White space emphasis

White space is often referred to as negative space and refers to the areas of visual rest in a composition. White space doesn't have to be white in color, but its purpose is to balance a layout, establish the pacing of content, guide the viewer's eye, and enhance focus by drawing attention to important elements.

Many young designers fail to appreciate the impact that white space has on how a design solution is perceived. White space can help in creating a more clean, sophisticated, and professional looking composition and can improve the viewer's experience.

Graphic designers can use white space the way a writer might use punctuation in a sentence. It can be used to pause, reflect, and emphasize a point — only white space does it through visual rest rather than by using glyphs. Take a look at Figure 6-14 and notice how the designer uses white space and visual rest to emphasize the name of the brand and to establish the pacing of the package design solution.

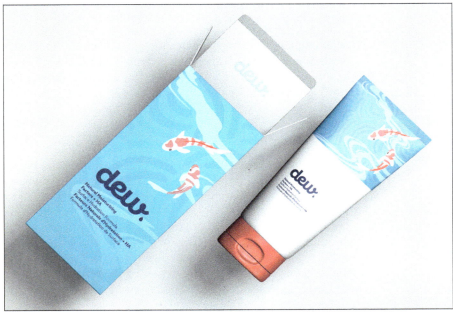

FIGURE 6-14: Graphic designer Caroline Mitchell's use of white space on a moisturizing cream to help establish pacing and emphasize the brand name.

*Dew*

We've all witnessed how Koi seem to be relaxed and never in a hurry. Now, think about how you would want to end a busy day. Probably with a few moments of self-care where you let go of the stress of the day and spend a few minutes focusing on yourself, your time is finally your own.

The designer in Figure 6-14 seems to reflect on this moment visually through her use of white space, which she strategically used to reinforce the pace of the moment and also draw attention to the name of the moisturizer brand, Dew. It's a clever approach when you can make a design decision that benefits your design in multiple ways.

TIP

As the famous saying goes, less is more. Sometimes, you can be more impactful by focusing on the important elements and removing visual clutter. A designer's use of white space is a great way to achieve this effect.

## Directional emphasis

Directional emphasis is a technique for leading the viewer's eyes through a composition by creating paths or focal points with elements such as lines, shapes, color, and contrast. The purpose of directional emphasis is to control the movement of the eyes. You can see how directional emphasis can be created, as shown in Figure 6-15.

**FIGURE 6-15:** Note the directional elements used to lead the viewer's eyes.

TIP

Gradients and starbursts can be an effective yet subtle way to create directional emphasis in a design composition. Gradients don't have to overtly change from one color to another; you can use a tint of the same color to create directional emphasis. Likewise, starbursts don't need to have hard edges; add a Gaussian blur to starbursts and adjust your opacity to create a more subtle effect like the examples in Figure 6-16.

CHAPTER 6 The Principles of Design: Balance, Contrast, and Emphasis    141

FIGURE 6-16:
More subtle uses of directional emphasis to help draw the eye to the center of the composition.

## Repetition and pattern emphasis

Repetition and pattern emphasis involve using repeated visual elements in a design solution. Repeated elements may be colors, fonts, patterns, and shapes. An example of this would be a website with a navigation bar and footer on every page or a background pattern that appears in a magazine feature story. The key is to be consistent with how the repetition and pattern appear and to establish a rhythm that becomes familiar to the viewer.

If you've ever seen Absolut Vodka's 25-year campaign, where they repeat the iconic shape of a bottle of Absolut in virtually every scenario possible, it's a master class in the power of repetition in advertising. In fact, the campaign skyrocketed Absolut's sales from 10,000 to 4.5 million cases in just 20 years, landing it the coveted position as the top-selling vodka in the United States.

TIP

Don't sleep on repetition. Familiarity creates a sense of trust and confidence in consumers. Advertisers have known this and practiced it for years. When consumers encounter a problem that aligns with a product or service, they are more likely to recall brands they have encountered through repetitive advertising.

**IN THIS CHAPTER**

» **Identifying and using the principle of unity in design**

» **Understanding Gestalt psychology principles**

» **Learning repetition's role in design and memory**

» **Establishing rhythm in a design solution**

# Chapter **7**

# The Principles of Design: Unity, Repetition, Rhythm, and Proportion

As we continue to explore the principles of design, the next principles we are going to explore are unity, repetition, rhythm, and proportion. Each of these design principles is a guideline that can be used to inform and guide the designer's efforts in creating a design solution.

## Unity

Unity, also known as harmony, refers to the cohesiveness and consistency of all of the elements in a design composition working together to create a sense of wholeness. Unity ensures that all of the parts in a design solution work together in unison. It's not uncommon for a graphic designer to have to step back and look at the individual parts of their design and determine if all the elements in their design solution are working together in unison.

REMEMBER

The principle of unity is like driving a car. You wouldn't want to step on your brake and your gas pedal at the same time. One pedal is to go, and the other to stop. When you begin looking at your work through the lens of unity, you're making sure that none of your elements are working against your concept in a way that counteracts your goals.

Design solutions are often amorphous and evolve as a project goes on. Evaluating the unity of a design solution is often an active process rather than a specific moment in time when the graphic designer makes a good or bad decision. As the visual language for a project evolves, the visual elements often evolve, too. Unity is achieved when the designer pauses to evaluate if all of the design elements are working together and reacts accordingly. Over the next few pages, I'm going to share some ways in which you can think about unity and look for it in your own design solutions.

## Gestalt unity

Gestalt unity is derived from Gestalt psychology, which studies how people perceive and process visual information. At its core, Gestalt principles interpret visual elements as unified holes rather than a collection of individual elements. You may have heard the phrase, "The whole is greater than the sum of the parts," which some have attributed to the philosopher Aristotle. In a nutshell, this means that individual elements can work together to create something greater. If you look at Figure 7-1, what do you see?

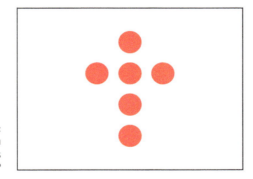

**FIGURE 7-1:** What do you see in this image?

Some people will see a cross, while others will see a kite, knife, arrow, sword, or shield; perhaps you will see something else. By any chance, did you see six red-orange dots? Don't you think it's odd that we see these other interpretations first? The way we *think* our brains work is sometimes very different then how they *actually* work and is a treasure trove of discovery for graphic designers to explore.

144   PART 2  Using the Principles of Design to Elevate Your Work

REMEMBER

We all bring our experiences to the table, and these experiences help shape our perception of this image and the world around us.

This is an example of "the whole being more than the sum of the parts" and helps us understand this concept of unity better. Clearly, the six orange dots are aligned, so there must be a reason for this alignment, thus our brains try to make sense of it. The red-orange color doesn't seem to play a role in what's being communicated, so your brain just kind of ignores this information until it seems relevant. Herein lies the power of Gestalt psychology, and if you can understand the concept, you can fold it into a design solution to achieve some really creative design solutions that play with — and challenge — the ways in which we perceive the world around us.

Following are some key Gestalt principles that you can use to achieve unity in a design solution. Many of these Gestalt principles have been illustrated in Figure 7-2. Sometimes, seeing principles at work helps make the concepts easier to understand.

- » **Proximity:** Elements that are close together are perceived as belonging to a group. The close proximity of elements implies that there is a relationship between elements. As you can see in the Proximity example in Figure 7-2, example A implies there is a group of items, and they share a relationship, and example B implies there are two groups of items and that there are differences between the two groups.

- » **Similarity:** Similarity implies that items that share visual characteristics such as shape, color, and size are viewed as being related to each other. This principle is useful for creating visual consistency and cohesiveness. As you can see in the Similarity example in Figure 7-2, example A shows how you can group items by color, example B shows that you can group items by shape, and example C shows that you can also group items by size. You can also group items by texture, dimension, orientation, and other visual cues, but some methods of grouping appear to be stronger than others.

- » **Continuity:** Continuity demonstrates that our eyes follow lines, curves, and sequential elements. Graphic designers often use this principle to guide the viewer's attention through a design solution in an intentional way. In the Continuity example in Figure 7-2, example A demonstrates that we mentally connect the lines despite the line being obscured by the orange square in front — we perceive the line as being continuous. In example B, we follow the implied line and mentally create the pathway the circles follow.

- » **Closure:** The principle of closure demonstrates that people tend to perceive a complete, closed shape even when there are gaps in the information, allowing designers to suggest shapes and images without fully defining them. It's a technique that engages the viewer's imagination.

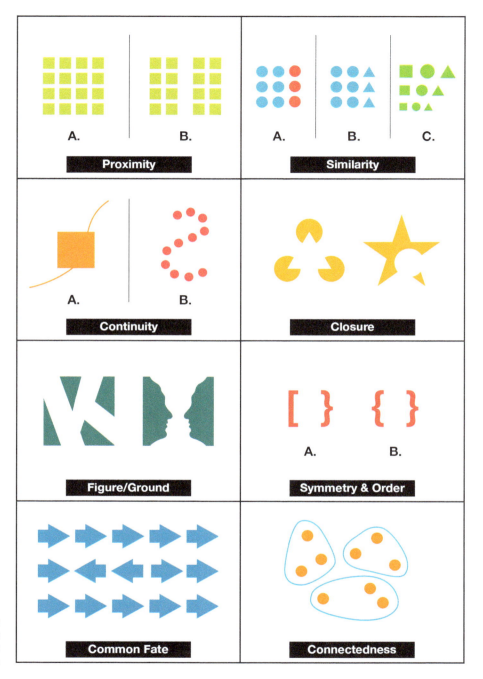

**FIGURE 7-2:** Eight examples of Gestalt psychology.

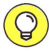
**TIP** Closure is a technique that often appears in logo design. It's a way for graphic designers to get more information into an otherwise very small space.

» **Figure/Ground:** This principle distinguishes the figure (main subject) from the background (ground) and can create a sense of stability and structure in the design solution. Figure/ground relationships can also be played with to create an effect where the viewer becomes more aware of elements in the background or the negative space in a composition. In the Figure/Ground examples in Figure 7-2, you can see how foreground and background elements have been used to make the relationship less structured and obvious.

» **Symmetry and order:** This principle states that symmetrical and well-ordered elements are perceived as harmonious and balanced and can be used to create a sense of stability and structure. In the symmetry and order example in Figure 7-2, you probably feel more at ease with example B rather than example A because of its inherent structural balance. When the brackets on the left are different than the brackets on the right, viewers tend to feel the relationship is off. Our brains tend to favor symmetrical forms and graphic designers will often create and use grid systems to evenly divide the spaces in a design solution to implement symmetry and order within a composition.

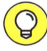
**TIP** Creating and using a grid system is a great tool to help your audience feel like the content has been prepared properly. A grid system can enhance clarity, coherence, and visual appeal through a framework of structure and organization.

» **Common fate:** Common fate demonstrates that when elements are moving in the same, or similar, direction, the motion is perceived as part of a group. We tend to perceive visual elements as moving in unison or as a group, and visuals don't need to be moving to convey motion. Visual cues like shapes and lines can help you achieve this effect. In the Common Fate example in Figure 7-2, you can see how the movement of the arrows is perceived as moving from left to right even though two of the arrows are pointed in the opposite direction. These two arrows share the common fate of the group.

» **Connectedness:** Elements that are visually connected are perceived as being more related than elements with no connection. This principle can be used to group related items together using visual cues like lines, colors, or other elements. Elements that are connected through a line or shared border are perceived as being in the same group. In the Connectedness example in Figure 7-2, you can see how the lines around the orange circles are used to override the Gestalt principle of proximity (where the location of elements dictates an implied grouping). Connectedness is useful to ensure themes are visible.

CHAPTER 7 **The Principles of Design: Unity, Repetition, Rhythm, and Proportion** 147

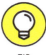

An example of connectedness that we run into frequently is a navigation menu in web design. A horizontal bar contains all the navigation links for a website, and the bar acts as a visual connector to perceptually link all of these items together.

## Visual unity

Visual unity (see Figure 7-3) refers to the cohesiveness and harmonious arrangement of elements within a composition. Visual unity ensures that all the parts work together to create a single unified piece, ensuring that a design solution is not only visually appealing but functional and effective.

Visit www.dummies.com and search for this book's title for a full-length chapter in which I walk you through designing the logo shown in Figure 7-3. You'll also find five other full-length bonus chapters there.

**FIGURE 7-3:** Visual unity in a logo.

If I were to pair my logo with my name, then I would want to choose a typeface that had some of the same visual properties as the logo to create a sense of visual unity. Take a look at the two examples in Figure 7-4 and think about which solution has the most visual unity.

**FIGURE 7-4:** Which typeface creates a stronger sense of connectiveness?

In the previous two examples, I would argue that there's more visual unity in example B. Look at the similarities between the weight of the lines in the logo and the weight of the text in this example. Do you see how there is less cohesiveness between the two in example A? Also, while small and perhaps a bit more difficult to see, notice how the logo aligns with the capline and baseline of the text. I've enlarged a portion of the logo in Figure 7-5 and used red and green guidelines to make this relationship easier for you to see.

**FIGURE 7-5:** Adhering to grid lines can help create visual unity.

A.   B.

REMEMBER

Visual unity doesn't just apply to logo design, but it can be applied to many different design solutions. Your visual elements need to work together in ways that support your concept to create a piece that speaks using a clear and cohesive visual language.

## Repetition unity

Repetition unity refers to the repeated use of visual elements to create a sense of harmony. Consistently repeating elements can help establish a visual theme and a rhythm. Think about some of your favorite brands and how they repeat their logo, a particular color palette, and typography across all of their print and digital advertising to present a unified visual brand.

Consider how a magazine might look chaotic if the designer didn't use headers and footers consistently or switched up their grid system on every page. Repetition is used to create a sense of stability and can help improve functionality, too.

In web design, think about how certain navigational elements, buttons, and icons repeat on each of the pages to create a cohesive experience for a user. Imagine if a retailer like Amazon.com decided to change their navigation system on each of their search results pages. Your experience navigating their website would be slower and prone to error.

REMEMBER

Some young designers feel they need to leave their creative mark on each and every spread of a magazine — failing to understand that they can be creative while adhering to repetition. Don't design a system only to throw it out on the very next spread. Instead try and repeat elements like divider lines, pull quotes, photographic treatments, typefaces, spacing, and other elements instead of repeatedly reinventing these elements.

## Proximity unity

Similar to the Gestalt theory, proximity unity refers to placing similar elements together to create a visual connection and infer that these elements are related to each other. By considering proximity unity, the designer helps the audience quickly understand that there's a relationship between the elements, can improve readability and organization, and can make the experience more user-friendly. See Figure 7-6.

TIP

Vary the amount of space between different groups of elements based on their relationship and importance.

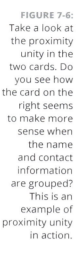

FIGURE 7-6: Take a look at the proximity unity in the two cards. Do you see how the card on the right seems to make more sense when the name and contact information are grouped? This is an example of proximity unity in action.

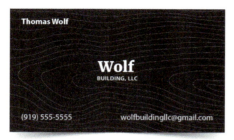

## Color unity

As you might expect, color unity refers to the harmonious use of color in a design composition. It often involves selecting a cohesive color palette and applying the colors consistently to create a unified experience.

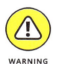

WARNING

Watch out for choosing colors that are subtle shades or tones of each other. Having enough contrast between your colors is an important consideration for creating a color palette that functions well.

## Typographic unity

Typographic unity is the consistent use of typefaces (and typographic elements) in a design solution. Typographic unity is achieved by using a limited number of typefaces (ideally one or two typefaces), establishing typographic hierarchy by manipulating the size, weight, and styles of type, and using the typographic elements cohesively.

TECHNICAL STUFF

If you are using more than one typeface, it's a good idea to select two typefaces that complement each other. You may want to consider two typefaces with a similar mood or vibe, typefaces with similar x-heights, which is the measurement from the baseline to the mean line of lowercase letters, or typefaces that have similar proportions.

Generally speaking, most graphic designers will avoid using two typefaces that are too similar (such as Helvetica and Arial) because there aren't enough visual differences between the two typefaces. You may have an easier time picking two typefaces that complement each other if you pick a serif and a sans-serif typeface or a typeface that is bold with a typeface that is a lighter weight.

## Spatial unity

Spatial unity refers to the spacing and arrangement of visual elements within a composition that creates a sense of visual cohesion. All of the visual elements should be perceived as belonging together, which is important for creating a unified whole.

Spatial unity may create a rhythm — or pace — for the design solution that the designer should pay attention to. In a magazine, for example, a viewer can get a sense of the spatial unity of the magazine on the first few pages. If the designer pays attention to spatial unity, this pacing of information is likely to continue through the entire magazine, which may contribute to creating a sense of visual cohesion. If the designer doesn't pay attention to their spatial unity, a viewer may feel that there is a disconnect between the pacing of the content.

Using a grid system as a structural framework for your content can be a way to ensure unity in a design solution. It can also help you work more quickly because you can refer to your grid system to make some spatial and other design decisions for you automatically.

## Conceptual unity

Conceptual unity allows designers to produce work that resonates with their audience. Conceptual unity is a cohesive and well-chosen idea or theme for a design solution that goes beyond aesthetics and touches on the message, purpose, and concept that ties the visual elements together.

Conceptual unity is the process of refining the story, the symbols, the metaphors, the mood, and other narrative and message-driven elements so they articulate the appropriate message that is delivered to the audience.

Imagine that you are designing an advertisement for Impossible Burgers, which is a plant-made hamburger that is a healthy meat alternative, and you had to create a color palette for the advertisement. Hot pink might not be the best color choice because it doesn't work with the concept of either a plant-made or healthy meat alternative. Choosing a color like hot pink would break the conceptual unity for many of the messages that Impossible Foods, the maker of Impossible Burgers,

wants to deliver to its audience. Impossible Foods wants its audience to know that people eat too much meat. Impossible Foods also wants its audience to reframe their ideas about what constitutes "meat" and that meat is also derived from plants as well.

A color like hot pink can feel artificial and non-organic and may not reinforce Impossible Foods' goals particularly well. The conceptual unity of your advertisement may be stronger if you chose another color to help you tell your story. A color like green would reinforce the plant aspects of the Impossible Burger but may not reinforce the meat substitute narrative quite as well. Perhaps a dark burgundy red or rich brown color might work better and support the "plant-based" and "meat substitute" concept more cohesively.

## Cultural unity

Cultural unity refers to the incorporation of cultural elements, values, and aesthetics in a design solution to create a cohesive solution that resonates with a particular culture.

WARNING

Incorporating cultural elements into a design solution is not something that you should do without first understanding and respecting the traditions, values, and background of the culture. Even then, I would want to engage with cultural experts or members of the community first.

When I taught overseas in Doha, Qatar, and Istanbul, Turkey, I collaborated with Arabic and Islamic members of the community on any projects that would be forward-facing or viewed publicly. While I was confident in my graphic design skills, I wasn't confident in my understanding of the cultural nuances and wanted to make sure my design work was received in the spirit intended. I approached working overseas as an opportunity to learn and grow, but I also wanted to show that I was respectful of both the culture and my immersive experiences.

It is inappropriate to take cultural elements and reappropriate them for your own purposes. For example, taking a symbol of the Eye of Ra from Egyptian culture or an Eagle from Native American culture and using it in ways that shift the meaning or trivialize its significance or importance is improper, unethical, and should be avoided.

Elements with cultural significance can include certain symbols, color palettes, typography, imagery, iconography, patterns, and layouts. To avoid using any of these elements incorrectly, make sure to do your research and try to understand the cultural references. You should also approach your design with respect for the

culture's values and traditions above your own needs. You should collaborate with designers and key stakeholders immersed in and knowledgeable of the culture and seek feedback from these cultural insiders to make sure your message is both accurate and appropriate.

If you make a mistake, my advice is to own up to it and apologize. Learn from your mistakes and make sure you don't repeat them again. We all make mistakes, but if you approach cultural unity with respect and humility, you will continue to grow and appreciate the differences that culture, travel, and humanity provide.

# Repetition

As its name suggests, the principle of repetition refers to the use of repeating elements to create a sense of unity, consistency, and rhythm in a design solution. While repetition is important in creating cohesion, it should also be balanced with variation to avoid creating a boring and monotonous solution. Repetition can be thought of as a drum beat for graphic design, but if you add in visual variations thoughtfully, then your composition comes alive the way a good guitar solo can elevate a song.

Over the next few pages, I discuss some criteria for thinking about how you are using repetition in your work. Remember, repetition isn't necessarily the sexy part of design but the structure on which your design solution can be built. The goal is to ensure that your elements work together cohesively throughout the entire piece.

## Shape repetition

Repeating shapes in a design solution can help tie various design elements together, making the design feel cohesive to the viewer. Often, repeating shapes creates a sense of cohesion, rhythm, and unity.

One way of integrating shape repetition into a design solution is to choose a shape that fits your design concept and aligns with your goals. Repeat the shape throughout your design solution. This can be achieved by creating a pattern or grid structure where the shape repeats and creates a rhythm and then introducing a variation to create areas of visual interest. You can create areas of interest by varying the cadence, size, or rhythm of your visual elements.

## Color repetition

Color repetition involves reusing specific colors throughout a design solution. When you create a color palette, it's sometimes easier to work with somewhere between two and five colors that work together well.

I have found it challenging to work with a large number of colors at once. Working with two to five colors is, generally speaking, a good number of colors to work with. When you work with a large color palette, there always seem to be some colors that don't work well together. By limiting your color palette, you can be more selective and may make your colors easier to manage and use cohesively in your design solution.

Don't forget that you can work with tints of color. A color palette with 4 colors can become a palette of 12 colors when you include tints of 30, 60, and 100 percent of the color. Just make sure there's enough contrast in your tinted color so that a user can distinguish your tints easily.

## Pattern repetition

Pattern repetition is when you use reoccurring patterns in a design solution to create a sense of harmony, rhythm, and consistency. Adobe Illustrator makes the pattern-making process extremely easy. As you can see in Figure 7-7, simply select the object that you want to turn into a pattern and choose Object > Repeat > Grid.

Once your pattern is created, select Object > Repeat > Choose Options to dial in your spacing and other preferences for how the pattern will repeat (in a standard grid, brick pattern, columns, mirror image, and so forth).

One of my favorite resources for downloading background patterns to use on websites is Subtle Patterns, provided by Toptal, a talent hiring agency. Toptal's background patterns can be found online at www.toptal.com/designers/subtlepatterns.

## Texture repetition

Texture repetition is the use of a texture or surface quality to create a sense of rhythm, harmony, and/or depth in a design solution. One thing I like about incorporating texture into my design solution is that it attempts to engage another sense — the sense of touch.

**FIGURE 7-7:** It's extremely easy to create a pattern in Adobe Illustrator that you can incorporate into a design solution that you can use to create pattern repetition.

Textures can be applied uniformly and consistently, repeating across the entire design, systematically using varied and different textures. Also, textures can be used more organically and less predictably, like the way different textures might be found in nature.

Textures can be used to create a sense of depth and dimension and can also be used to help establish areas of visual interest. Certain textures can help create a mood or atmosphere (such as the concrete jungle of a big urban city or using the texture of organic elements found in nature in a spa-like setting). That said, the designer may need to exercise some restraint when using texture because it's easy to go overboard and overwhelm your audience if you introduce too many textures at once.

CHAPTER 7 The Principles of Design: Unity, Repetition, Rhythm, and Proportion   155

**TIP**

I love creating typography that contains subtle levels of texture as a fill instead of always color-blocking my type. I wouldn't do this with body copy, but my display type sometimes gives me an opportunity to flex my texture muscles and add another layer to my communication.

Take a look at the two images in Figure 7-8 and see for yourself how texture might be used to create another layer of communication when added to your typography. The texture effect is subtle but one that can be used to reinforce or lean into a design concept. The type in Figure 7-8 is constant, but the texture inside the two examples has been subtly tweaked. Textures can often be subtle, but effective to include in a design solution.

**FIGURE 7-8:** Notice how texture can be used in typography to help steer the meaning of a word from an urban street hustle to a high-dollar hustle with a silk-like texture.

Sometimes, textures won't just appear once in a design solution but will make its way into other visual elements in a composition to create repetition.

## Space repetition

Space repetition involves not only the use of negative space but also the repetition of the space around visual elements to create a balanced and organized feeling. Space repetition can help establish the structure, readability, and aesthetic look of a design solution.

I often see students create a document in Adobe Illustrator or Adobe InDesign that uses too many text boxes, introducing spacing errors into the design solution like the example shown in Figure 7-9.

**TIP**

Learn to use Adobe Illustrator and Adobe InDesign's paragraph styles instead. Using too many individual text boxes often causes issues with consistent space repetition and text reflow issues.

156   PART 2  Using the Principles of Design to Elevate Your Work

FIGURE 7-9: Don't fall into the trap of using too many individual text boxes and introduce space repetition errors into your design solution. Use paragraph and character styles instead. It will help you maintain your spacing and consistency.

If you compare Figure 7-9 with Figure 7-10, you'll notice there are substantially fewer text boxes, but the design hasn't changed significantly. In fact, there are inconsistent spacing issues that were fixed through the use of paragraph styles. Paragraph styles set the attributes, like font size, color, and spacing, that determine how the text looks. Once your paragraph styles are set up, it only takes one click to apply them. In example 7-10, I created paragraph styles for the section headers, the body copy, and items that appear in bold. This allows me to create consistent spatial repetition throughout the document very quickly. In fact, it's much faster than moving individual boxes of text around.

TECHNICAL STUFF

Another reason why I encourage you to learn paragraph styles is because you can make edits to a paragraph style and the change will immediately be pushed to all of the content that has been tagged with that particular style. For example, I could change the maroon text in the section header to navy blue in the paragraph style settings, and it would immediately update all my section headers to navy blue, saving an enormous amount of time and ensuring consistency.

The repetition of space throughout a piece is invaluable to a graphic designer because it helps establish a cadence and rhythm. Our vision system is biologically tuned to spot inconsistencies in our environment, so being consistent with spacing helps our audience focus on our message rather than on any spatial inconsistencies with how we deliver it. Our ability to spot inconsistencies is what allows us to quickly recognize the differences between a snake and a stick that is laying in a path we're traveling.

CHAPTER 7 **The Principles of Design: Unity, Repetition, Rhythm, and Proportion**    157

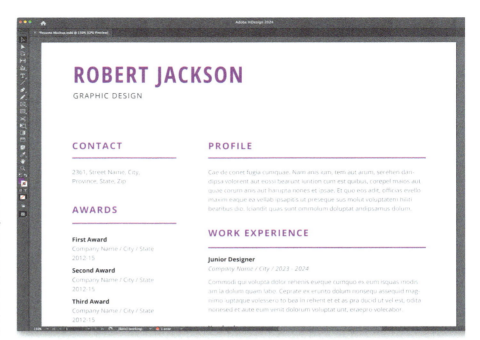

FIGURE 7-10: Reducing the number of text boxes and replacing them with paragraph and character styles is a great way to design faster and more consistently.

## Grid repetition

Grids are a structural framework composed of guidelines often used to organize content on a page or a screen. Grids provide a systematic way to arrange elements, help ensure a consistent and coherent design solution, and often help graphic designers create a balanced and aligned composition.

There are many types of grids (multicolumn grids, modular grids, baseline grinds, hierarchical grids, and so forth), but some grid systems seem to favor certain types of content, mediums, and cultures more than others, so it is part of the designer's job to choose and create the grid structure that meets the needs of the project and the audience the best.

REMEMBER

Grid systems aren't there to confine you or stifle your creative process; they are simply a tool for helping organize your content.

Grid repetition is based on the idea that a designer will use a structured grid system to organize and align visual elements consistently and repetitively. If you take a simplified 3 × 3 grid system like the example in Figure 7-11, there are 512 different ways to use this simplified grid system.

**FIGURE 7-11:** Some examples of the possible layouts for a simple 3 × 3 grid system.

What's interesting about grid repetition is that it is often used to establish a cadence or structure, making some design decisions more consistent and efficient. Adhering to an underlying structure can establish a rhythm and flow for your content and may help speed up the design process — particularly with large projects or multipage documents.

As you can see in Figure 7-11, this simple 3 × 3 grid system provides a lot of flexibility with how content can be distributed, but the underlying structure makes these solutions cohesive as a whole — the grid provides the underlying framework for where content could be placed.

TIP

If you're interested in learning about some different types of grid systems, take a look at Chapter 9.

As grid systems get more complex, the possibilities of how and where content can be placed also increase exponentially. For example, developing a grid system for an app or other user interface project ensures consistency across numerous screens and can help dictate the placement of buttons, icons, and other interface elements for consistency.

CHAPTER 7 The Principles of Design: Unity, Repetition, Rhythm, and Proportion    159

While grid repetition is valuable and provides structure for your content, breaking the rules of a grid system can be an effective strategy when done so thoughtfully and purposefully. It can emphasize key elements, create visual interest, and accommodate difficult content.

While grid systems and repetition are important, it's worth reiterating that the designer doesn't always need to "follow the rules," and there can be some compelling reasons to break away from the system if the need outweighs the consequences of doing so.

## Conceptual repetition

Conceptual repetition involves strategically repeating ideas, themes, and concepts in a design solution to reinforce messages, create emotional connections, and aid in memory recollection. Conceptual repetition is a powerful tool in graphic design because the technique is often used to drive home a main point or important message. Conceptual repetition is also a great lens for the graphic designer to implement to determine if all the visual elements are in line with the project goals.

Conceptual repetition doesn't just mean that you have to bang home the same message repeatedly and monotonously but that you repeat key elements or messages in different ways. Repetition aids memory, but monotony breeds boredom, so it's important to strike a balance.

When thinking about conceptual repetition, you might frame your investigation with some of the following points in mind:

- » **Repetition:** Repetition aids our ability to recall information. By reinforcing concepts consistently, our audience may remember key details and core concepts and retain them for longer.
- » **Theme:** Repeat the underlying theme or concept throughout your project to reinforce the message and unify the elements.
- » **Narrative:** Tell a story across the various parts of a project that reinforces the main message or goal.
- » **Emotions:** Repeat concepts or introduce elements to create a stronger emotional appeal or to evoke specific feelings or sentiments.
- » **Symbolism:** Use symbols or metaphors to create a deeper level of understanding.

# Rhythm

Rhythm is when the designer uses visual elements to create a visual tempo or pacing for a design solution. The repetition of elements such as shapes, colors, lines, texture, typography, and other elements is used to create a sense of harmony and structure. Similar to aspects of rhythm in music, patterns and sequences are often repeated to provide a framework for the instruments to syncopate with.

TIP

Breaking the rhythm of a piece can be visually jarring and off-putting. Once a viewer comprehends the rhythm of a piece, it often becomes an expectation. If you break the rhythm of a piece, do so intentionally and with a purpose in mind. Otherwise, try to stick to the rhythm that you established. Failing to do so might come off as an unintentional mistake or oversight.

Rhythm can be created by consistent use of space, repeated visual elements, repeated colors, or even a grid system. Rhythm relies on repetition and the variation of elements to create a sense of movement, harmony, pacing, and flow.

The rhythm for a piece can be dictated by the needs of the client, audience, designer, or content, the way a jazz musician might interact with other members of the band in a set. Each musician works both independently and also in collaboration with the other members of the group ideally taking time to interpret their vision for the song on their instrument but leaving time for others in the group to do so also. The rhythm of a design solution can be created with a variety of elements, but the overarching goals of the design solution must still be met. Figure 7-12 illustrates three ways to establish rhythm.

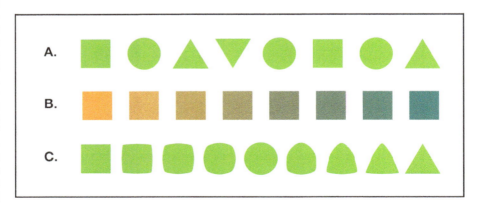

**FIGURE 7-12:** A.) Establishing rhythm through the space between visual elements. B.) Establishing rhythm through the progression of color. C.) Establishing rhythm through the progression of morphing shapes.

Just like repetition, rhythm creates opportunities to introduce variations that can prevent the design solution from becoming monotonous and create emphasis. When the user gets accustomed to a rhythm, breaking the rhythm can be unexpected and a means of capturing your audience's attention. In the immortal words of the Beastie Boys:

*I am known to do the wop*

*Also known for the Flintstone Flop*

*Tammy D gets biz on the crops*

*Beastie Boys known to let the beat*

*. . .*

*Mmm, drop!*

The pause in the lyrics for "Intergalactic" by the Beastie Boys creates a moment where the audience tunes in because the cadence is interrupted. A similar effect can be achieved visually with the design principle of rhythm and create a moment where the viewer's attention is directed to the element that breaks your visual cadence that was established with rhythm.

# Proportion and Scale

The design principles of proportion and scale are vital to graphic design because they ensure that different elements in a composition pleasingly relate to each other. Proportion and scale help create balance in a design solution so that no element overwhelms the others, contributing to a unified and cohesive solution.

## Hierarchy of scale

Scale can be an effective way to create a hierarchical organization, with the most important elements being the easiest to identify first and then move the audience's eyes through the rest of the composition in a controlled way. This principle can be used to create visual order and ensure that the most important information is noticed first.

162    PART 2  Using the Principles of Design to Elevate Your Work

Larger visual elements will typically draw more attention to smaller ones, and designers will often use size to visually emphasize some of the most important elements in a composition. By varying the sizes of different elements, a designer can create a path for the viewer's eyes to follow, guiding them through the composition. An example of the hierarchy of scale can be seen in Figure 7-13. You can see how the designer did not recognize the hierarchy of scale and created a mixed message about where the focal point is and how the user's eyes should flow through the composition.

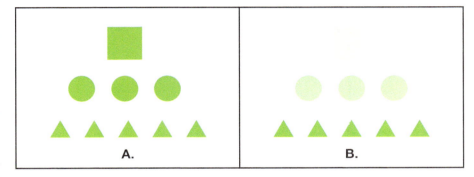

FIGURE 7-13: Hierarchy of scale is demonstrated in example A, where the largest item is typically noticed first (square), then the circles, then the triangles. In example B, the designer is sending mixed signals to the audience by introducing opacity changes that interrupt or conflict with the hierarchy of the composition.

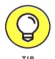

TIP

It's important to recognize the principles of design in your work and to know how the principles function so you don't end up working against them and inadvertently sending a mixed message to your audience.

## Sequential proportion

Sequential proportion is the arrangement of elements in a sequence where each element is sized proportionally in relation to the other elements in a logical

progression. The use of scale can be used to help establish a focal point and can help organize information. By prioritizing elements through the use of scale, designers can increase the audience's comprehension of the message. This way the most important messages are received first, and tertiary information is presented in a way that doesn't conflict with the hierarchy of scale and order that the information is comprehended.

# Harmonic proportion

Harmonic proportion refers to the use of rations and proportions, often based on mathematical principles, that have been observed to produce visually appealing results. Harmonic proportions can be used to do the following:

>> Create a page layout

>> Divide a composition into parts

>> Pick the type weights and sizes

>> Crop images

>> Place content

>> Determine the spacing for white space, columns, and margins

Two of the most utilized harmonic proportions are discussed in the following sections.

## Golden ratio

The golden ratio, or Fibonacci sequence, is a mathematical ratio that approximately equals 1.618:1 and is a ratio that is often found in nature. This ratio has been used in art and architecture and can be applied to compositions, typography, and spacing to create pleasing aesthetic results.

In Figure 7-14 are some examples of this proportion as seen in nature on the top row and two ways that this proportion can be used to create a grid system on the bottom row. The golden ratio is still being studied, and some believe it may suggest the presence of a universal order that underlies the structure of our world, while others dismiss its importance and relevance.

**FIGURE 7-14:** The golden ratio, or Fibonacci sequence, is observed in nature (top) and used to create two grid systems based on the 1.618:1 proportion to organize content (bottom).

*Kaz Chiba/Getty Images*   *Butterfly Hunter/Shutterstock*

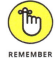

The golden ratio appears in natural objects and in some manufactured systems like art, architecture, and music. The golden ratio can be found in the *Mona Lisa* by Leonardo da Vinci, the Taj Mahal, the Parthenon, the Great Pyramid of Giza, and Beethoven's *Fifth Symphony*.

## Rule of thirds

The rule of thirds is an off-center compositional technique where important elements are placed along a 3 × 3 grid, which divides the composition into nine parts. We know that humans are naturally drawn to the center of a composition, so the rule of thirds challenges this tendency and creates an opportunity by breaking up what would otherwise be a static composition.

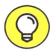

The key to using the rule of thirds is knowing when to break the rule. The rule of thirds should be considered a guideline, not a strict rule, because in some cases, following the rule of thirds can crop out important content, so be mindful of the medium and context for which your design will be viewed.

CHAPTER 7 **The Principles of Design: Unity, Repetition, Rhythm, and Proportion**    165

Implementing the rule of thirds is relatively easy. The important elements are placed at the intersecting points shown in red in Figure 7-15. In fact, the number one focal point is the intersection at the top left (41 percent), followed by the intersection on the bottom left (25 percent), and so forth.

FIGURE 7-15: The rule of thirds is a technique to avoid centering content and frame content. Designers will often place content along one of the vertical lines or at an intersection point.

Even if you don't use the rule of thirds in a composition, it's a great tool to get you thinking about how your audience's eyes will travel through your composition. When I'm cropping images or designing a website, I try to think about the composition and how close I am to the rule of thirds. If it's close, then I'll modify my image or design solution so the areas of interest hit the intersecting guidelines because I want the subject to adhere to some type of underlying structure. However, if the content doesn't lend itself to the rules of thirds, I won't try to force-fit the content.

You'll notice that when you're using the cropping tool in Adobe Photoshop, the tool displays the rule of thirds guidelines to help you crop your image. In Figure 7-16, you can see how the intersection of the top and right-hand guidelines converge to meet between the young man's eyes, and the right-hand guideline runs down the bridge of his nose, bisecting his face. Before cropping the image, I'll make sure to rotate the image to align the eyeline horizontally.

REMEMBER

Use negative space by placing the subject off-center, allowing the white space and surrounding area to enhance your composition. The rule of thirds is a great starting point, but don't be afraid to break it when the content requires you to do so.

166   PART 2  Using the Principles of Design to Elevate Your Work

**FIGURE 7-16:** Photoshop's cropping tool can be easily changed between the rule of thirds, a grid, a diagonal, a triangle, the golden ratio, and the golden spiral guidelines.

CHAPTER 7  The Principles of Design: Unity, Repetition, Rhythm, and Proportion    167

> **IN THIS CHAPTER**
>
> » Using movement to control the viewer's eyes
>
> » Organizing and prioritizing information with a hierarchy
>
> » Using alignment to ensure elements are position in relation to each other
>
> » Using white space to create visual rest

Chapter **8**

# The Principles of Design: Movement, Hierarchy, Alignment, and Space

Continuing deeper with our exploration into the principles of design, our final principles to explore are movement, hierarchy, alignment, and space. All four of these principles can be used to control how our viewer's eyes travel through a design composition.

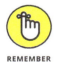
REMEMBER

When designers control how their user's eyes move through a composition, they control the order, pace, and flow of information that the audience sees.

## Movement

Movement doesn't necessarily require elements to move like what you would expect to see in an animation or website. Movement also refers to the way a viewer's eyes move through a composition, which leads to an engaging experience. Often graphic designers and artists will create a pathway in their composition so

a viewer will view a piece in a certain direction or in and out of a composition in a particular way.

A composition with no movement may appear uninteresting and static, while the addition of movement can add life, energy, and purpose to the piece, engage the viewer, and direct their attention.

There are many ways to create a composition with elements that create a sense of movement, but as you might expect, we're going to look at a couple of examples of different approaches to movement and explain the concepts at work. This approach is meant to serve as a model for your consideration as you create design solutions of your own.

## Directional movement

Directional movement refers to the technique of using visual elements to guide the viewer's eye through a composition. It can be used to help create a sense of flow and pacing and deliver a narrative to draw the viewer's attention to the most important parts of your message.

Design elements like lines and shapes can be used to direct the viewer's eyes from one area to another. Directional movement can also be achieved through hierarchy and emphasis. As designers emphasize certain elements over others, this process is a way to naturally guide the viewer's attention from larger, more prominent elements to more subordinate elements, which can also create a pathway for a viewer's eyes to follow. Color, gradients, shading, and contrast can be used to create a directional movement and lead the eye through a composition, and how you position and space objects on a composition can create a sense of movement as well. Take a look at Figure 8-1 to get a better sense of some of these tactics in action.

While all of these techniques can be effective for creating movement, one of my favorite options is using implied lines to direct the viewer's attention. To help you understand this concept a little better, have a look at Figure 8-2 and pick a number.

Figure 8-2 doesn't contain any special effects or editing, but if you picked a number, then there's a good chance that you picked number three. If you did, then there's also a good chance that I was successful in using directional movement to lead you to this choice. Take a look at how I'm holding the card and literally pointing to the number three. Of course, this technique doesn't work 100 percent of the time, and there can be numerous variables that might disrupt or override the effect, but it serves as an example of how directional movement works and how an audience might respond.

FIGURE 8-1: Examples of design elements creating directional movement.

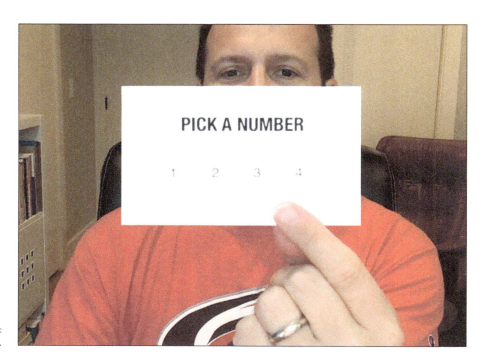

FIGURE 8-2: Pick a number.

CHAPTER 8  The Principles of Design: Movement, Hierarchy, Alignment, and Space     171

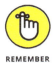

REMEMBER

Even though directional movement can lead your viewer's eye in a composition, it's not going to force your audience to make a decision that they don't want to make. Directional movement can be used to direct attention to a particular area, but it shouldn't be confused with some type of hypnosis or subliminal messaging.

## Repetition movement

Repetition movement refers to using repeated elements to create a sense of rhythm and movement within a design composition. As with other forms of movement, the purpose is to lead the viewer's eyes through a composition in a predictable way. Colors, shapes, lines, textures, and patterns can help create a rhythm, and repeating these elements can serve a directional purpose.

Some elements that can be used to create repetition movement are:

- Layering and overlapping elements
- Leading lines
- Patterns
- Progressions
- Sequences
- Textures

In Figure 8-3, you can see how the repeating patterns can be used to create a sense of horizontal or vertical movement, direct user movements, and create focal points.

FIGURE 8-3: Repetition movement to move to help move your audience's eyes.

**REMEMBER**

Movement is a crucial element in graphic design that can be used to create visual interest and guide the viewer's eye. Movement can help bring even simple design solutions to life and make them feel more engaging.

## Sequential movement

Sequential movement relies on a sequence of elements or steps in a specific order to create a sense of movement within a design composition. Sequential movement is governed by creating a controlled and logical flow.

In Figure 8-4, you can see some very simple examples of sequential movement that allow you to follow a path or progression of visual elements through each of the compositions.

FIGURE 8-4: Using sequential movement to lead the viewer's eyes through a composition in a logical way.

## Overlap movement

Overlap movement is a technique where elements are placed in a way to partially cover each other to create a sense of depth, hierarchy, and interaction between visual elements. In Figure 8-5, you can see how the batter's hands and bat break through the frame, as well as the outfielder's glove, to emphasize these elements and prepare the viewer for the implied actions that are about to take place.

The relationship between the figures and the frame is important because framing elements like the 1-point stroke in Figure 8-5 often contain a subject, but in this case, the stroke is overlapped by portions of the subject that appear to break or come out of the frame.

**FIGURE 8-5:** Overlap movement can create a sense of depth and hierarchy.

**TIP**

We see examples of overlap movement often. I'm sure you've seen text that's been placed partially over an image to help make the two elements seem more visually cohesive or shapes and graphics overlapping to create layered visuals that can add depth and visual interest.

## Implied movement

Implied movement is the visual suggestion or illusion of motion in a static composition. Implied movement is a technique to create a sense of motion and direction and can help encourage a viewer's eye to travel in a particular way.

In Figure 8-6, you can see how the lines are used to indicate speed and direction in the two figures, indicating how their bodies are moving. The man on the left is moving at a fast pace from left to right, and the woman on the right is moving in a cyclical, rhythmic motion. However, lines aren't always required to create implied movement. Other visual cues like opacity, scale, overlapping, blurring, focus, and positioning can also be used to create a sense of movement.

**FIGURE 8-6:** Implied movement can be used to suggest how a static object moves.

**REMEMBER**

Implied movement can be used to catch attention, establish a sense of urgency, lead the viewer's eyes, and create a dynamic layout that contains a sense of movement or motion. It can also be used to create, enhance, or emphasize a narrative or message.

# Hierarchy

Hierarchy is a crucial component of graphic design because it is a way to organize and prioritize information. Hierarchy allows us to guide the viewer's eyes through a composition, which is important for graphic designers to be able to control.

When you can guide your viewer's eyes through a composition, you can highlight the most important elements and ensure that they stand out and are noticed first. Hierarchy can also improve a viewer's comprehension of a piece by structuring information in a way that allows the viewer to understand and process the content more quickly.

**REMEMBER**

There are numerous ways to establish hierarchy in a design solution, and many of the design principles I've discussed offer different strategies for doing so. There's no one "right" way, but some strategies may be more successful than others on a case-by-case basis.

I believe hierarchy is the component that makes a design solution look clean and professional. If the hierarchy is unclear or muddled, the solution risks looking amateurish. Many of the critiques I have with my design students are spent discussing hierarchy. As mentioned above, there are a number of ways to implement hierarchy, but it's worth taking a moment to dive a little deeper and take a look at some visual examples of strategies you can use to create hierarchy in your own work.

## Visual weight

Visual weight refers to the perceived importance or dominance of an element. It's measured by how much attention one element receives when compared to the other elements around it. In Figure 8-7, the squares are all the same size, but the squares on the left feel more significant than their counterparts on the right. We know that we've created a hierarchy by manipulating the visual weight of the squares.

FIGURE 8-7: Hierarchy through line weight, transparency, and focus.

## Size hierarchy

The bigger you make something, the more likely it is to get noticed. As one might expect, size hierarchy has a lot to do with the scale of your visual elements. By varying the size of your elements, you can create a visual hierarchy that helps organize information and direct your viewer's eye.

TIP

Design elements can and should be adjusted by how an element is *perceived* rather than by mathematics alone. Sometimes, values and sizes that we enter can technically be correct but perceptually wrong.

Sometimes, you need to use your gut and your critical eye over mathematics. It sounds hokey, but sometimes it's the right call. Take a look at the two images in Figure 8-8. The image on the left uses mathematics, and the triangle and circle are exactly the same height. Do you notice how the circle looks smaller? That's because of its shape. Compare this to the image on the right where I made the circle bigger than the triangle to adjust for how we perceive the two shapes. Now, the two shapes look more similarly sized, don't they? When you're designing, don't let mathematics dictate your design solutions. Remember that you're designing for humans, and sometimes, you have to design for how something will be perceived — not how it's measured.

FIGURE 8-8: Look closely. In which example, A or B, do the circle and the triangle look the same size? There's a size difference between examples A and B.

176  PART 2  Using the Principles of Design to Elevate Your Work

In Figure 8-8, the circle in example B is mathematically larger than the triangle, but the two shapes are perceived as holding the same visual weight better than in example A. What we can conclude from this experiment is that sometimes, designers need to depart from mathematics and tap into how we perceive visual weight and other factors with our imperfect interpretations of what we see and how we perceive change.

That said, when designing a size hierarchy, your main images, text, or graphics should be larger to dominate the composition, and tertiary information should be made proportionally smaller. Size is a very quick way to establish your hierarchy in a composition, and most people pick up these cues quickly. Let's continue to explore some other ways to establish a hierarchy in a design composition.

## Position hierarchy

Position hierarchy refers to how you arrange and organize your elements in a design solution. For cultures that read top-to-bottom and left-to-right, visual elements that are placed in the top-left corner are typically seen first and are generally viewed as a good location for important information.

In the newspaper and web publishing world, the phrase "above the fold" means that your most important information should be located at the top of the page. Newspapers were often folded in half and placed in a newspaper box where only the top half of the newspaper could be seen, so your most important stories needed to appear above the fold to entice customers to buy their newspaper. Similarly, "above the fold" in web design refers to the idea that you should be able to see the most important information on a home page without having to scroll to see it.

Similar to the advice you might receive when choosing a home, it's all about location, location, location! Choosing the right location for your information can be a cue that certain information is more important than other information, depending on where it's placed in your composition.

Also, elements placed in the center of a layout receive more attention than elements placed in the periphery. In Figure 8-9, the concept of position hierarchy has been illustrated to help show the concept of position hierarchy.

The effective use of position hierarchy involves paying attention to how your viewer's eyes naturally move through a design solution. You can either take advantage of how their eyes naturally flow through a composition or create visual elements and use other design principles to override this effect and lead the viewer's eyes through the composition in a different way.

**FIGURE 8-9:** Where you place elements in a composition can affect hierarchy.

## Alignment hierarchy

Alignment hierarchy is the organization of visual elements based on their alignment. When I think of alignment hierarchy it's most frequently in the context of typographic alignment, but the concept can apply to other visual elements, too. In Figure 8-10, you see two examples of alignment hierarchy in action. Notice how indenting text in example A and indenting the shapes in example B help create a sense of hierarchy.

**FIGURE 8-10:** Notice how alignment creates a hierarchy with both text and images.

Even a subtle alignment shift can be used to create hierarchy and create a sense of order and organization.

## Alignment

Alignment is the arrangement of visual elements to create a cohesive, organized, and visually appealing composition. Proper alignment ensures that the elements in a composition are positioned in relation to each other consistently and contributes to the balance of the design. Alignment is important because it creates a sense of structure and order and can be used to improve aesthetics, establish relationships, and guide the viewer's eye.

Robin Williams emphasized the CRAP acronym in *The Non-Designer's Design Book* to teach about the design principles of contrast, repetition, alignment, and proximity. Understanding and following these principles is helpful in getting almost any design problem off the ground and heading in the right direction, and it speaks to the importance of alignment.

In my second year at college studying graphic design, I experienced a rather painful critique where my instructor challenged how I placed an element on the page in relation to the other elements. I didn't have a good explanation, and he asked me, "Did you just flick a booger at your monitor and decide that's where you should put it?" I was embarrassed by his comment, but the teacher drove an important concept home for me. I needed to have a reason for where I placed elements within a composition. I was spending a lot of time creating all the parts, but I didn't think about how all the parts related to each other. Aligning elements to one another creates order and structure, and I think this is part of why alignment is such an important consideration for new and seasoned designers alike.

## White space

White space — also referred to as negative space — is the empty space between and around visual elements in a design solution. White space doesn't actually need to be white; it can be any color or pattern, but it needs to be perceived as empty. Graphic designers often use white space as areas for visual rest. Also, white space can be used between an important element to create emphasis — making those areas of visual rest stand out more effectively.

Generous amounts of white space can be used to help create a sense of luxury or exclusivity, and minimalist design solutions with lots of white space are often perceived as modern or cutting-edge.

White space can also be useful in achieving balance in a design solution by helping visually balance the composition and ensuring that no part of the composition feels too heavy or dense.

## IN THIS CHAPTER

» Learning how using a grid structure can provide stability and cohesiveness

» Identifying the different elements of a grid structure

» Learning to create a baseline grid from your typographic decisions

» Creating effective page layouts with some basic principles

# Chapter 9

# Creating Grid Systems and Page Layouts

A grid is a structure to help the designer make decisions about the placement of design elements. Choosing a good grid structure can make the decision-making process easier and can make the design solution more accurate and consistent in how design elements are placed.

People scan both printed and digital documents similarly. Most people start by scanning for keywords and areas of interest and look at other information afterward. Designers can take advantage of this natural phenomenon by creating focal points or using hierarchy to make the information-gathering process more efficient and intuitive.

Your key information should be easy to find and accessible, but you should also consider the limitations and requirements of the media you are working with. For example, if you're designing a cookbook that's going to be printed in book form, you might use a modular grid system with two to four columns and generous margins. But if you're designing a cookbook that will be distributed digitally, you might want to use a 12-column responsive grid system that offers the flexibility to adapt to different screen sizes instead.

 REMEMBER

A grid system is a structure to work off of, but the structure needs to meet the needs of the content and the media. If you're using a one-size-fits-all approach to the grid system, you might want to reconsider this approach.

In order to reduce feeling frustrated by your grid system, you need to understand the needs of your content and media — to the point where your decisions about your grid system are well-informed and complement the content. For example, if I were designing a grid system for a 6 x 9-inch book, I'd want to know how the pages in the book will be bound because this information is likely to affect my grid system — specifically my inside margin. I would also want to know the target page count, and I'd want to take a look at how much written content I have to fit into this page count. In Figure 9-1, I've created a grid system for a 200-page, 6 x 9-inch perfect-bound book — a binding technique where the pages are glued together at the spine before the book cover is attached. This binding method is similar to the printed version of the book you're holding in your hands right now (unless, of course, you're reading a digital copy).

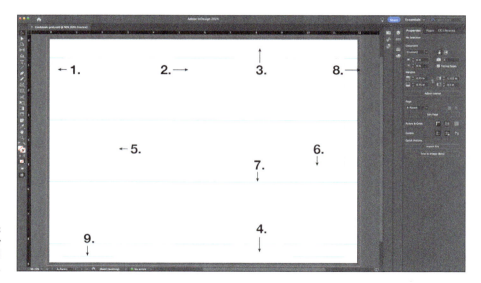

FIGURE 9-1: The anatomy of a basic grid structure.

Here are the components of the grid structure in Figure 9-1 and how they are used:

1. **Outer margin:** The outer margin helps frame the content and provides a place for the user to grip the book and not cover up the content with their thumbs. I used a 0.5-inch outer margin.

2. **Inside margin:** The inside margin is also known as the gutter. This is the area that can be affected by how the book pages are bound together. You'll notice

that when you open a perfect bound book in the center the pages curve, so you'd normally leave a little extra space in the inside margin of a book to accommodate this effect. Since the book is about 200 pages and perfect bound, I made the inside margin dimensions 1.125-inch, which is the standard 0.75-inch margin, plus an additional 0.375-inch of room to accommodate the book's perfect binding plus the curve of the pages.

3. **Top margin:** The top margin is used to help frame the content. After reading through the text for the book I decided not to add chapter information or section titles here, so my top margin is 0.75-inch.

4. **Bottom margin:** This is the margin at the bottom of the page that helps frame the content. My bottom margins are 0.75-inch, and I'm going to place my page numbers (folios) and chapter titles here.

5. **Intercolumn space:** Also known as a gutter, the intercolumn space is the space separating two columns. In Figure 9-1, I'm using 0.25-inch for my intercolumn space, which makes both of my columns 2.0625 inches wide. This column width should work well for 10- to 11-point text, but I'll have to experiment with different typefaces before I can be certain.

6. **Baseline grid:** A basic structure used to guide the placement of text and other elements on the page. I set my baseline grid to start at 0.75-inch (my top margin) and to be spaced every 12 points. I want my baseline grid to land on both my top and bottom margins. If they don't, then I'll adjust my measurements until they do. You can snap your text to the baseline through an option found in Adobe InDesign's Paragraph menu.

7. **Hangline:** A hangline is a horizontal guide to help maintain consistent placement of elements across different pages. In the grid system above, my hanglines divide the page content into thirds.

8. **Bleed lines:** Bleed lines are used when printing to ensure that artwork that goes off the page extends far enough when the paper is cut n the production process. Most of the time, a 0.125-inch bleed works fine.

9. **Page number area:** This is the area I've chosen to place my page numbers and chapter titles. Adobe InDesign has special characters that can be placed here to number your pages automatically. Simply create a textbox, choose your typeface and point size, and choose Type > Insert Special Characters > Marker > Current Page Number.

Setting up a grid system and thinking about its purpose, your content, and the media is paramount to creating a grid system that is going to expedite your design process and not frustrate you. Whether you're designing for print or digital mediums, there's a grid system that can accommodate your content, but designers should be aware that there are times when the right call is to break the grid system if there's a compelling reason to do so.

CHAPTER 9 Creating Grid Systems and Page Layouts **183**

**REMEMBER**

While grids provide structure, there are scenarios when breaking away from a grid system is the right call. Breaking the system is a decision that can be used to emphasize key elements, create visual interest, and accommodate creative freedom. If you do break your grid system, do so with a clear purpose in mind and ensure that the layout remains cohesive and readable.

## Choosing a Grid Type

A grid system isn't a formula for an effective and creative design solution, nor is it a structure that should hinder your ability to be expressive or creative. They are simply a foundation upon which a design solution is constructed.

Graphic design wasn't always linked so closely to the computer. Grid systems used to be created with rulers and T-squares with non-repro blue pencils to create grid lines that wouldn't show up in graphic arts camera film and copiers. Today, it seems that whenever you create a new file, you're often asked to specify your margins, bleeds, number of columns, and so forth. As a result, some younger designers probably don't understand how many of these decisions can and will affect their underlying grid structure and, subsequently, their design solution.

In order to address this, let's dive in and take a look at some popular grid structures to understand their purpose, how to set them up, and some ways you can use them effectively for your own purposes.

### Column grid

A column grid is a system that divides a page into columns with spaces between them known as intercolumn spaces — or gutters. Hanglines — or horizontal guidelines — can be added to act as a reference for the placement of text, images, and other media. Column grids are ideal for layouts and useful in a variety of situations when you need a system to provide a linear flow for content — usually from top to bottom.

**TIP**

A column grid system works well for layouts like magazines, books, websites, and marketing materials like brochures, catalogs, posters, and flyers.

In Figure 9-2, I used a column grid system for a three-panel brochure on 8.5 x 11-inch paper. The outside margins are 0.375 inch, which makes each panel on the brochure 3.67 inch wide by 8.5 inches tall. On each panel, there are two columns separated by a 0.25-inch intercolumn space and divided vertically with six hanglines. There is a 0.125-inch bleed line around the entire brochure.

The grid system on each panel provides a reference that a designer can use to place and align text and photographic and illustrative elements on the brochure. More importantly, this example demonstrates the flexibility of a column grid system and how it can be used to divide a page up into areas for the content to flow through and be read by the audience.

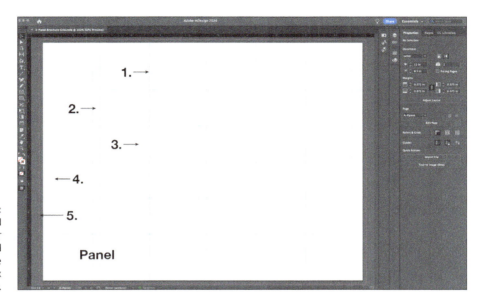

FIGURE 9-2: Column grid design for a trifold brochure on 8.5 x 11-inch paper.

1. **Panel divider:** Divides the 8.5 x 11-inch paper into thirds.
2. **Intercolumn space:** Divides each panel into two columns.
3. **Inside margin:** Defines the inside margin for each panel.
4. **Outside margin:** Defines the outside margin for each panel.
5. **Bleed line:** Defines the area where artwork that goes off the page needs to be extended.

A grid structure like this can accommodate many types of design solutions, but sometimes, seeing a system in action helps prime the pump for ideas of your own. Take a look at Figure 9-3, where I mocked up a fictitious brochure for a garden club. You'll get a sense of how I used the grid system to help place my content and how I'm using the grid to structure information. Now that my system is in place I can use the elements of design to create areas of emphasis to direct the viewer's eyes to the most important content on the panels.

CHAPTER 9 Creating Grid Systems and Page Layouts    185

**TIP**

When you design a brochure, you need to think about how the brochure will be folded in order to put the right information on the right panel. A *tri-fold* is the most common type of brochure fold, and the panels are folded inward, so the right panel is tucked inside the left. A *z-fold* is folded so that each panel folds in the opposite direction, creating a "Z" shape.

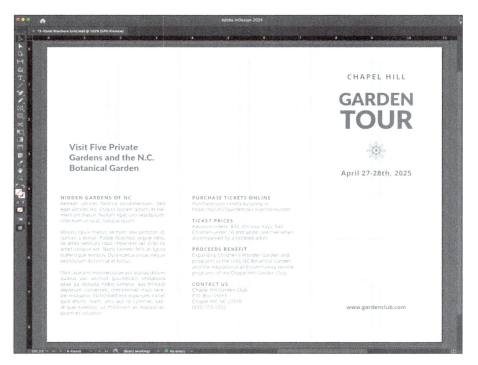

**FIGURE 9-3:** A quick mockup of a 3-panel brochure to explore the pacing and structure of information. The gray boxes and circle are meant to be replaced with photographs and illustrations as the design process unfolds.

## Modular grid

A modular grid is a framework for dividing a composition up into uniform cells, or modules, that are created by the intersecting vertical and horizontal likes. This type of grid structure helps designers organize content consistently and flexibly. Modular grids are known for being highly adaptable and allow for a variety of content to be placed within the grid. Modules — or the individual cells — can be combined to form larger areas for content or used individually to guide in placing smaller elements.

**TIP**

Modular grids are widely used in responsive web design to create layouts that adapt to different screen sizes and devices. They can also be used in complex print design layouts such as magazines and annual reports where the content needs to be organized cohesively.

In Figure 9-4, I created a modular grid system for an 18 x 24-inch poster. Each module is 1.1875 x 1.2159 inches with a 0.25-inch intercolumn spacing around each module. There is a 0.5-inch margin around the outside of the composition with a 0.125-inch bleed line for elements that bleed off the composition.

Shown on the left-hand side, you can see how I placed my visual elements using the modular grid system. On the right side, you can see how I placed visuals of Albert Einstein and the cosmos using radial balance with a description and call to action on the bottom-right side of the page.

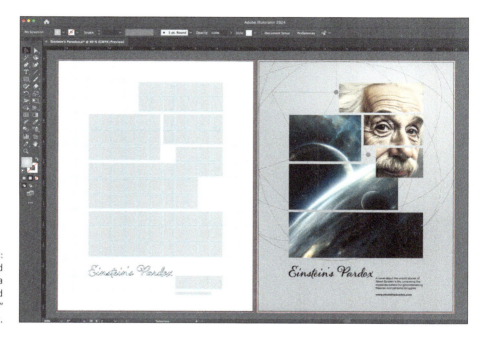

FIGURE 9-4: A modular grid structure for a poster printed on 18" x 24" paper.

TIP

When using a modular grid structure, stick to your grid. Don't abandon your grid too quickly, but look for ways to use it to create spacing and alignment consistency.

## Hierarchical grid

A hierarchical grid is a system that organizes elements to emphasize their importance and relationship with each other. Many other grid systems have a uniform structure, but a hierarchical grid adapts to the content rather than the content adapting to the grid. It can be a difficult system to work with, but it can be effective in complex visual storytelling.

The columns in a hierarchical grid can have different widths, asymmetrical layouts, and adaptive structures, which help emphasize certain elements over others. They can also be useful in magazine and editorial design, where the structure can lead a reader through the content naturally. In a hierarchical grid, the most important information is given the greatest space, and less important information is given less space. In Figure 9-5, you can see what content is the most important on a web page grid system just by observing the space allocated for the different types of content.

FIGURE 9-5: Hierarchical grid systems adapt to the content and are used most frequently in web design and publication design. Notice how space affects the hierarchy of the structure.

REMEMBER

Hierarchical grid systems can be complex and require a good understanding of visual hierarchy. They can also be inconsistent if not used properly, so they aren't always the most time-efficient grid system; however, they can complement some types of content quite well, so there's an inherent creativity versus usability balance to strike when using hierarchical grid systems.

## Baseline grid

A baseline grid is a tool used to align text and other elements across columns and modules in any grid system. A baseline grid is a series of horizontal lines that run across a page and are usually spaced to complement the typographic spacing of the text and create consistent spacing and a structured appearance.

When I set up a baseline grid system, I begin by choosing a typeface and filling an entire column of text with placeholder text. (In InDesign, you can get to this by drawing out your text box, choosing Type, and selecting Fill with Placeholder text.) Placeholder text is dummy text to give a designer a sense of how their text will look after adjusting the typeface, size, and spacing; see example A in Figure 9-6. Make sure your column of text goes all the way from the top margin to the bottom margin. Once you're happy with your type, print it and double-check how it looks off the screen, as shown in example B in Figure 9-6. Count the number of lines of type from your top margin to your bottom margin; see example C in Figure 9-6.

FIGURE 9-6:
A quick way to set up a baseline grid system.

Now draw a rectangle box from your top margin all the way to your bottom margin (see example D) and divide the height of the rectangle by the total lines of type you counted in example C. This will give you a short rectangle; copy the rectangle's height (see example E). Finally, in InDesign, choose Preferences > Grids and paste this number into the Increment Every field, as shown in example F. While you have this window open, make sure the measurement in the Start field is the

CHAPTER 9 Creating Grid Systems and Page Layouts    189

same as your top margin. Congratulations, you've set up a baseline grid. All you have to do is select View > Grids & Guides > Show Baseline Grid.

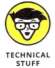
TECHNICAL STUFF

Your baseline grid will disappear if your page is zoomed out too far, so make sure you are zoomed in to at least 75 percent.

In order to snap your text to the baseline grid, you need to select your text and click the Align to Baseline Grid button in the Paragraph window, as shown in Figure 9-7.

FIGURE 9-7: To align text to a baseline grid, highlight the text and then click "Align to baseline grid" in the Paragraph menu.

## Responsive grid

A responsive grid system is a flexible grid system that is designed to work well on various screen sizes. The primary goal of this type of grid system is to ensure that content is readable across different sized devices. This is usually done by creating breakpoints — predefined screen widths at which the layout changes. Some common breakpoints are mobile phones, tablets, laptops, and desktop computer screen sizes.

TECHNICAL STUFF

Responsive grid systems often depend on the use of media queries. A media query is a snippet of CSS code that applies styles based on the width, height, and orientation of a device's screen.

Take a look at Figure 9-8 and see how a headline and paragraph of text might react to two different screen widths. In the mobile phone, on the left, the designer would probably want to use all 12 columns of space to display the text. Mobile phones have narrow screens, so it may be a good idea to use all the horizontal space available. Compare this to the tablet on the right, where the screen has more horizontal space. The headline and text may not need to span all 12 columns, so the designer has specified in their media query that this content should only span 8 columns instead of all 12.

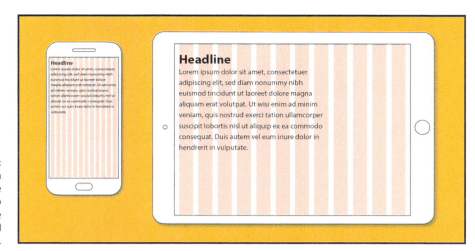

**FIGURE 9-8:**
A 12-column responsive grid applied to both a mobile phone and tablet.

REMEMBER

You never know what type of screen someone will use to look at your content. Whether they use the screen in their Tesla or the screen on their old mobile device, there is an infinite number of screen sizes. Responsive grid systems can be used to accommodate almost every screen size.

In Figure 9-8, a 12-column grid structure is used on both screens, but the size of these columns changes to fit the screen dimensions and provides the designer with an opportunity to create layouts that can adapt to a variety of screen sizes. Instead of using fixed units of measurement, like pixels, using column widths instead provides the designer with a more flexible way to scale content for a variety of screen sizes.

In Figure 9-8, you may have noticed that the font sizes in the mobile phone and tablet are different. This was also done by using a media query so the graphic designer could design a better experience for a user. The typical reading distance for a mobile phone is 10 to 12 inches away, while the reading distance for a tablet device is 12 to 14 inches away. Because tablets are typically held farther away from the face, it makes sense that the font size would be increased to make reading easier for the user.

TIP

When using a responsive grid system, don't forget that images and other digital media should be responsive, too!

CHAPTER 9 **Creating Grid Systems and Page Layouts**   191

# Working with Page Layout

When creating a page layout, you will want to begin by choosing the most appropriate type of grid structure and then use this structure to align, visually balance, and emphasize particular elements. You will need to create a hierarchy, utilize white space effectively, implement a typographic hierarchy, and be consistent with how you treat different types of design elements.

There are a variety of strategies you can use to create better page layouts, so I'm going to break this decision-making process down into bite-sized chunks to understand how these decisions might affect your page layout design strategies.

## Consider your content

Before you begin designing a layout, stop to think about the content that you'll be working with. How much text do you have? Will you need to include illustrations, images, infographics, or other media like videos, slideshows, or other files?

It can be helpful to create a list of the items that need to fit into the available space. On the heels of this decision, the next step is to determine the importance of your content to help you establish your visual hierarchy.

There are times when a photograph can lend more toward the communication than a paragraph of text (and vice versa). Be sure to build your layout and visual hierarchy around your strongest, most important pieces of information.

If you have amazing copy, lean into highlighting the text. If you have amazing photographs, lean into a page layout where your images are prioritized. If all of your elements are equally important, aim for a layout where elements can take turns and complement each other to lead the viewer through the content in an impactful way using the principles of design.

One of the most agonizing positions to find yourself in is one where you are surprised by your content because you haven't read the text or looked at the images, illustrations, and graphics to understand their importance before you've begun designing the composition. It's a bit like painting yourself into a corner where you can't escape, so understanding what content you have and its importance is a good first step in creating an effective page layout.

## Establish your layout hierarchy

Now that you know what information you need to include and an understanding of their importance it's time to establish hierarchy in your layout.

Ask yourself where you want your viewers' eyes to land. Is it on a photo, a headline, a quote, or a graphic? The viewers' eyes need to land somewhere at first and then move around the page to take in the various parts of the composition. A subsequent question is where you want the viewers' eyes to exit your composition.

With this information in mind, we can begin to put together a couple of quick sketches on how we might tackle laying out our content. In Figure 9-9, you'll see two quick sketches of a layout for a type-heavy solution and a layout for an image-heavy solution. Quick sketches like this can help you organize your thoughts, experiment with how you might order, and prioritize your content. Filling a page with some loose sketches takes little time but can help you out tremendously with planning your composition.

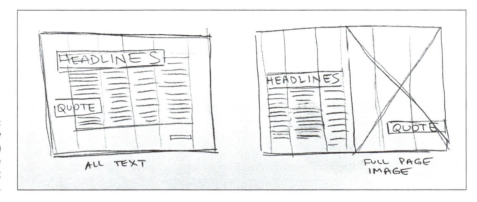

FIGURE 9-9: Type heavy layout (left) and image heavy layout (right).

This is the point in time where you'll want to implement the principles of design to create a composition with balance, contrast, emphasis, unity, repetition, rhythm, proportion, movement, alignment, and white space to emphasize certain elements, provide structure, consistency, and hierarchy, and guide the viewer's eyes through your composition.

REMEMBER

You can use scale, color, contrast, white space, alignment, and other techniques to create a hierarchy and help your users' eyes land and depart from certain areas in your layout.

If you're feeling stuck creating a hierarchy in a layout, all you have to do is simply look around to find examples of how other designers have tackled similar problems by deconstructing their design solutions (see Figure 9-10). You can learn a lot by simply taking the time to observe and understand what we see and often take for granted. This isn't an effort to copy the work but to observe and understand the strategies they used to create a compelling composition with the hopes that this information will prime your own creative endeavors. Take a trip to your favorite bookstore and pay attention to some of the layouts that are on display right in front of you.

CHAPTER 9 **Creating Grid Systems and Page Layouts** 193

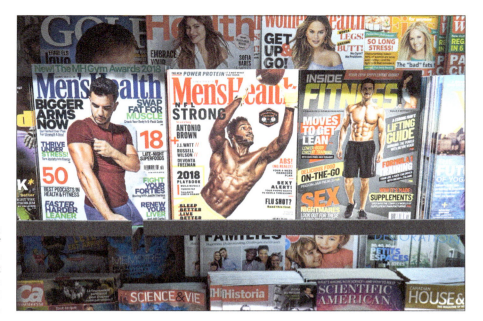

**FIGURE 9-10:** Examples of layouts you can deconstruct and learn from are all around you.

## Set margins, gutters, bleeds, and trim lines

As discussed earlier in this chapter, margins, gutters, bleed, and trim lines are aspects of layout design that need to be understood and planned. Knowing what these four guidelines are for is a critical step in ensuring the final product matches the graphic designer's intentions in how the piece will be printed and bound.

Margins are used to provide visual space around your content and contribute to the white space on the page that is crucial for the readability, visual rest, and aesthetics of your layout. Margins are often used to define the safe area in which important content should be placed to make sure it doesn't get cut off or cropped during the printing or binding process.

REMEMBER

Always consider your medium when you set your margins. Printed design solutions may need more margins than digital design solutions to account for the printing, trimming, and binding process. Digital design solutions may have smaller margins due to limited screen size constraints.

Gutters, or intercolumn spaces, are the areas between columns so your content in one column does not run into the content in another column. Having ample gutter space can help improve readability and consistency in multi-page layouts.

194   PART 2 Using the Principles of Design to Elevate Your Work

Bleed lines are used to prevent white edges from appearing in printed documents. By extending elements outside the trim line, minor inaccuracies when printing and binding documents can be hidden and made less noticeable.

Trim lines indicate where the printed piece will be cut to its final dimensions. Trim lines work with bleed lines to make sure that any minor inaccuracies in the printing process are less obvious.

## Group related elements

Grouping related items might sound simple — and indeed it is — but I see young designers make this mistake repeatedly. To be fair, grouping related items can be a bit of a moving target, but a good strategy is to make decisions based on the needs of your audience. When you're designing your page layouts, make sure to group related items to make finding and using this information easier for your audience.

For example, you might group the following kinds of items:

- » Items that share a similar function or purpose (such as paying for items in your cart on a website)
- » Related items that are categorized by type (such as trips you can take for under $1,000 in a magazine sidebar)
- » Items with a similar frequency of use (such as placing all the ways your client can be contacted or followed on social media in one area on their website)

So, how do you choose how to group related items? You anticipate how your audience is likely to look for and use this information and make the process as intuitive and painless as possible.

TIP

Don't let your design ego get in the way of making a decision that improves the functionality of a design solution. When I was a young designer, I mistakenly thought that my aesthetics were more important than the functionality of my solutions. Now, I view this as more of a balancing act between form and function.

## Be consistent

When I was learning about graphic design in college, I disliked receiving critique feedback about my lack of consistency. I'd start out with a grid system and then choose a typeface to work with; however, before the project was over, I would

abandon my grid system and introduce new typefaces. To me, I always wanted to work expressively and intuitively, and I felt handcuffed by my teacher's feedback to work more consistently. If I was working on a magazine, every blank spread felt like an opportunity to flex my design muscles. But the lesson I needed to learn was that working consistently establishes a rhythm and a pace so that when you strategically break the rules, it creates a significant amount of emphasis that can be surprising and engaging.

Think about consistency this way: In Figure 9-11, you see an image of fireworks over Brooklyn, New York. When it gets dark and fireworks begin, they don't light off all their fireworks at once. Instead, they establish a pace, and you hear the rocket launch, a loud bang, and then you see the fireworks light up the sky. The show continues, and new types of fireworks are introduced. Some fireworks go off with loud bangs and sizzles, and others whistle loudly and burst into green streaks.

FIGURE 9-11:
Consistency is an element that can be used to create emphasis.

Randy Duchaine/Alamy Stock Photo

The fireworks show continues, and the pace and number of explosions build, and you witness a dazzling display of light and sound. As time goes by, you can see, hear, and smell the intensity of the moment — and then it stops. Is it over? How long has it been? You aren't sure. You strain your ears, listening for the whistle of a rocket.

The pace of the fireworks has been broken, and your full attention is on this moment. Right before you think about getting up, you hear it — the screaming whistle of a rocket, and then all hell is unleashed. The sky is filled with explosions and smoke trails until there are no more rockets to fire. You think to yourself, "That was awesome!" You look over at your kid whose mouth is open, and their eyes still fixated on the sky clutching their stuffed teddy bear, and they whisper, "Whoa!"

Take a moment to think about the choreography and pacing that went into the fireworks display you just saw. That pause where nobody was sure if the show was over was a setup for the grand finale was an important moment in time. That's the moment when the pyrotechnician broke their system in order to engage your senses and focus your attention before kicking off the grand finale.

Well, it took me a long time to learn that consistency with your design decisions can set you up for a memorable and impactful grand finale. Your consistency creates a moment when you break free of the cadence to drive home a point in a way that your audience will remember for some time. Your consistency sets expectations and structure, but it also provides an opportunity for greater impact when — and if — you decide to strategically break the rules to create emphasis.

Don't be too quick to abandon the consistency of your page layouts. There are ways to follow the rules of your system to avoid boring repetition, but make sure you don't reinvent the rules as you go along. If you break the rules, make sure you have a purpose for doing so.

In my younger years, when I was breaking the rules on every page, I didn't realize that these micro-decisions were completely forgettable. Nobody was going to remember what I interpreted as design flexes. They had virtually no impact and were, in fact, counterproductive to my greater purpose. If I could go back in time, I'd tell myself to hold my powder until I reached a point in time where breaking the rules of the system had the greatest impact and reinforced my message.

I often see young designers make a lot of arbitrary decisions — I did it, too! If you're about to change the size of your body copy and make it bigger so you can fill up the entire sidebar on your résumé, don't do it! It's okay to have a sidebar that doesn't fill the entire space, and if you don't like how it looks, get busy and add some additional items to your résumé or write more about the jobs you've held. Don't arbitrarily increase your font size as a means of filling space unless you're willing to increase the font size in your entire document.

CHAPTER 9 **Creating Grid Systems and Page Layouts** 197

## Align elements consistently

If you want to create a good page layout, you simply have to pay attention to how you align your design elements on the page. Referencing and using your grid system is a great way to establish consistency, and aligning elements with other elements on the page is a tried-and-true approach to creating a page layout that leads the viewer's eye through the page, creating balance for aesthetic appeal. When a designer pays attention to how the elements in their design solution are aligned with each other, the solution seems to have more gravitas, thoughtfulness, and trustworthiness.

REMEMBER

I often run into situations where a young designer has used flush left, centered, and flush right text on the same page, and I scratch my head over this design decision. There rarely seems to be a reason for switching their text alignment beyond "I thought this looked better." What this tells me is that the designer isn't thinking about consistency or how their audience will consume their content as much as they are thinking about aesthetics.

A good rule of thumb in graphic design is that if two elements are kind of aligned, go ahead and align them fully; failing to do so can look like a mistake. When design solutions look like they contain mistakes, we tend to trust the messages they communicate less. Consistency is a critical component to consider when designing your page layouts.

## Incorporate white space

If there's one thing I want to tell you about white space, it's not to forget to use white space! Adding white space to your page layout can make a huge difference. Take a look at the two documents in Figure 9-12 — one document uses little white space, while the other has more white space.

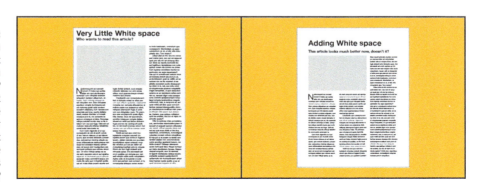

FIGURE 9-12:
Which document would you rather read? The document with very little white space or the document where white space has been added?

Most people would choose to read the document that has more white space included in it because the content doesn't seem as dense and the task of reading the content can seem more approachable.

If you're not sure how to add white space to your page layout, here is a list of ideas where you can add some visual rest to your page design:

- » **Margins and padding:** You can increase your margins around the edges of your document and increase the padding around images, graphics, and text to increase the white space in a page layout.

- » **Leading:** You can adjust the leading, or line spacing, in your text to make your text easier to read and to reduce visual tension.

- » **Paragraph spacing:** Instead of indentations to denote a new paragraph, you can add space between your paragraphs to add small areas of visual rest.

- » **Gutters or intercolumn spacing:** You can increase the space between columns in multi-column layouts.

- » **Breaking up content:** You can use headings, subheadings, and bullets to break up text and introduce areas of white space.

- » **Using larger elements:** Larger images or graphics can help introduce white space into a page layout.

- » **Leaving areas blank:** Avoid trying to fill a layout completely and intentionally leave blank areas of space to introduce areas for visual rest.

REMEMBER

white space can help focus your audience's attention, create a sense of calm and order, and enhance your overall aesthetics. If your page layout seems a little too intense, then add white space to your layout to break up the feeling of intensity and introduce areas for visual rest.

**IN THIS CHAPTER**

» Exploring color psychology

» Strategies for choosing color palettes

» Designing for audiences with visual color deficiencies

# Chapter **10**

# Constructing Color Systems

We haven't talked much about color yet, so this chapter is to help you create color systems for a variety of needs. Before you begin, you should know that we all see color a little differently, so your color preferences aren't likely to be shared by everyone. Additionally, culture can play a role in shaping people's perceptions of color because color preferences can be linked to culture and customs.

With this in mind, can you build a functional color system? And aren't colors used to convey meaning? The short answer is yes. I'm going to discuss color so you can learn to put a variety of color systems together, and I'll also talk about how color can be used to convey meaning. Let's jump in and get started!

## Defining the Brand Personality

When you start a new project where you're going to be making some color decisions, take a few moments to reflect on your needs. Think about how *abundant* color will be in your project and how *important* color will be in your final project. You don't have to use a lot of color for it to play an important role in a design solution, and if you create a piece with an abundance of color, then you'll probably need to test how a collection of colors in a color palette works together as a group.

CHAPTER 10 Constructing Color Systems **201**

REMEMBER

It's unlikely that you'll nail your color palette right out of the gate. For me, this process often involves a try-it-and-see approach to picking colors. For instance, I know I want to use a blue, but I'll play with and test various blues as I work on the project until I find a blue that I feel confident using. For me, choosing colors is a bit of a process rather than making a snap decision.

In some instances, your color palettes will be chosen for you. If I were working with the now-retired Dunkin' Donuts logo, I would need to use the color palette shown in Figure 10-1. When you encounter a situation like this, it's important to use the brand's exact colors, so you'll want to use the color codes for RGB, CMYK, or Hex, depending on what medium you're designing for. RGB colors are typically used for digital screens, CMYK is used for printing, and Hex colors are used on the web. Referencing color codes can help ensure brand continuity no matter the medium you are working in.

FIGURE 10-1:
Color codes can be helpful for matching colors in various mediums.

You might think that all brands have a pretty elaborate color system in place, but some brands that are color don't always appear in a particular color. This means they can adapt their logo to fit different contexts, campaigns, and cultural settings. One example of this is Nike By You, which is an extension of Nike that allows customers to personalize their Nike merchandise. Nike By You allows the customer to become the designer, customizing the colors, patterns, and materials. The Nike logo is still an important visual element on the shoe, but the customer has a variety of options to customize the logo rather than being forced to accept a particular color that might detract from their colorway — or color scheme for the customized shoes.

Typically, color systems for brands are known for being less flexible, which is why Nike's color flexibility is noteworthy. Humans recognize color more quickly than many other embellishments like patterns, shapes, or textures, which involve

more complex processing and take longer. Color, however, is perceived almost instantaneously thanks to specialized cells in our eyes that are sensitive to different wavelengths of light.

Rapidly recognizing color has evolutionary benefits, such as distinguishing between poisonous and non-poisonous animals or detecting emotional cues like blushing in others.

There will be numerous times in your career when you won't have to use a predetermined color system, meaning you can create a color system from scratch, which can be a lot of fun. In order to prepare you, let's talk about some tools and strategies you can use to start building color systems from scratch and set you up for success.

# Exploring Color Psychology

Before we begin exploring color psychology there are a couple of caveats we need to discuss. First, it's important to remember that the meanings of colors aren't fixed. Red doesn't inherently mean "love" or "passion," but over time, the color has been associated with this interpretation in Western culture.

Culture can play a big role in how we extrapolate the meaning of certain colors. One example of this is the color white. In Western cultures, white is typically associated with purity, innocence, and peace, while in Eastern cultures, white often symbolizes mourning and death.

There are both *positive* and *negative associations* for many colors. So, while red can symbolize passion, love, power, and strength, it is also associated with anger and frustration. White can symbolize purity, innocence, and cleanliness, but it can also symbolize emptiness or loneliness. So, how do you choose a color like red and steer it toward love and away from anger? The answer is simple: You'll need to begin by choosing a red that taps into our connotations of love and then use other design elements to help build context for how you want your audience to interpret the color. See Figure 10-2 and look at how combining the color red with an expressive typeface might help your audience dial into your intended meaning.

In Figure 10-2, I chose the word "desire" because both love and anger have some connection to this word. Desire is a strong feeling that can result in both loving actions and angry responses, so the meaning of the word doesn't reveal much about my message.

**FIGURE 10-2:** The color red can be used for love as well as anger. Take a look at how two simple context clues help steer the audience toward my intended meaning.

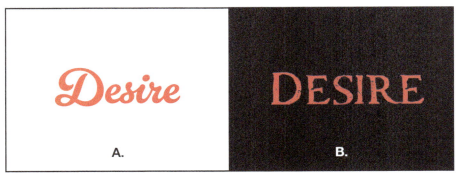

However, the biggest context clues are in the typefaces I've chosen. In example A, I've selected a script, humanistic typeface that is curvy and sensual, which pushes the meaning toward love and intimacy. In example B, I've selected a serif typeface that appears in all caps, is inconsistently spaced, and has texture in the type that gives the impression of being well-worn or previously used. The tail of the R is sharp, feels a bit dangerous, and helps me push the meaning toward instability, danger, and unpredictability. In addition, I've placed the text on a black background to help make the composition more ominous.

To remind ourselves once again of the point of this exercise, the meaning of colors can be manipulated and pushed in various directions depending on the context that other design elements provide. Table 10-1 is a list of positive and negative connotations that certain colors can evoke.

**TABLE 10-1    Positive and Negative Connotations Colors Can Make**

| Color | Positive Connotations | Negative Connotations |
|---|---|---|
| Red | Passion, love, excitement, energy, courage, power | Anger, danger, aggression, warning, violence |
| Orange | Enthusiasm, happiness, creativity, success, stimulation | Frivolity, insincerity, loudness, overwhelming |
| Yellow | Happiness, optimism, intellect, energy, sunshine | Cowardice, deceit, caution, anxiety, frustration |
| Green | Nature, growth, freshness, harmony, safety, fertility | Jealousy, envy, inexperience, sickness, greed |
| Blue | Calm, trust, loyalty, serenity, wisdom, confidence | Sadness, coldness, aloofness, melancholy |
| Indigo | Intuition, perception, wisdom, spirituality, integrity | Depression, fear, isolation |
| Purple | Royalty, luxury, mystery, ambition, creativity | Arrogance, mourning, sensitivity, moodiness |

| Color | Positive Connotations | Negative Connotations |
|---|---|---|
| Brown | Stability, reliability, comfort, earthiness, warmth, simplicity | Dullness, conservatism, heaviness, lack of sophistication |
| Pink | Love, kindness, femininity, innocence, playfulness, romance | Weakness, naivety, inhibition, over-sensitivity |
| White | Purity, innocence, cleanliness, simplicity, peace, freshness | Emptiness, sterility, coldness, isolation, loneliness |
| Gray | Neutrality, balance, sophistication, calmness, practicality | Boredom, indecisiveness, lifelessness, dullness, ambiguity |
| Black | Power, elegance, sophistication, formality, mystery, authority | Death, mourning, evil, fear, sadness, oppression |

## Color hierarchy

Color hierarchy is used to prioritize colors within a design solution. Once again, this is a technique that can be used to guide the viewer's eyes through a composition and create visual interest or emphasis.

Color can be used to help control where a viewer looks first and what they notice next. When you begin picking colors, think about the colors in your industry and any specific goals you might have identified.

Primary colors are the most dominant colors used to grab attention, and they are often used to highlight the most important elements in a composition, while secondary colors are often used to highlight supporting or secondary information. Usually, a company will choose between one and three primary colors and use them as elements to help drive branding. Often, primary colors will be used in important branding elements like a company logo.

The goal of secondary colors is to provide contrast, but these colors should not overpower or disrupt the hierarchy established through your primary colors. Typically, there are somewhere between 1-6 secondary colors, and while you can have numerous secondary colors, a limited color palette can help with customer recognition and consistency.

Tertiary colors, or accent colors, are the least dominant colors and are often used for background elements or to provide accents of colors. Tertiary colors should not disrupt the hierarchy established through the use of primary or secondary colors. Tertiary colors are often used for elements like backgrounds in sidebars, charts, and graphs.

# Color Contrast

Swiss artist Johannes Itten wrote in his book, *The Elements of Color*, that there are seven categories of color contrast, which he defined as shown below:

- » **Contrast of light and dark:** The lightness or darkness of a color refers to the differences in brightness between colors. Light colors are closer to white on the brightness scale, while dark colors are closer to black.

- » **Contrast of cool and warm:** The contrast of cool and warm colors refers to the differences between colors that are perceived as cool (such as blue, green, and purple) with colors that are perceived as warm (such as red, orange, and yellow). Cool colors perceptually seem to recede into the background, while warm colors appear to advance into the foreground.

- » **Complementary contrast:** Complementary contrast refers to the impact and vibration of colors that are directly opposite of each other on the color wheel. Colors that are opposites on the color wheel have a high level of contrast because they are so different from each other. When two complementary colors are placed together, they make the other colors appear more vibrant and intense.

- » **Simultaneous color contrast:** Simultaneous color contrast refers to the way that colors can affect each other when they are placed side by side. Showing the two colors next to each other can affect how we perceive their hue, brightness, or saturation — making the colors look different than if we viewed each color on its own.

- » **Contrast of extension:** Contrast of extension refers to the *proportion* of colors used in a composition. A dominant color might occupy the largest area in a composition, and subordinate colors might occupy smaller areas and provide accents to the dominant color.

- » **Contrast of saturation:** Contrast of saturation refers to the intensity, or purity, of colors in a composition. Highly saturated colors are bright, vivid, and pure colors and draw a lot of attention, while low-saturated colors are muted, dull, or grayish versions of colors that are less intense.

- » **Contrast of hue:** Contrast of hue simply refers to the differences between colors on the color wheel. These colors are on opposite sides of the color wheel and have broader differences but are not necessarily complementary colors. They are, however, distinct in hue and create a noticeable contrast.

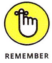

Why is color contrast important? Because contrast in one of the principles of design and helps guide the viewer's eyes through a composition and can be used to create areas for emphasis. Color contrast provides several different approaches to achieving this effect.

# Choosing Primary Colors

There are many strategies for choosing colors for brands and companies. As a graphic designer, you can choose to *reflect* the colors that are often found in certain professions, or you can choose colors that *disrupt or challenge* the status quo and stand out in a unique or non-traditional way.

Take a look at three color profiles built around professions in Figure 10-3. Do you notice how they seem to oddly match our preconceived notions for these types of businesses? You have a choice to either take advantage of these preconceived notions and lean into them or to challenge these notions and reinvent them to stand out from the crowd.

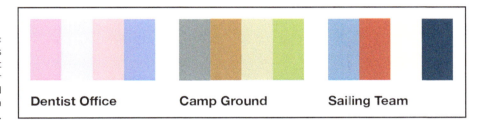

FIGURE 10-3: Color systems that might tap into our preconceived notions of a company.

TIP

If you aren't sure whether to tap into an existing color system or challenge an existing color system, talk to your client about their goals and make sure you're on the same page.

Another strategy is to research a color combination based on a theme like modern, bold, vintage, or sophisticated color profiles, like the examples shown in Figure 10-4. There are a number of online color palette generators like Coolors (https://coolors.co), Colormind (http://colormind.io), and Adobe Color (https://color.adobe.com) that you can use to explore color palettes, create accessible themes for audiences with visual disabilities, or look at trending color combinations that get voted on by members of the community.

Finally, there are also several apps that you can use to extrapolate color palettes from photographs and images that you take on your mobile device, like in Figure 10-5. I simply uploaded to Adobe Color a photo I took on vacation and chose the color mode I wanted Adobe Color to capture (such as colorful, bright, muted, deep, dark, or none). Then, I could name and export the color palette to all my Adobe applications with a click of a button.

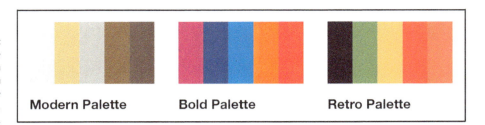

**FIGURE 10-4:** Color palette built from examining a theme like modern, bold, or retro.

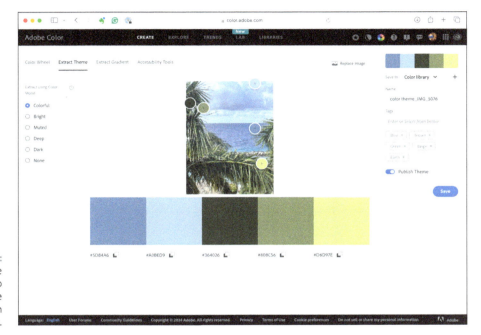

**FIGURE 10-5:** Using Adobe Color to extrapolate colors from an image.

TIP

Adobe Color can be a great way to get outside for a springtime walk in a flower garden, by the pool in the heat of summer, on a hike on a crisp autumn day, or after the first snowfall in winter and extrapolate color palettes from some of your favorite photos.

## Creating Color Combinations

Most people begin building a color palette by choosing their primary color(s) first and pairing it (them) with a neutral or accent color. In Figure 10-6, I've picked three primary colors for a client who sells her handmade crafts on Etsy.

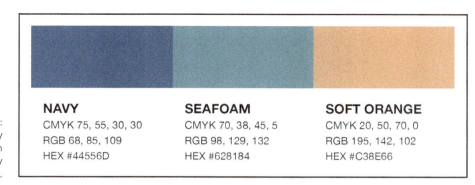

FIGURE 10-6: Three primary colors chosen for an Etsy seller.

I feel comfortable choosing these colors as my primary colors, but if I were to create a website and use only these three colors, it might be a bit overwhelming. These colors look great together, but I need to choose some secondary colors that are going to be more subdued but will still work with my primary colors.

In Figure 10-7, you can see that I chose two monochromatic colors — colors based on a particular hue. (I chose my navy and seafoam colors.) You can also see lighter and darker versions of my soft orange color. Since orange is a warm color, I wanted a lighter and darker version of this color to work with in my color palette.

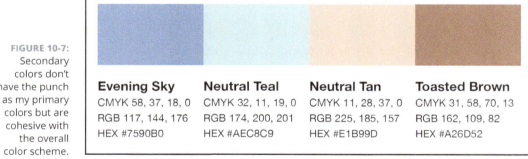

FIGURE 10-7: Secondary colors don't have the punch as my primary colors but are cohesive with the overall color scheme.

My last step is to pick a few tertiary colors that I can use in backgrounds and other areas to support the color theme. I chose a Cream color (#FFFDD0) and a Buttercream color (#F5EDD7) for my tertiary colors. You can see the entire color palette in Figure 10-8.

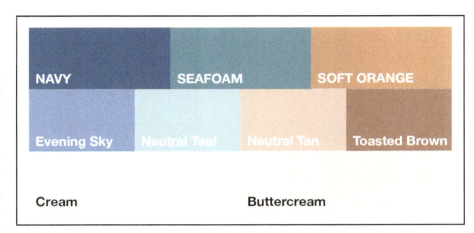

FIGURE 10-8:
A fairly robust color palette with primary colors on the top row, secondary colors in the middle row, and tertiary colors on the bottom row.

## Addressing Color Accessibility

Creating color palettes for people with color vision deficiency requires thoughtfulness to ensure your content is viewable and usable by everyone. There are a number of online tools that allow you to test your colors following the Web Content Accessibility Guidelines (WCAG), which are a series of recommendations for making web content more accessible. The WCAG standard defines two levels of contrast: AA (minimum contrast) and AAA (enhanced contrast).

The AA level requires a contrast ratio of at least 4.5:1 for normal text and 3:1 for large text that is at least 18 points or bold text at least 14 points to achieve this standard. The superior AAA level requires a contrast ratio of at least 7:1 for normal text and 4.5:1 for large or bold text. When I put my HEX color values into an online contrast checker, shown in Figure 10-9, you can see that this particular color combination scores a 6.49 contrast ratio, which is an acceptable or good contrast ratio.

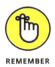
REMEMBER

Always test your color choices using simulation tools to see how they appear to users with various types of visual deficiencies. Using high-contrast colors and testing your design can help you create a more accessible design solution that all users can appreciate.

210   PART 2  Using the Principles of Design to Elevate Your Work

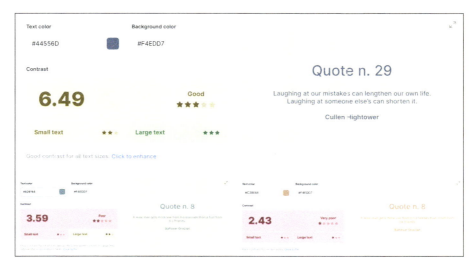

**FIGURE 10-9:** You can use an online color contrast checker to check your color combinations.

In Figure 10-9, navy blue performed significantly better than seafoam or soft orange on the cream background, so I'll make sure to use this color combination instead of the others for my text to make my written content easier to read.

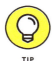

TIP

When choosing a typeface, choose a simple sans-serif typeface and avoid decorative, script, or cursive fonts, which can be harder to read. Small, informed decisions like appropriate contrast ratios and typefaces that lend themselves toward inclusive designs help all users enjoy your content more.

Another strategy you should consider is to avoid using color alone to convey important information. Of course, color can be used in a design solution, but you should also make use of text, shapes, patterns, icons, and other visual cues to make sure your audience can discern your message.

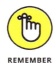

REMEMBER

By adhering to best practices, you can create more inclusive and accessible design decisions that accommodate the needs of users with visual deficiencies.

When you are in the early stages of design, you might want to use a tool like Coblis, which is the Color Blindness Simulator (`https://www.color-blindness.com/coblis-color-blindness-simulator/`). It allows you to upload a design solution like the magazine spread I was working on in Figure 10-10. Coblis allows me to view my work through the lens of people with various types of color vision deficiencies, enabling me to make more informed design decisions.

CHAPTER 10 **Constructing Color Systems** 211

**FIGURE 10-10:** An example of a magazine spread uploaded to the online color blindness simulator on www.color-blindness.com. Notice how you can toggle through different types of color vision deficiencies at the top of the page and simulate how someone with a specific type of color blindness might view your design solution.

# Strategies for Making Charts and Graphs More Colorblind Friendly

There are some simple strategies that you can implement to help users with color vision deficiencies comprehend your charts and graphs more easily. If you're making a chart or graph in Adobe Illustrator, you can access an internal color blindness tool by choosing View > Proof Setup > and choosing either Color-Blindness - Protanopia-Type or Deuteranopia-Type.

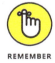

Don't just rely on color to communicate. There are a number of other visual cues that you can use with color to make sure your audience can discern the data in your charts and graphs more easily.

In Figure 10-11, take a look at this very generic chart and think about how you might modify it to make it more accessible.

**FIGURE 10-11:**
What are some ways you could make this generic chart more accessible to people with color vision deficiencies?

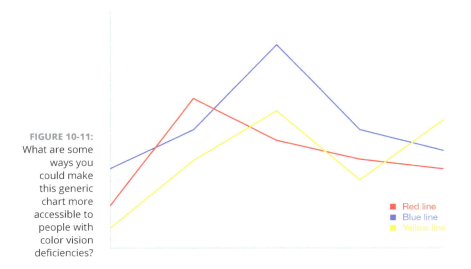

First, let's pick some better colors. Instead of using red, blue, and yellow, let's switch up our colors to blue (RGB: 0, 114, 178), orange (RGB: 230, 159, 0), and green (RGB: 0, 158, 115) to make them more distinctive and higher contrast, as you can see in Figure 10-12.

**FIGURE 10-12:**
Yellow can be a particularly problematic color to use because it has such low contrast on a white background.

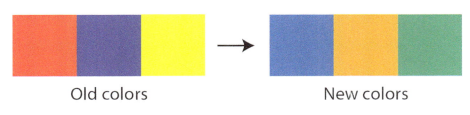

Next on our list is to think about how we can differentiate the lines in the chart beyond using color. We can use 1) different variations of dashed lines, 2) various stroke thicknesses, and 3) integrate shapes into our chart. We can also take the legend for the graph and create a direct label at the end of the line as a means of confirmation. Take a look at how these changes have affected the chart in Figure 10-13.

CHAPTER 10 Constructing Color Systems    213

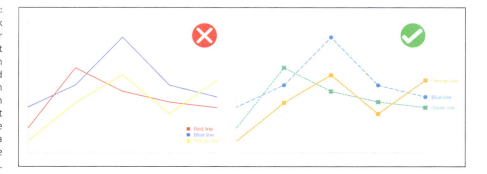

**FIGURE 10-13:** Take a look at how our generic chart has been transformed through simple design decisions that integrate some strategies for a more inclusive approach.

Designing for people with visual disabilities is important for creating a more inclusive and accessible experience. Here are a few tips to help you think about your approach to designing a more inclusive experience:

- » Use high-contrast colors and ensure there is a significant amount of contrast between text and background colors.

- » Use a legible font and ensure that your text is an appropriate size. When designing for digital environments, avoid using fixed-size text that viewers can't adjust.

- » Don't rely on color alone to convey information. Use labels, patterns, text, shapes, and colors together to create content that is accessible for colorblind individuals.

- » When designing for digital environments, use semantic HTML to ensure your content is interpreted correctly by screen readers. This includes using appropriate headings, lists, and alt text for images.

- » Ensure that video content includes captions and audio descriptions.

- » Make sure all interactive elements (links, forms, buttons) can be navigated and operated with a keyboard. This is crucial for users who are unable to use a mouse.

- » Conduct a usability test or use tools to help you create more accessible content. Direct feedback from users is great, but there are times when direct feedback may be difficult to obtain.

Accessible design shouldn't be a begrudging afterthought. With a little planning, you can create elegant, beautiful, and accessible design solutions that consider the needs of your audience.

**IN THIS CHAPTER**

» Using your typography to establish purpose, tone, and message

» Creating a typographic system and choosing good typefaces

» Avoiding typographic faux pas

# Chapter **11**

# Choosing Type and Creating a System

We've talked about typography a bit already, but the purpose of this chapter is to dive a little deeper and demystify how to choose a good typeface. If you polled ten designers on how they choose their typefaces, I wouldn't be surprised at all if you received ten different answers.

Making good decisions about your typography can help make a good design solution a great design solution, but the reverse can also be true. Poor typographic decisions can weaken a good design solution. Like it or not, your typographic choices can either buttress your design solutions or diminish them.

Your typographic decisions can impact:

>> The message of your design solution

>> The brand identity of your design solution

>> The ability to create a visual hierarchy

>> The aesthetics of your design solution

>> The legibility of your written text

>> The emotion and tone of your design solution

>> The functionality of your design solution

CHAPTER 11 Choosing Type and Creating a System 215

I often see my design students pour all of their time and effort into developing their design elements only to gloss over their typographic decisions. My advice is to slow down and think about your type a bit more because it will likely impact how your message is conveyed, perceived, and remembered.

Over the next few pages, we'll dive into some strategies for picking typefaces to bolster your design solutions. Before we begin, it's important to remember that typography is more of an art than a science and that many of the decisions you make, including your type choices, are subjective.

## Purpose, Tone, and Message

One of the first steps to take in choosing a typeface is to look over your content and think about its needs. Typefaces that work well in print won't necessarily work well on a screen, too, so we can use the fact that a piece is being designed for print or digital as a limiting factor to help eliminate some of our decision-making. However, the lines between print versus digital have begun to blur, so we can't use this as a definitive method for backing into a decision.

Think about the qualities you need from your type. In print, you might need your type to fit neatly into the columns in a magazine and something that is easy to read, but for digital screens, you may be concerned with picking a web-safe font to ensure consistency across different devices and browsers or choosing a typeface with a fast load time. These qualities of type should not be framed as "good" or "bad," but understanding how these qualities might pair with your design goals and medium is a step in the right direction.

Pairing type with your design goals is like choosing a wine to go with your entrée. You can ask the waiter for a recommendation, but often, the choice is a matter of preference.

The next consideration you might wrestle with is identifying the tone of your design solution. The tone of a design solution refers to the overall feel, mood, or emotional quality that you are trying to convey to your audience. Bright colors and playful fonts can be used to create a cheerful tone, while more desaturated colors and a good sans-serif typeface might reinforce a more subdued, professional tone. It doesn't make a lot of sense to deliver a mixed signal to your audience where your visual elements create a tone, but your typographic decisions create another. Most people would expect your visual elements and typographic elements to work together in harmony.

TIP

Sometimes, young designers choose typefaces that are too visually expressive at first until they develop their typographic tastes. Choosing a typeface that is too expressive can sometimes feel like someone who explains the punchline to a joke. If you have to explain the punchline of a joke, it makes the joke less funny. My advice for young designers is not to choose a typeface that visually encapsulates your tone but to choose a typeface that works with your other design elements rather than overpowering them. You'll want to choose a typeface that's a helper rather than the town crier.

Take a look at Figure 11-1 and think about how these four typefaces might influence, reinforce, or change your perception of why this man is in handcuffs.

FIGURE 11-1: Think about how these typefaces pair with the image above to influence, reinforce, or change your perception of why the man in the image is in handcuffs.

jinga80/Adobe Stock Photos

All of this said, sometimes rules are meant to be broken. There are times when an unexpected pairing of type and visual elements will break the rules in an unexpected way and perhaps create a new interpretation in the process. Instead of pairing Figure 11-1 with a bold, gritty, reckless typeface, you could explore the possibility of pairing the image with a casual script like the typeface in Figure 11-2.

CHAPTER 11 Choosing Type and Creating a System    217

**FIGURE 11-2:** Do opposites attract? Instead of pairing the image in Figure 11-1 with a bold and gritty typeface, perhaps a casual script typeface might open new possibilities. This pairing begins to raise questions about the relationship between these two elements.

*Alpine Script Regular*

Does the typeface in Figure 11-2 work with the image of the handcuffed man? I'm not fully confident that it does, but this illustration raises an earlier point about how sometimes typography is more art than science, and you might need to try a few outside-the-box approaches before finalizing your typographic decisions. If a "try-and-see" approach feels a little too loosey-goosey for you, then you'll be happy to know we're about to look at the pragmatics of choosing your type.

In terms of black-and-white typographic decision-making, the philosophy of "honoring your content" is a rule of thumb that is likely to help steer your typographic decision-making in a good direction.

REMEMBER

It's really important to read your content and understand what the needs are. What do you need to accomplish with your hierarchy? Are there particular glyphs, or typographic characters, you need to use? How much text is there? These are examples of questions that are likely to help you narrow down your search.

Suppose I read the content and see that I need to create a strong hierarchical framework. In that case, I'll make sure I choose a typeface with a deep bench like the typeface Apparat, which is available in hairline, hairline italic, thin, thin italic, extralight, extralight italic, light, light italic, regular, italic, medium, medium italic, semibold, semibold italic, bold, bold italic, extrabold, extrabold italic, black, black italic, heavy, and heavy italic styles.

All these type families are designed to work together to create a cohesive aesthetic — or style — while also providing numerous opportunities for creating typographic hierarchy and emphasis. If your content doesn't require such robust hierarchical options, you may not need to narrow your search for a typeface down to achieve these constraints. If your content requires particular glyphs, fractions, scientific symbols, non-Latin characters, ligatures, or certain OpenType features, this might be a constraint you can use to identify a smaller selection of typefaces that meet these criteria.

Honoring your content is a very practical way of choosing a typeface, and when paired with the criteria of choosing a typeface for a particular purpose and tone will help to scale down a seemingly infinite number of typographic options to a very manageable list of candidates.

# Staying Timeless or On-Trend

For those of you who are just starting out, it can be helpful to have a list of classic typefaces that are known for their enduring quality and versatility. Many of these typefaces have been time-tested, well-loved, and frequently used by graphic designers for decades.

## Timeless typefaces

The following timeless typefaces are separated into serif and sans-serif:

### SERIF TYPEFACES

» **Times New Roman:** Most commonly used in books and printed documents, Times New Roman allows for tight line spacing and has a smaller appearance, a high x-height, and short descenders.

» **Garamond:** Most commonly used in body text, books, and printed material, Garamond has excellent readability but does not perform well on screen due to its small x-height.

» **Baskerville:** Most commonly used in body copy and printed documents, Baskerville has high contrast and generous proportions, making it an elegant and easy-to-read typeface.

>> **Georgia:** Georgia performs well in print and on digital mediums. Georgia is easily readable due to its widely spaced characters and is compatible with both Windows and Mac computers, which makes it a popular typeface for graphic designers.

>> **Palatino:** Palatino performs well in both print and digital mediums. Palatino features wide, open counters that enhance its legibility.

### SANS-SERIF TYPEFACES

>> **Helvetica:** Helvetica performs well in both print and digital mediums. Helvetica has clean lines and is widely considered to be an efficient, inoffensive typeface. Helvetica is one of the most popular and widely used fonts in the world.

>> **Arial:** Arial performs well in both print and digital mediums. Arial is an extremely versatile typeface that is easy to read, particularly in small sizes.

>> **Futura:** Futura performs well in both print and digital mediums. Futura is an extremely legible typeface based on geometry and it is an efficient and versatile typeface.

>> **Verdana:** Verdana performs best on screens, particularly in instances where legibility at low resolution is an issue. Verdana is widely considered an accessible font and easy readability.

>> **Univers:** Univers is best for print, with a large x-height and short descenders, making it a compact yet readable typeface. Univers has a robust typographic family with a wide range of styles and weights, providing numerous options for creating a typographic hierarchy.

## Trending typefaces

The following trending typefaces are separated into serif and sans-serif.

### SERIF TYPEFACES

>> **Merriweather:** Merriweather is an open-source Google font designed for on-screen reading. The letterforms have a tall x-height but with a slightly condensed letterform, making it both readable and good for compositions with limited horizontal space.

>> **Lora:** Lora is a well-balanced, open-source Google font that strikes a balance between elegance and simplicity. Lora has a calligraphic feel and looks great on screen.

>> **IBM Plex Serif:** IBM Plex Serif is an open-source Google font designed to work with the Plex family, which includes Sans, Sans Condensed, Mono, and Serif faces. IBM Plex Serif is a neutral yet friendly typeface that is very readable and works well in both print and digital mediums.

>> **Freight Text:** Freight Text is a humanist style typeface with curved strokes and a generous x-height. Freight Text is warm and inviting and is a versatile font that can work well in both print and digital mediums.

>> **Calluna:** Calluna is a chunky typeface with exaggerated serifs and broad language support. Calluna combines a classic feel with a modern touch and can work well in both print and digital mediums.

### SANS-SERIF TYPEFACES

>> **Helvetica Neue:** Helvetica Neue is a modern version of Helvetica that's known for its clean, modern look and wide range of weights. This typeface is suitable for a wide range of projects.

>> **Roboto:** Roboto is an open-source Google font that has a modern typeface with open curves that is popular for digital interfaces and looks great on screen. Roboto is a popular font choice for web designers.

>> **Open Sans:** Open Sans is an open-source Google font that is designed for legibility and works well in both print and digital mediums. Its consistency across mediums makes it extremely versatile.

>> **Proxima Nova:** Proxima Nova is known for its modern appearance while referencing the classic sans-serif type. Proxima Nova is a popular web font that can be used for anything.

>> **Gotham:** Gotham is known for its clean lines and versatility. It's widely used in both print and digital mediums. It's a good, clean, legible font that performs well in both print and digital mediums.

# Considering Legibility

Legibility in typography refers to how easily people can identify and interpret symbols and words in a particular typeface. Legible typefaces are often the most restrained typefaces and are often devoid of overt flourishes and over-the-top visual embellishments. Legible typefaces aren't excessively light or bold and have ample letter spacing. The counter space, or the space within letterforms, is also balanced and isn't too large or too small. A typeface with good legibility also has

glyphs that are distinct from similar letterforms, so a lowercase "l" will have visual differences from the number "1" and the letter "O" should appear different than the number "0."

You might hear the terms "readability" and "legibility" used to describe type, but "legibility" refers to a font's visual qualities. Legibility includes character differentiation, x-height, counterforms, stroke contrast, letter spacing, and so forth. The term "readability" refers to how the font is typeset and includes the size, type case, line spacing, line length, color, alignment, and so forth.

I often try to set my body text in a very legible typeface but allow myself to be a bit more expressive with the typeface I use for headlines and quotations. There are a variety of strategies for using more than one typeface in a design solution, but my goal is usually to remove as many barriers as I can for users trying to engage with my content. Take a look at Figure 11-3 and see how three different typefaces, all set in 8-point text, can make the job of reading easier or harder.

FIGURE 11-3: Some typefaces are more legible than others. Choose your typefaces wisely.

"I'm sick of following my dreams, man. I'm just going to ask where they're going and hook up with 'em later."
—Mitch Hedberg

"I'm not offended by blonde jokes because I know I'm not dumb…and I also know that I'm not blonde."
—Dolly Parton

"The best way to get most husbands to do something is to suggest that perhaps they're too old to do it."
—Shirley MacLaine

## Establishing Typographic Hierarchy

In Chapter 1, "Designing Together," which can be found on this book's page at www.dummies.com, I discussed typographic contrast and how different typefaces, sizes, weights, and styles of text are used to create typographic contrast. Many of these variables are the same typographic elements used to create typographic hierarchy, but the goal isn't to create contrast as much as to establish hierarchy.

The goal of typographic hierarchy is to use various typographic variables to convey a sense of structure and importance with typographic content. There are many ways to use type to create a hierarchy, but a lot of the decisions you make are likely to rely upon the needs of your content. For example, if you have typographic content that requires three levels of typographic hierarchy (such as a headline, body copy, and a quotation), you might make decisions like what you see in example A in Figure 11-4. If your content requires five levels of typographic hierarchy (such as a headline, a quotation, a lead-in paragraph, body copy, and captions), perhaps you'll end up with a solution like example B, where I used two typefaces, numerous weights, and multiple text sizes.

**FIGURE 11-4:** Creating typographic hierarchy through weight, size, and typeface selection.

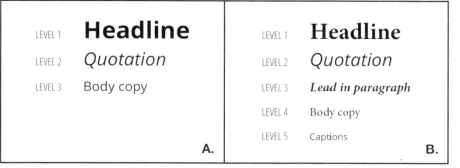

The two examples in Figure 11-4 are one among many ways to create a typographic hierarchy. Other variables you can use to create a typographic hierarchy include:

» **Font size:** Typically, larger text is used for headlines or key pieces of information.

» **Font weight:** A font with varying weights (such as light, medium, bold, and black) can be useful to indicate different levels of importance.

» **Font style:** Different font styles (such as italic, uppercase, or small caps) can be used to emphasize certain parts of your content. For instance, you could use small caps to emphasize content that is less dominant than all caps, but using small caps in the middle of a paragraph would be weird, so in situations like this, you might use italics instead.

» **Color:** Color can be used to emphasize important text or differentiate between different sections of your content. Just make sure to provide enough contrast between your text and your background.

» **Spacing:** You can use spacing to create visual distinctions between different text elements. For example, you might add additional spacing after a headline or a section header.

» **Alignment:** You can use alignment to create a cohesive structure for text but introduce a secondary alignment for emphasis. For example, you can use left-aligned text for all of your content but use centered text for your quotations.

» **Indentations and lists:** Using indenting, bulleted, or numbered lists can help you organize your content and make it easier to scan.

The preceding bulleted list highlights a number of ways you can create a typographic hierarchy. Remember that typographic hierarchy is a system where all the parts need to work together in unison, so don't approach each level of hierarchy without thinking about how it plays into the level above and below it hierarchically.

When creating multiple levels of typographic hierarchy, it's important to make decisions that create the hierarchy you need but are visually cohesive as a group. You may remember that many designers recommend using one or two typefaces, so when you choose your typefaces, it may be advantageous to look for ones that provide several different weights and styles, like light, regular, bold, and black. Having options like this can be very useful in creating different types of typographic hierarchies. Conversely, picking a typeface that has one weight and only capital letters is a quick way to narrow your options and may paint you into a corner.

Typographic hierarchy is using your typographic elements to organize and prioritize your content. It can be used to establish a structure to help your audience understand the importance of different components of content and how they might relate to each other. In fact, research shows that people process visual information faster when there is a clear hierarchy. A well-designed typographic hierarchy can help readers scan and understand content faster and also improve the readability, comprehension, and experience of interacting with written content.

I often see young designers incorporate too many options for establishing typographic hierarchy in a design solution. For example, a younger designer might set a headline in a large, bold typeface, make it red, add a drop shadow behind the text, and use directional elements to point to the headline when all they needed to do was make it big and bold. Typography courses often help students develop a sensitivity to — and awareness of — how to create typographic systems and typographic hierarchy more confidently, efficiently, and with less ambiguity.

# Limiting the Number of Typefaces

Most graphic designers recommend limiting the number of different typefaces that you use in a design solution to one or two typefaces. Of course, there can be legitimate exceptions, but for most projects, one or two typefaces are usually sufficient. When you use too many typefaces in a design solution, you usually put your consistency, clarity, or visual harmony at risk. A design with too many typefaces can often appear amateurish and chaotic.

## Working with type families

While choosing too many typefaces is thought of as a no-no, choosing a typeface with a large number of type families is largely considered a wise decision. The visual aesthetic of a well-designed type family is cohesive and may provide a number of ways to establish a typographic hierarchy. Take a look at Figure 11-5, where you can see the type family for Helvetica Neue.

FIGURE 11-5:
The type family for Helvetica Neue. Notice how the aesthetics of the typeface are cohesive, but the varying weights leave room for creating a typographic hierarchy.

> Helvetica Neue Ultra Light
> *Helvetica Neue Ultra Light Italic*
> Helvetica Neue Thin
> *Helvetica Neue Thin Italic*
> Helvetica Neue Light
> *Helvetica Neue Light Italic*
> Helvetica Neue Regular
> *Helvetica Neue Italic*
> Helvetica Neue Medium
> *Helvetica Neue Medium Italic*
> **Helvetica Neue Bold**
> ***Helvetica Neue Bold Italic***
> **Helvetica Neue Condensed Bold**
> **Helvetica Neue Condensed Black**

Choosing the typeface Helvetica Neue counts as selecting one typeface, but Helvetica Neue's elaborate type family opens the door for robust options in creating a typographic hierarchy. Not every typeface has so many type family options, so think about your project's needs before choosing your typefaces.

REMEMBER

The typeface you choose is important to consider. Look for a typeface with enough options to meet the needs of your project, and think about how your typeface might pair well with other typefaces if you're using more than one typeface in your design solution.

## Pairing complementary typefaces

While most designers agree that using a limited number of typefaces in a design solution is a good idea, many young designers don't know how to choose typefaces that pair together. Here are some strategies you can use when choosing your type.

Once again, the design principle of contrast comes into play. Choose typefaces that contrast yet complement each other. For example, you might choose a serif and a sans-serif typeface or a light sans-serif with a dark sans-serif typeface. You should look for two distinct qualities that a user will be able to recognize easily because using two similar-looking typefaces with little contrast between them is a recipe for confusion.

Sometimes, it can be helpful to look at the x-heights for the fonts you are considering. The x-height of a font is the measurement from the baseline to the median line, as shown in Figure 11-6.

CHAPTER 11 **Choosing Type and Creating a System** 225

**FIGURE 11-6:**
The x-height is the distance from the baseline to the median line, marked in orange. Choosing fonts with similar x-heights can be advantageous in many instances.

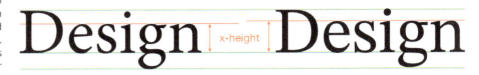

Choosing two typefaces with a similar x-height can be a tremendous help when working with a grid that includes a baseline grid. Typefaces with similar x-heights can help prevent odd spacing issues when text is aligned to a baseline grid and can also help your type look balanced and unified.

There are a number of good websites that have lists of recommended font pairings that you can use to help you make good font pairing decisions. See fontpair.co, typewolf.com, and fonts.google.com.

Choosing typefaces with similar proportions can also be helpful. For example, if one typeface is condensed or very narrow, then pairing it with an extended or wide typeface can look odd because of the differences between the proportions.

Finally, consider the mood you are trying to achieve with your font pairings. Choosing two similarly themed typefaces is a good way to ensure a cohesive look and also integrate sentiments about the mood. For example, choosing two Art Deco typefaces working together in unison can help set the tone in your typographic system.

# The Importance of Font Size and Leading

It's important to remember that your text is meant to be read, so if the font size is too small, then it can be off-putting to some readers who have difficulty reading small text; conversely, if your text is too large, it can make people feel a bit overwhelmed. This is one of the reasons why you should test your typefaces in the environment in which you are designing them. Text that is designed to be printed should be actually printed out and read. Text for screens should be displayed on screens and read before committing to a particular point size.

I can't tell you how many times I've watched young designers design something beautiful on their computer screen, only to watch it fail when they print it out at the last minute before turning it in. Make sure you test your font sizes before designing an entire solution, only to realize that you have to redo it later because you forgot to test it out early in your process.

Similarly, opening up your leading, or the vertical space between lines of type, is something that needs to be tested in the environment for which the piece was designed. Adding leading to body copy can make dense areas of text seem more accessible and easier to get through compared to a dark, dense wall of text. Proper leading improves readability by giving our eyes space to distinguish one line of text from another, but it's a balancing act. Too much leading can also be difficult to read, which is why it's so important to test your font size and leading in the environment for which it is designed.

## Understanding Usage and Licensing

When you're picking typefaces, you also need to take a look at the usage and licensing terms; if you don't, you might back yourself into a corner. Fonts come with different licensing terms, and each license defines how and where the typeface can be used. A desktop license might allow you to use the typeface in print and static digital designs, but a web license is required if you want to use a particular typeface on a website.

Many of my design students look for free typefaces because they don't have much of a budget to purchase typefaces, but be careful! Some fonts are free for personal use, but if you want to use them for professional projects, you need to pay to use them. Don't get into the habit of thinking that any typeface you find for free is okay to use.

Open-source and free fonts released under open-source licensing can be used, modified, and distributed, but even free fonts can come with terms of use that you should know about before choosing this type. For example, the font designer might require attribution or other requirements in exchange for their permission for you to use the typeface. You should always read the licensing agreement before settling on a typeface. Some licensing agreements won't allow you to embed fonts or require you to purchase a multi-user licensing agreement if you're working on a team. Additionally, some font licenses are temporary and need to be renewed, while other licenses are good in perpetuity.

REMEMBER

It's not a good look to steal fonts or use fonts without permission. Think about how you'd feel if someone stole your design solution and used it without your permission. Your best option is to understand font licensing, respect intellectual property rights, and use fonts ethically.

## Avoiding Typographic Faux Pas

I asked an online group of 500+ design professors what were some typographic faux pas that graphic design students did that drove them nuts and I was surprised to see that there was consensus. After going through the list of complaints, here are some typographic faux pas that graphic design professors across the country would like to remind you of:

- **Alignment:** Using too many alignments in a design solution is considered a design no-no. Your typographic alignments should be limited to one, possibly two, alignments tops. Also, as a graphic design professor, I'll add that you might want to rethink using centered body copy in your design solution.

- **Justified type and rivers:** While we're talking about typographic alignments, I would be remiss if I didn't gesture to using justified type. Justified type is aligned on both the right- and left-hand sides, so this alignment often creates white space between the words in a line of type. When the white space in between lines of type aligns it creates a river, or path of white space through your block of text. If you are going to use justified type, then you also need to learn how to control your hyphenation and justification settings to avoid creating rivers of white space in your text.

- **Hanging quotes:** Hanging quotes is when your quotation mark is positioned outside the margin of the text block to ensure that the quotation remains visually aligned and creates a more professional look. If you want to make hanging quotes in Adobe InDesign, select your text, choose Window > Type & Tables > Story, and then check the Optimal Margin Alignment box.

- **Wrong glyphs:** There are a number of glyphs you should know and use correctly. This includes the difference between a hyphen, an en-dash, and an em-dash, prime glyphs for measurements versus quotation marks, and an ellipsis versus three periods.

- **Widows and orphans:** Widows and orphans need to be removed, but in order to do so, you need to know what they are. Widows are a short last line of a paragraph that appears on top of a new page or column, while an orphan

is a single line of text at the bottom of a page or column of text. Both widows and orphans should be edited out — often, you can edit or rewrite part of your text to avoid them.

» **Distorting type:** Distorting type is another graphic design no-no. You should avoid stretching your typography, which subsequently wrecks the proportions of your type.

» **Kerning:** Nobody likes bad letterspacing. Kerning is the process of adjusting the space between characters of type. When you're kerning your type, aim for visual consistency. You may have observed that you can choose metric kerning or optical kerning in your typography menu. Metric kerning uses the kerning data built into the font and is based on the font designer's recommendation, while optical kerning is based on the shape of the characters and how they look. Optical kerning can be useful if you're working with custom or non-traditional typefaces.

There are a number of fantastic resources out there to help you make great typographic design decisions. You should know there will be some disagreements in how to classify type or differences in how to approach typographic decision-making. This ongoing discussion is part of what makes typography an art rather than a science, so don't be afraid to jump in and pick a lane that aligns with your own typographic approach.

# The Part of Tens

**IN THIS PART . . .**

Identifying what you need to know when putting together a portfolio

Learning how AI might change graphic design

**IN THIS CHAPTER**

» Focusing on quality over quantity

» Making your work tell your story

» Keeping your portfolio up to date and stuffed with keywords

# Chapter **12**

# Ten Things You Should Know When Putting Together Your Design Portfolio

Your graphic design portfolio is one of the most useful tools in your arsenal to show potential employers that you can talk the talk and walk the walk. In fact, it's estimated that over 85 percent of hiring decisions are based on seeing the work in your visual portfolio. That's huge!

I tell my graphic design students that it is imperative that they put their best foot forward and create a highly creative, relevant, and error-free graphic design portfolio to optimize their chances of landing a job they love. The ten things in this chapter are some of my best pieces of advice for those working on their graphic design portfolios.

# Focus on Quality over Quantity

Most portfolios feature 6 to 12 portfolio pieces in total because studies have shown that it's better to create a portfolio with a lower number of stellar and exceptional portfolio pieces than it is to create a larger portfolio with a mix of stellar and okay pieces in it.

Generally speaking, most people don't want to pay for "meh" work, so showing only your best work is considered a more solid strategy for getting noticed. It goes without saying that you should only include your strongest work, and often, this involves reworking portfolio pieces until they are just about perfect.

On a scale of 1-10, with 10 being perfect, I tell my students only to include work if it ranks as an 8 or higher — otherwise, the piece needs to be reworked or removed from the portfolio. Think about it: If we won't buy a toilet brush from Amazon that has four out of five stars and only 12 reviews, then most people won't invest big money to hire a designer whose portfolio also comes across as mediocre. This is why you trim the fat and only put work in your portfolio to create a five-star impression.

# Tailor Your Portfolio for Your Audience

This might seem like a "no duh" statement, but many graphic designers get this wrong. It's easy to forget that your portfolio isn't for you. This is because it's your work, it's your story, and you're making the decisions for how to mock it up in your portfolio, but make no mistake, you aren't the audience.

When you design your portfolio, you need to think about what the creative director or hiring manager wants to see — not just what you want to show. You need to make sure that the work you show aligns with the type of job and clients that the agency works with. If you're applying for a branding job, make sure you highlight branding projects. And don't forget about branding yourself!

One thing I see young designer overlook on their website portfolios is making sure your contact information is easy to find and accessible on all your pages. I recommend repeating your contact information in the footer of each page on your website as well as including it in other areas like your "Contact" page.

# Show a Range of Skills

If you're applying for publication design, highlight your publication design projects for sure, and then highlight other types of work that are relevant to the job, too. Some relevant examples of other types of work for a publication design might include advertising, social media promotion, photography, or email marketing.

Imagine that you're interviewing candidates for a web design position, and the candidate has nine websites in their portfolio. After reviewing the fourth website in a row, you might find yourself a bit bored by the monotony. Even though you need a website designer, it wouldn't hurt if they threw in some app design, banner ads, or some other relevant work to break up the monotony a little. Showing that you can do more than one thing shows that you can think on your feet, are a versatile and adaptable designer, and that you understand how to use the principles of design regardless of the medium.

# Make Your Work Tell Your Story

The work in your portfolio should help you tell your story. For example, it should reinforce that you are passionate about your discipline, but it can also be used to talk about internships, unique opportunities, study abroad courses, relevant hobbies you have, and so much more.

When I'm leading someone through my portfolio, I won't do it linearly or from my most recent to the earliest piece in my portfolio. Instead, I'll order the pieces to create a narrative. For example, maybe I'll introduce the first app that I created and talk about what I learned by working on this project, then I'll show a social media campaign and talk about how I used some of the same storytelling skills that I used in the app and applied them to a social media campaign. Then, I might say that this social media campaign is a big reason why I was hired for an internship and then show the work I created for my internship.

You're using the work in your portfolio to help your interviewer get to know you, what your interests are, and what opportunities you've had. Having worked as a graphic designer and creative director for more than 20 years, I can tell you for certain that I may not remember your name, but I'll remember your work, so it makes sense to try to attach your story and memorable details to your work and present yourself as a package.

# Put Your Best Work Above the Fold

Putting your work above the fold means putting your most important content at the top of a web page. The term "above the fold" originated in the newspaper industry, where the most critical news stories were placed on the upper half of the newspaper because the newspaper would be folded in half and placed in a newspaper rack and sold. Passersby would see what the major news items were and purchase the paper to read the stories.

Similarly, your most important elements should be placed at the top of your website. If I click on a thumbnail to view one of your portfolio pieces, I want to see the most compelling illustrations, photographs, and text at the top of the page; I don't want to have to scroll down and hunt for them.

You'd be surprised how long you have to make a great impression on a web page before you begin to lose your audience. Chances are good that you only have around 15 seconds or less before visitors move to the next page. So, why do you put all this effort into your website? Because if they see something they like, then your audience will dig deeper. But they'll only dig deeper if you only have moments to make a great impression, so don't waste an opportunity by having your audience scroll down to see the good stuff — put it right at the top of your page, so if they see nothing else on the page. Then, they will have at least seen your best work.

# Lean into Your Establishing Shots

We've all heard the phrase, "A picture is worth 1,000 words," so I would encourage you to make sure to lean into creating and using establishing shots at the top of your portfolio pages. An establishing shot gives the viewer a good sense of the significance, scope, and scale of a portfolio piece, and it only takes a split second to provide your viewer with a lot of information.

If you created the labels for three bottles of wine (a Pinot Noir, a Pinot Grigio, and a port wine), then your establishing shot should be an impressive photograph of all three wine bottles together looking amazing, rather than three photographs of individual bottles that the user must scroll through or an image carousel that the viewer must wade through.

I like to think about my establishing shots as the eye candy that helps draw my viewer into my written and tertiary content on my page. Often, I'll see a graphic designer put the title and a description of the work at the top of the page, but I prefer having a title and image at the top of the page instead. Also, I like including

large establishing shots of the work, so make sure you don't choose a template that uses a small image at the top of your web page and go with a template that allows you to include a large image instead.

# Include Sketches and Process Work

You don't have to do this for every piece in your portfolio, but including a few pieces in your portfolio where you show your sketches and process work is a great idea! Employers know that there are plenty of templates and design work out there that you could have borrowed from, so seeing how someone develops an original idea and brings it to fruition is really informative.

I love looking at graphic designers' sketches, but sometimes the sketches can visually compete with other elements on the page. Plus, sketches are there for the designer to get their ideas out and explore their options, but normally, these types of sketches aren't meant to look nice. To solve this problem, I simply ask my students to scan in their sketches and process work and add an Adobe Acrobat link to their portfolio web pages. This way if the audience wants to look at their sketches and process work, then they are one click away from being able to view this content, but the link won't clutter a beautifully considered portfolio web page with pages of sketches and research.

I've also been known to put sketches in a sketchbook, so if I have a sketchbook that I like a lot, then I might bring it with me to a job interview, and at some point, I'll ask the creative director if they would like to take a look at my sketchbook. I've never had a creative director turn down my offer to look through my sketchbook, and it worked to my advantage on several occasions.

Many times before you get a face-to-face interview an employer will have already looked at your website, so when you meet with them in person, they have already seen a lot of your work. Bringing in a sketchbook that you've physically drawn in is new information they may not have seen already, and it's a great way to quietly distinguish yourself from others who may also be vying for the same position.

# Keyword Stuff Your Portfolio

We all know that keywords can help your search engine optimization (SEO), but keywords can also help you look like a great fit for a specific position. When I read through a job description, I make sure to highlight words that are specific to the

job description. I've found that different positions use different language, and my goal is to match the language the employer is using with the language I use on my résumé, cover letter, and portfolio.

I've heard that if you want to make someone feel at ease when you talk with them, you should adopt a similar energy, posture, and language, and this is the basis for this advice. I try to match the language they use in their job descriptions with that of my own. If they are looking for an artist, I describe myself as a digital artist. If they want a designer with marketing experience, I make sure I talk about my work and highlight its marketing potential.

I ran each of my students' résumés through a keyword density analyzer and then I ran a job description they were interested in through the same tool. We quickly learned that we were using completely different languages to describe the same types of work. In order to make you look like a great fit for a particular role, I recommend that you don't just write your materials in a one-size-fits-all format but study the language they use and repeat it in your own documents. This way you look like you're going to be a great fit for their team.

# Meet with an External Reviewer

Meeting with an external reviewer or someone whose advice you trust and respect to review your portfolio is some really good advice. The entire time you build your portfolio, you're trying to be awesome, position yourself smartly, choose projects that show you off in a particular way, and put your best foot forward. An external reviewer will also allow you to test for first impressions and ask them what they think about work they haven't seen before to make sure that you're on target. Meeting with an external reviewer will also help you rehearse how you will tell the story of each piece and/or your whole portfolio. It is important to know how to talk about your work and be prepared for specific questions.

Getting a fresh perspective and unbiased feedback can help you out immensely when you're too close to your work, and let's be honest, you're probably going to be too close to your work.

Putting a portfolio together is a big job and an external reviewer can help you spot blind spots and inconsistencies that you simply cannot see yourself because of how long it takes to put a portfolio together. A fresh set of eyes can help you catch small errors and make suggestions for how to improve your website.

Most of the time, my students tell me that the experience is largely positive and boosts their confidence. Even if there are critique elements in the discussion, they can feel empowering because they provide a path for the student to take to improve their portfolio. My advice is to find someone you trust and show them your portfolio before you share your portfolio publicly and ask others to connect you with employment leads. That second set of eyes on your portfolio can sure come in handy and may prove invaluable.

# Keep Your Portfolio Up to Date

Keeping your portfolio up to date is a good way to reflect on how you're learning and growing as a designer. It's also a way to show that you're up to date with the latest and greatest trends in graphic design. It's easy to fall behind in updating your portfolio, and sometimes, graphic design positions come and go quickly. Keeping your portfolio up to date allows you to apply for positions as they are available.

Typically, graphic design positions open and close because of demand, so if an agency is hired to work on a big project, then they'll hire extra hands to join the team. This means you won't have a ton of time to update your work, remove old pieces, and update your content. If you keep your content evergreen, then you'll have a much easier time throwing your hat into a ring when the opportunity presents itself.

# IN THIS CHAPTER

» Using AI-generated assets

» Putting AI to work to improve efficiency

# Chapter **13**

# Ten Ways Artificial Intelligence May Change Graphic Design

Artificial intelligence (AI) represents a prolific change in some graphic design workflows and can help automate some manual tasks. Artificial intelligence can be used to improve efficiency, reduce costs, and increase accuracy, but don't be fooled; artificial intelligence has its downsides, too. Some graphic designers point to artificial intelligence stealing original artwork and design solutions, reducing job opportunities, and other legitimate moral and ethical concerns. Right now, artificial intelligence is not a threat for stealing your job, but graphic designers who know how to use artificial intelligence just might because artificial intelligence enables these individuals to work very efficiently. Artificial intelligence has been a disrupter in a wide swath of industries and disciplines, so it makes sense that the graphic design profession will be disrupted, too.

In fact, a lot of the software that graphic designers use has already begun to adapt AI tools into their software to give designers better workflows and options to implement in their design solutions. As such, let's take a look at ten ways in which artificial intelligence may change the graphic design profession.

# Automated Tools

Generative artificial intelligence tools are being built in standalone platforms like Midjourney and Dalle-3 and also being built into applications like Adobe Photoshop and Wix. What strikes me most about artificial intelligence-driven design tools is that they do a good job of automating certain tasks that you may not have a lot of experience doing. Here's an example of a few tools:

>> **Anyword** (`https://www.anyword.com`): Anyword is an AI tool that can help you generate marketing copy, product descriptions, website content, and social media posts to convert views to sales.

>> **Beautiful.ai** (`https://www.beautiful.ai`): Beautiful.ai generates visually cohesive presentations with layouts, fonts, and images to collaborate with others on visual presentations.

>> **Zapier Central** (`https://zapier.com/central`): Zapier Central allows you to create and interact with AI bots designed to streamline your tasks. So, you could create an AI bot to analyze data from a spreadsheet and get answers about customer sentiment, remind teams about upcoming deadlines, and automatically draft email responses.

While these tasks aren't design-related per se, they are all tasks that a graphic designer may perform as part of their normal day-to-day activities. If tools like these can help me expedite certain aspects of my job and leave me more time to do my design work, well, they would certainly be worth considering. Right now, it seems that AI tools are springing up everywhere, vying for customers to adopt their tools and automate repetitive tasks, and there is a lot of competition for companies to make their tools an invaluable part of our day-to-day operations.

# Improved Efficiency

Artificial intelligence can help designers streamline their workflows and automate certain tasks such as resizing and cropping images, removing backgrounds, color matching, pattern and texture generation, image enhancements, file management, and more. Artificial intelligence can also track changes in design files, manage versioning, tag, categorize, or organize design assets, generate mockups and rapid iterations, assist in collaborations and task management, optimize resources, and other tools that can improve and maximize the efficiency of graphic designers.

# Data-Driven Design

Artificial intelligence can analyze data faster and more accurately than humans, so AI tools that can identify trends and patterns can help graphic designers create highly targeted, customized, and personalized design solutions for their target audience.

AI tools can also simulate user interactions and A/B testing, providing graphic designers with insights on potential design solutions in close to real-time time frames. When AI is given good data, data-driven design will help graphic designers take some of the guesswork out of the graphic design process. Artificial intelligence has the potential to empower designers with a set of tools to help them communicate more effectively.

# AI-Powered Design Assistants

While AI can automate some repetitive tasks, there is also an opportunity for an AI-powered design assistant to assist with the following tasks:

>> Perform tasks like analyzing a design solution a graphic designer has created

>> Generate variations on the design to explore different styles and layouts

>> Test for different user interactions and preferences

>> Provide suggestions

>> Gather mood board elements

>> Perform accessibility checks on design solutions

>> Tag and organize design assets

>> Assist with code

>> Provide eco-friendly design solutions

While some of these tasks are thought experiments, it's easy to speculate how an AI-powered design assistant could be quite helpful for a graphic designer to access.

I recently read a post that said, "I want AI to do my laundry and dishes so I can do art and writing, not for AI to do my art and writing so I can do my laundry and

dishes." There's some wisdom in this statement; I believe many graphic designers could see an advantage of having AI do some tasks and provide feedback, but generally want to maintain control over the creative process rather than trying to offload these tasks to an AI algorithm.

# Advanced Image Recognition

Artificial intelligence systems can help designers sort through images, tag photos with relevant keywords, and create advanced search features for graphic designers. Advanced image recognition can also provide content-aware design solutions where graphic designers can select areas of photographs that they want to manipulate or replace (for example, removing a distracting element) and retouch photographs that have imperfections, blemishes, or lighting issues.

Advanced image recognition tools may also be helpful in generating descriptive alt text for images that viewers with visual impairments — a step that all designers should make so their content is easier to access. Artificial intelligence can also analyze images to make sure that design solutions include representation from a broad range of people, perspectives, and backgrounds, helping all members of our communities feel more included, represented, and engaged.

# AI-Generated Assets

Artificial intelligence can help gather inspiration for the graphic designer and capture elements that can be used for mood boards. AI can also generate custom visuals through text-to-image prompting and reference color palettes, brand voices, and target audience preferences to help create visuals that are likely to resonate with a target audience.

Artificial intelligence can also provide alternatives to stock images and artwork and may be able to create custom fonts and other design elements on the fly, ensuring each design solution is a unique creation. Using artificial intelligence to generate assets may help designers put less emphasis on "how to use the tools" and allow them to spend more time on the message they are trying to shape by allowing more time for experimentation and exploration in the design process.

# Dynamic, Adaptive Design

Artificial intelligence will be able to analyze user behaviors and analytics and adjust design solutions dynamically to optimize responses. For example, one might imagine that a website design could change as AI monitors visits, clicks, scrolls, and navigation patterns. One could also imagine that AI could adapt to factors like time of day, weather, geographical location, and other factors to customize an experience. Along these same lines, AI can adjust layouts, fonts, and images depending on the type of device and resolution limitations or prioritize particular content based on the data available.

For example, if I pull up the Home Depot website on my desktop computer, I may be looking for information like product availability or reviews, but if I pull up the Home Depot website on my mobile phone, then I'm likely to want to know how far the nearest Home Depot is from my current location and what its store hours are. AI can help deliver the content that users need more quickly and accurately than you could by using a set of static variables.

# Optimized Advertising

Artificial intelligence can analyze lots of audience data and understand patterns well. As such, AI can predict which users are most likely to engage with content and match targeted content with these users.

AI can also assist in creating ads, audience insights, behavioral analysis, sentiment analysis, A/B and multivariate testing, predictive marketing, fraud detection, enhanced customer experiences, performance analysis, and more. The tools we use to predict and model audience engagements are likely to become deeper and more robust and offer deeper insights into our audience and their preferences. Conversely, companies will be able to serve their audiences more effectively and offer deeper discounts and savings.

# Cost Reduction

The return on investment (ROI) for graphic designers to complete some simple tasks leaves the door open for artificial intelligence to expedite these processes. Let's say that I need to create a starburst that I want to put behind a logo in an

advertisement. It might take me 10 minutes to create the starburst from scratch manually. If my hourly rate is $150/hour, then my client will pay $15 for me to create this design element. If I can use a text-to-graphic feature and get Illustrator's AI tool to help me make a starburst in 45 seconds, and AI does a great job, I can pass these savings on to my client, who will be thrilled when they discover I've come in under budget on their project.

# Creating New Design Roles

Artificial intelligence is likely to create new design jobs. Some of these jobs might involve AI specialists who work with AI tools to enhance a design project or AI consultants who ensure that AI tools are ethically created and used. There are likely to be individuals who will be responsible for creating and maintaining data sets with up-to-date audience behaviors, market trends, and other data sources. Of course, we will continue to need designers who aren't afraid of AI and are willing to create and use AI-related tools in their design processes.

# Index

## A

AA (minimum contrast), 210–211
AAA (enhanced contrast), 210–211
adjustment layers (Photoshop), 75
Adobe Capture app, 88
Adobe Color website, 207–208
Adobe Creative Cloud
  Behance platform, 38, 88
  Illustrator
    AI capabilities, 70–71
    drawing and editing capabilities, 69–70
    overview, 66–67
    repeating patterns, 154–155
    software alternatives to, 86–87
    text boxes, 156–158
    typography and text tools, 68–69
    vector drawing tools, 67–68
  InDesign
    baseline grids, setting, 189–190
    bleed line, 82
    bottom margin, 82
    columns, 82
    document edge, 82
    inside margins, 81
    interactive documents, 84–85
    margins, 81–82
    outside margins, 75
    overview, 79–80
    page layout and design, 80–82
    parent pages, 83
    PDFs, 84–85
    software alternatives to, 87–88
    text boxes, 156–158
    top margin, 81
    typographic elements, 83–84
   overview, 65–66
  Photoshop
    adjustment layers, 75
    AI capabilities, 78–79
    blend modes, 75
    brightness, adjusting, 74
    Clone stamp tool, 75
    color tools, 74, 77–78
    Content-aware fill, 75
    contrast, adjusting, 74
    cropping tool, 166–167
    Curves feature, 74
    filters and effects, 75
    Healing brush tool, 75
    Highlight tool, 74
    Hue tool, 74
    image editing and retouching, 74–77
    layers, 74–77
    Levels feature, 74
    Masking, 75
    masking in, 75
    overview, 72–73
    Saturation tool, 74
    Selection tool, 75
    Shadow tool, 74
    software alternatives to, 87
   software alternatives to, 85–88
Adobe Express app, 88
advertising, optimizing with AI, 245
Affinity app, 85–86
affinity diagram, 99
agencies, working for, 11–12
AI (artificial intelligence)
  adaptive design and, 245
  advertising, optimizing with, 245
  Anyword website, 242
  Beautiful.ai, 242
  cost reduction, 245–246
  creating jobs, 246
  data-driven design and, 243
  design assistants, 243–244
  generating assets with, 244
  in Illustrator, 70–71
  image recognition, 244
  list of tools, 242
  overview, 241
  in Photoshop, 78–79
  streamlining workflow, 242
  Zapier Central, 242
alignment
  page layouts and, 198
  as principle of design, 178–179
  typography and, 228
Anyword website, 242
Apple Pencil, 63–64
Aquent website, 9
Arial (font), 220
artificial intelligence (AI)
  adaptive design and, 245
  advertising, optimizing with, 245
  Anyword website, 242
  Beautiful.ai, 242
  cost reduction, 245–246
  creating jobs, 246
  data-driven design and, 243

artificial intelligence *(continued)*
  design assistants, 243–244
  generating assets with, 244
  in Illustrator, 70–71
  image recognition, 244
  list of tools, 242
  overview, 241
  in Photoshop, 78–79
  streamlining workflow, 242
  Zapier Central, 242
asymmetrical balance, 124–125
audience
  empathizing with
    maps, 47–48
    mood boards, 50–51
    overview, 46–49
    personas, 32, 48–49
  identifying, 31–33
  interviewing, 53–54
  observing, 53–54
  surveying, 53–54
  tailoring porfolio to, 234
  trends, analyzing, 36

# B

balance
  asymmetrical, 124–125
  crystallographic, 126–127
  horizontal, 123–124
  mosaic, 126–127
  overview, 123
  radial, 124–125
  symmetrical, 123–124
  vertical, 123–124
baseline grids, 183, 188–190
Baskerville (font), 219
Beautiful.ai, 242
Behance platform, 38, 88
Bézier curves, 67–68
black, positive and negative
  connotations of, 205

bleeds
  InDesign settings, 82, 183
  overview, 195
  printing and, 42
blend modes (Photoshop), 75
blue, positive and negative
  connotations of, 204
bottom margins, 82, 183
brainstorming
  affinity diagram, 99
  fostering nonjudgmental
    environment, 98
  goals of sessions, 97–98
  ideas, refining and sorting,
    99–100
  overview, 96–100
  practicing divergent
    thinking, 98
  prioritization matrix, 91–93, 99
  researching projects and,
    95–96
  reverse, 99
  theme mapping, 99
  value quantity over quality, 98
branding, 9, 201–203, 205
brightness, adjusting
  (Photoshop), 74
brown, positive and negative
  connotations of, 205

# C

Calluna (font), 221
CamScanner app, 89
Canva app, 87–88
career paths for graphic
  designers
  agency work, 11–12
  freelancing
    asking for feedback, 52–53,
      108–109
    balancing feedback with
      design expertise, 109–110
    benefits of, 12

charging clients, 12–13,
  245–246
clients choosing color
  palettes, 202
including clients in design
  process, 96
collaborating with other
  professionals, 51–54
communicating with clients,
  23–24, 35–36, 93, 111
competitor analysis, 36
considering technical
  requirements, 41–43
constraints set by clients, 22
contracts and, 13–15, 18, 34
deadlines, 93–94
defining scope of projects,
  33–34
educating clients, 108–110
flat-rates, 17
getting approval from
  clients, 106
hourly rates, 16–17
micro/macro feedback,
  110–111
overview, 12–15
prioritizing feedback, 109
project brief and goals, 93
Proof Approval form,
  111–113
proposing solutions to
  clients, 23–24
receiving feedback, 107–108
researching projects and
  feedback, 96
retainer agreements, 18
sharing sketchbooks with
  clients, 25, 61
as side hustle, 16–18
speculative work, rejecting,
  18–19
tailoring porfolio to
  clients, 234
timelines, 93–94
overview, 11–15

charts, 212–214

circles (shape), 40, 132

clients

  charging, 12–13, 245–246

  choice of color palette by, 202

  including in design process, 96

  communicating with, 23–24, 35–36, 93, 111

  competitor analysis, 36

  constraints set by, 22

  defining scope of projects, 33–34

  educating, 108–110

  getting approval from, 106

  project brief and goals, 93

  Proof Approval form, 111–113

  proposing solutions to, 23–24

  sharing sketchbooks with, 25, 61

  tailoring porfolio to, 234

Clone stamp tool (Photoshop), 75

collaborative sketching, 102–103

Colormind website, 207

colors

  accessibility of, 210–214

  black, 205

  blue, 204

  branding and, 201–203

  brown, 205

  colorblindness, 211–214

  combining, 208–210

  contrast and, 127–128, 206

  cool, 128, 206

  emphasizing elements with, 138–139

  gray, 205

  green, 204

  hierarchy, establishing with, 138–139, 205

  hues, 74, 128, 206

  indigo, 204

lightness, 128

mood boards, 50–51, 244

orange, 204

overview, 201

pink, 205

positive and negative connotations of, 203–206

primary, 205, 207–208

printing and, 42–43

psychology of, 203–206

purple, 204

red, 204

repetition, 154

saturation, 128, 206

secondary, 205

temperature, 128

tertiary, 205

tools in Photoshop, 74, 77–78

typography hierarchy and, 223

unity of, 150

warm, 128, 206

white, 205

yellow, 204

column grids, 184–186

columns (InDesign), 82

competitor analysis, 35–36

conceptual repetition, 160

conceptual unity, 151–152

Content-aware fill tool (Photoshop), 75

contracts, 13–15, 18, 34

contrast

  AA and AAA, 210–211

  colors, 127–128, 206

  complementary, 206

  emphasizing elements with, 135–136

  enhanced, 210–211

  hierarchy and, 127, 129–130, 132–134

  hues and, 128, 206

  lightness, 128

  minimum, 210–211

  overview, 127

  saturation and, 128, 206

  shapes and, 131–132

  simultaneous, 206

  size, 129–131

  spatial, 132–133

  temperature, 128

  textural, 129

  tonal, 128–129

  tool in Photoshop, 74

  typography and, 133–134

Coolors app, 88–89, 207

copyright infringement, 26, 29

CorelDRAW Graphics Suite app, 86

Creative Cloud

  Behance platform, 38, 88

  Illustrator

    AI capabilities, 70–71

    drawing and editing capablities, 69–70

    overview, 66–67

    repeating patterns, 154–155

    software alternatives to, 86–87

    text boxes, 156–158

    typography and text tools, 68–69

    vector drawing tools, 67–68

  InDesign

    baseline grids, setting, 189–190

    bleed line, 82

    bottom margin, 82

    columns, 82

    document edge, 82

    inside margins, 81

    interactive documents, 84–85

    margins. 81–82

    outside margins, 75

    overview, 79–80

Index    249

Creative Cloud *(continued)*

  page layout and design, 80–82

  parent pages, 83

  PDFs, 84–85

  software alternatives to, 87–88

  text boxes, 156–158

  top margin, 81

  typographic elements, 83–84

 overview, 65–66

 Photoshop

  adjustment layers, 75

  AI capabilities, 78–79

  blend modes, 75

  brightness, adjusting, 74

  Clone stamp tool, 75

  color tools, 74, 77–78

  Content-aware fill, 75

  contrast, adjusting, 74

  cropping tool, 166–167

  Curves feature, 74

  filters and effects, 75

  Healing brush tool, 75

  Highlight tool, 74

  Hue tool, 74

  image editing and retouching, 74–77

  layers, 74–77

  Levels feature, 74

  masking in, 75

  overview, 72–73

  Saturation tool, 74

  Selection tool, 75

  Shadow tool, 74

  software alternatives to, 87

 software alternatives to, 85–88

creative thinking, 56–58

crystallographic balance, 126–127

cultural unity, 152–153

curves (shapes)

 associations with, 40

 tool in Photoshop, 74

cyan, yellow, magenta, and key (CYMK) colors, 202

cyclical process of graphic design. *See* iterative process of graphic design

# D

data-driven design, 243

deadlines, 93–94

design development

 overview, 106–107

 time spent on, 96

design tools

 Adobe Capture app, 88

 Adobe Express app, 88

 Affinity app, 85–86

 Apple Pencil versus Wacom tablets, 63–64

 Behance app, 88

 CamScanner app, 89

 Canva app, 87–88

 Coolors app, 88–89, 207

 CorelDRAW Graphics Suite, 86

 electronic, 62–64

 GIMP app, 87

 Illustrator

  AI capabilities, 70–71

  drawing and editing capabilities, 69–70

  overview, 66–67

  repeating patterns, 154–155

  software alternatives to, 86–87

  text boxes, 156–158

  typography and text tools, 68–69

  vector drawing tools, 67–68

 InDesign

  baseline grids, setting, 189–190

  bleed line, 82

  bottom margin, 82

  columns, 82

  document edge, 82

  inside margins, 81

  interactive documents, 84–85

  margins, 81–82

  outside margins, 75

  overview, 79–80

  page layout and design, 80–82

  parent pages, 83

  PDFs and, 84–85

  software alternatives to, 87–88

  text boxes, 156–158

  top margin, 81

  typographic elements, 83–84

 Inkscape app, 86

 mobile apps, 88–89

 overview, 59

 Paper by WeTransfer app, 89

 pencil and paper, 60–62

 Photoshop

  adjustment layers, 75

  AI capabilities, 78–79

  blend modes, 75

  brightness, adjusting, 74

  Clone stamp tool, 75

  color tools, 74, 77–78

  Content-aware fill, 75

  contrast, adjusting, 74

  cropping tool, 166–167

  Curves feature, 74

  filters and effects, 75

  Healing brush tool, 75

  Highlight tool, 74

  Hue tool, 74

  image editing and retouching, 74–77

**250** Graphic Design For Dummies

layers, 74–77
Levels feature, 74
masking in, 75
overview, 72–73
Saturation tool, 74
Selection tool, 75
Shadow tool, 74
software alternatives to, 87
Pixlr app, 87
Procreate app, 89
Scanner Pro app, 89
Scribus app, 87
Sketchbook app, 89
software alternatives to Adobe CC, 85–88
Vectr app, 87
digital design, 9
digital technical requirements, 42–43
directional emphasis, 141–142
directional movement, 170–172
divergent thinking, 98
document edge (InDesign), 82
drawing in Illustrator, 67–70
Dribbble platform, 38

## E

editing
in Illustrator, 69–70
images in Photoshop, 74–77
education, assessing, 10–11
effects (Photoshop), 75
egg-drop assignment, 30
electronic design tools, 62–64
*Elements of Color, The* (Itten), 206
empathy
interviewing audience, 53–54
maps, 47–48
mood boards, 50–51
observing audience, 53–54
overview, 46–49

personas, 32, 48–49
surveying audience, 53–54
emphasis
color, 138–139
contrast, 135–136
directional, 141–142
isolation, 137
overview, 134–135
pattern, 142
positional, 137–138
repetition, 142
typography, 139
whitespace, 140–141
enhanced (AAA) contrast, 210–211
exhibition design, 10
experimentation, 39–41

## F

feedback
balancing with design expertise, 109–110
improving via, 52–53
asking for, 52–53, 108–109
micro/macro, 110–111
overview, 107–111
prioritizing, 109
receiving, 107–108
researching projects and, 96
Fibonacci sequence, 164–165
files
formats, 42–43
size of, 43
tips regarding, 114–116
filters (Photoshop), 75
flat-rate pricing, 17
fonts
Arial, 220
Baskerville, 219
Calluna, 221
Freight Text, 221

Futura, 220
Garamond, 219
Georgia, 220
Gotham, 221
Helvetica, 220
Helvetica Neue, 221
IBM Plex Serif, 221
Lora, 220
Merriweather, 220
Open Sans, 221
pairing, 226–227
Palatino, 220
print technical requirements, 42–43
Proxima Nova, 221
Roboto, 221
Times New Roman, 219
typographic, 134, 223
Univers, 220
Verdana, 220
freelancing
benefits of, 12
clients and
charging, 12–13, 245–246
choosing color palettes, 202
including in design process, 96
communicating with, 23–24, 35–36, 93, 111
competitor analysis, 36
constraints set by, 22
defining scope of projects, 33–34
educating, 108–110
getting approval from, 106
project brief and goals, 93
Proof Approval form, 111–113
proposing solutions to, 23–24
sharing sketchbooks with, 25, 61
tailoring porfolio to, 234

Index   251

freelancing *(continued)*
  collaborating with other professionals, 51–54
  considering technical requirements, 41–43
  contracts and, 13–15, 18, 34
  deadlines, 93–94
  feedback
    balancing with design expertise, 109–110
    asking, 108–109
    micro/macro, 110–111
    overview, 107–111
    prioritizing, 109
    receiving, 107–108
    researching projects and, 96
    seeking, 52–53
  flat-rates, 17
  hourly rates, 16–17
  overview, 12–15
  retainer agreements, 18
  as side hustle, 16–18
  speculative work, rejecting, 18–19
  timelines, 93–94
Freight Text (font), 221
Futura (font), 220

# G

Garamond (font), 219
Georgia (font), 220
Gestalt unity
  closure, 145–146
  common fate, 146–147
  connectedness, 146–147
  continuity, 145–146
  figure/ground, 146–147
  order, 146–147
  overview, 144–148
  proximity, 145–146
  similarity, 145–146
  symmetry, 146–147

GIMP app, 87
golden ratio, 164–165
Google Trends website, 38
Gotham (font), 221
Graphic Artists Guild, 71
graphic design
  career options, 11–15
  defined, 1, 7–8
  education and training, assessing, 10–11
  overview, 1–4, 7–9
  specialization in, 9–10, 246
  speculative work, rejecting, 18–19
graphs, 212–214
gray, positive and negative connotations of, 205
green, positive and negative connotations of, 204
grids
  baseline, 183, 188–190
  column, 184–186
  hierarchy and, 158, 187–188
  modular, 186–187
  overview, 181–184
  repetition and, 158–160
  responsive, 190–191
gutters
  setting, 194–195
  whitespace and, 199

# H

hanglines, 183
harmonic proportion, 164–167
Healing brush tool (Photoshop), 75
Helvetica (font), 220
Helvetica Neue (font), 221
hexagons (shape), 132
hierarchy
  alignment, 178
  colors, 138–139, 205

contrast, 127, 129–130, 132–134
establishing in page layouts, 192–194
grids, 158, 187–188
overview, 175–178
position, 177–178
of scale, 162–164
size, 176–177
typography, 150
visual weight, 175–176
Highlight tool (Photoshop), 74
horizontal balance, 123–124
hourly rates, 16–17
hues, 74, 128, 206

# I

IBM Plex Serif (font), 221
ideas
  brainstorming
    affinity diagram, 99
    fostering nonjudgmental environment, 98
    goals of session, 97–98
    overview, 96–100
    practicing divergent thinking, 98
    prioritization matrix, 91–93, 99
    researching projects and, 95–96
    reverse, 99
    theme mapping, 99
    value quantity over quality, 98
  evaluating, 98
  refining, 95–96, 99–100
  sorting, 99–100
  synthesizing, 29–30
  thumbnail sketches and, 101
Illustrator
  AI capabilities, 70–71

**252** Graphic Design For Dummies

drawing and editing
capabilities, 69–70
overview, 66–67
repeating patterns, 154–155
software alternatives to, 86–87
text boxes, 156–158
typography and text tools,
68–69
vector drawing tools, 67–68
implied movement, 174–175
InDesign
baseline grids, setting,
189–190
bleed line, 82
bottom margin, 82
columns, 82
document edge, 82
inside margins, 81
interactive documents, 84–85
margins, 81–82
outside margins, 75
overview, 79–80
page layout and design, 80–82
parent pages, 83
PDFs and, 84–85
software alternatives to, 87–88
text boxes, 156–158
top margin, 81
typographic elements, 83–84
indigo, positive and negative
connotations of, 204
industry trends, analyzing, 36
Inkscape app, 86
inside margins
overview, 182–183
tool in InDesign, 81
inspiration, 26–28, 60
interactive documents
(InDesign), 84–85
interactivity (digital technical
requirements), 43
intercolumn space, 183
isolation emphasis, 137

iterative process of graphic
design
brainstorming
fostering nonjudgmental
environment, 98
goals of session, 97–98
overview, 96–100
practicing divergent
thinking, 98
reverse, 99
sorting and refining ideas,
99–100
value quantity over
quality, 98
design development, 106–107
feedback
balancing with design
expertise, 109–110
asking, 108–109
micro/macro, 110–111
overview, 107–111
prioritizing, 109
receiving, 107–108
overview, 39–41, 91–92
projects
briefs, 93–94
files, tips regarding,
114–116
finalizing, 111–115
goals, 93–94
planning, 94–96
printed work, tips regarding,
112–114
repeat phase, 116–117
researching, 94–96
revising phase, 110
sketching
collaborative, 102–103
combining, 104–105
iterative, 101–102
overview, 100
thumbnail, 100–101
visual metaphors, 103–104

versioning, 110
Itten, Johannes, 206

# K

kerning, 229

# L

layers (Photoshop), 74–77
layout (InDesign), 80–82
leaders in industry, 37–38
legibility (typography), 221–222
Levels feature (Photoshop), 74
lightness (contrast), 128
logical thinking, 56–58
logos
branding, 9, 201–203, 205
colors and, 202–203
communicating with
clients, 111
as specialization in graphic
design, 9
visual unity, 148–149
Lora (font), 220

# M

margins
bottom, 82, 183
inside, 81, 182–183
outer, 81, 182
setting, 194–195
tool in InDesign, 81–82
whitespace and, 199
Masking (Photoshop), 75
Merriweather (font), 220
metaphors
conceptual repetition and, 160
overview, 103–104
micro/macro feedback, 110–111
minimum (AA) contrast, 210–211
modular grids, 186–187

mood boards
  AI and, 244
  creating, 50–51
mosaic balance, 126–127
motion graphics, 9
movement
  directional, 170–172
  implied, 174–175
  overlap, 173–174
  overview, 169–170
  repetition, 172–173
  sequential, 173

# N

narrative
  conceptual repetition and, 160
  porfolios and, 235
*Non-Designer's Design Book, The*
  (Williams), 179

# O

Open Sans (font), 221
orange, positive and negative
  connotations of, 204
organic shapes, 40–41
outer margins, 81, 182
ovals (shape), 132
overlap movement, 173–174
overview movement, 169–170

# P

packaging design, 10
page layouts
  alignments and, 198
  bleeds
    InDesign settings, 82, 183
    overview, 195
    printing and, 42
  considering content, 192
  consistency, 195–198

establishing hierarchy,
  192–194
grouping related
  elements, 195
gutters, 194–195, 199
hangline, 183
InDesign, 80–82
intercolumn space, 183
margins
  bottom, 82, 183
  inside, 81, 182–183
  outer, 81, 182
  setting, 194–195
  top, 183
  whitespace and, 199
overview, 181–184, 192
page number area, 183
trim lines, 194–195
whitespace, incorporating,
  198–199
page number area, 183
Palatino (font), 220
paper and print specifications
  (printing), 42
Paper by WeTransfer app, 89
parent pages (InDesign), 83
patterns, 142, 154
PDF (Portable Document
  Format) files, 84–85
pencil and paper, sketching
  with, 60–62
personas
  developing, 48–49
  overview, 32
Photoshop
  adjustment layers, 75
  AI capabilities, 78–79
  blend modes, 75
  brightness, adjusting, 74
  Clone stamp tool, 75
  color tools, 74, 77–78
  Content-aware fill, 75

contrast, adjusting, 74
cropping tool, 166–167
Curves feature, 74
filters and effects, 75
Healing brush tool, 75
Highlight tool, 74
Hue tool, 74
image editing and retouching,
  74–77
layers, 74–77
Levels feature, 74
masking in, 75
overview, 72–73
Saturation tool, 74
Selection tool, 75
Shadow tool, 74
software alternatives to, 87
pink, positive and negative
  connotations of, 205
Pinterest Trends, 38
pixel density
  digital technical
    requirements, 43
  raster graphics and, 72–73
Pixlr app, 87
placeholder text, 189
platforms for trend analysis,
  38–39
polygons (shape), 132
porfolios
  audience, tailoring to, 234
  establishing shots,
    236–237
  keywords, 237–238
  narrative, 235
  overview, 233
  quality work, including, 234
  reviewing, 238–239
  showing adaptability, 235
  sketching and, 237
  updating, 239
  website, 236

254    Graphic Design For Dummies

Portable Document Format (PDF) files, 84–85
position hierarchy, 177–178
positional emphasis, 137–138
precedents, finding, 28–31
pricing, 16–18
primary colors
  choosing, 207–208
  overview, 205
principles of design
  alignment, 178–179
  balance
    asymmetrical, 124–125
    crystallographic, 126–127
    horizontal, 123–124
    mosaic, 126–127
    overview, 123–127
    radial, 124–125
    symmetrical, 123–124
    vertical, 123–124
  colors
    accessibility, 210–214
    black, 205
    blue, 204
    branding and, 201–203
    brown, 205
    colorblindness, 211–214
    combinations, 208–210
    combining, 208–210
    contrast and, 127–128, 206
    cool, 128, 206
    emphasizing elements with, 138–139
    gray, 205
    green, 204
    hierarchy, 138–139, 205
    hues, 74, 128, 206
    indigo, 204
    lightness, 128
    mood boards, 50–51, 244
    orange, 204

    overview, 201
    pink, 205
    positive and negative connotations of, 203–206
    primary, 205, 207–208
    printing and, 42–43
    psychology, 203–206
    purple, 204
    red, 204
    repetition, 154
    saturation, 128, 206
    secondary, 205
    temperature, 128
    tertiary, 205
    tools in Photoshop, 74, 77–78
    typography hierarchy and, 223
    unity, 150
    using contrasting, 127–128
    warm, 128, 206
    white, 205
    yellow, 204
  contrast
    AA and AAA, 210–211
    colors, 127–128, 206
    complementary, 206
    emphasizing elements with, 135–136
    enhanced, 210–211
    hierarchy, 127, 129–130, 132–134
    hues, 128, 206
    lightness, 128
    minimum, 210–211
    overview, 127
    saturation, 128, 206
    shape, 131–132
    shapes and, 131–132
    simultaneous, 206
    size, 129–131
    spatial, 132–133
    temperature, 128

    textural, 129
    tonal, 128–129
    tool in Photoshop, 74
    typography, 133–134
  emphasis
    color, 138–139
    contrast, 135–136
    directional, 141–142
    isolation, 137
    overview, 134–135
    pattern, 142
    positional, 137–138
    repetition, 142
    typographic, 139
    whitespace, 140–141
  grids
    baseline, 183, 188–190
    column, 184–186
    hierarchy, 158, 187–188
    modular, 186–187
    overview, 181–184
    repetition and, 158–160
    responsive, 190–191
  hierarchy
    alignment, 178
    colors, 138–139, 205
    contrast, 127, 129–130, 132–134
    grids, 158, 187–188
    overview, 175–178
    position, 177–178
    size, 176–177
    typography, 150, 222–224
    visual weight, 175–176
  movement
    directional, 170–172
    implied, 174–175
    overlap, 173–174
    overview, 169–170
    repetition, 172–173
    sequential, 173

Index    **255**

principles of design (continued)
overview, 121–123
proportions
golden ratio, 164–165
harmonic, 164–167
rule of thirds, 165–167
sequential, 163–164
repetition
color, 154
conceptual, 160
emphasizing elements with, 142
grids and, 158–160
movement and, 172–173
overview, 153
pattern, 154
shape, 153
space, 156–158
texture, 154–156
unity, 149
rhythm, 161–162
scale, 162–163
typography
alignments, 228
avoiding mistakes, 228–229
avoiding similar typefaces, 151
capabilities in InDesign, 83–84
contrast, 133–134
emphasis, 139
font hierarchy, 223
fonts affecting contrast, 134
hierarchy, 150, 222–224
impacting message, 216–219
importance of font size, 226–227
kerning, 229
legibility, 221–222
licences and, 227–228

limiting number of typefaces, 224–226
list of fonts, 219–221
overview, 215–216
pairing complementary typefaces, 225–226
purpose, identifying, 216–219
as requirement, 43
sans-serif typefaces, 220–221
serif typefaces, 219–221
texture repetition, 156
tone, identifying, 216–219
tools in Illustrator, 68–69
trending typefaces, 220–221
type families, 224–225
unity, 150–151
web-safe fonts, 43
x-height, 225
unity
color, 150
conceptual, 151–152
cultural, 152–153
Gestalt, 144–148
overview, 143–144
proximity, 149–150
repetition, 149
spatial, 151
typographic, 150–151
visual, 148–149
whitespace, 140–141, 179, 198–199
printing
CYMK colors, 202
design, 9
technical requirements, 42
tips regarding, 112–114
prioritization matrix, 91–93, 99
problem-solving skills
analyzing trends and styles
audience perceptions, 36

experimention, 39–41
identifying gaps and opportunities, 36
industry, 36
influencers and leaders, following, 37–38
iteration, 39–41
tools and platforms, 38–39
unique selling points, 36
collaborating with other professionals, 51–54
communicating with clients, 23–24
competitor analysis and, 35–36
considering technical requirements, 41–43
creative versus logical thinking, 56–58
decision-making, 21–22
design tools and, 61–62
digital technical requirements, 42–43
egg-drop assignment, 30
empathizing with audience
empathy map, 47–48
interviews and surveys, conducting, 53–54
mood boards, 50–51
observations, 53–54
overview, 46–49
personas, 32, 48–49
identfying problem, 23–25
inspiration and, 26–28
learning from mistakes, 58
logical versus creative thinking, 56–58
overview, 21–22
precedents and, 28–31
print technical requirements, 42
researching projects and, 95

scope of projects, defining, 33–34

sketchbooks and, 24–25

synthesizing ideas, 29–30

target audience, identifying, 31–33

Procreate app, 89

projects

briefs, 93–94

defining scope of, 33–34

executing, 111–115

files, tips regarding, 114–116

finalizing, 111–115

goals, 93–94

learning from mistakes, 58

logical versus creative thinking, 56–58

planning, 94–96

printed work, tips regarding, 112–114

Proof Approval form, 111–113

repeat phase, 116–117

researching

brainstorming, 95–96

design development, 96

feedback, 96

overview, 22–23, 94

problem-solving, 95

refining ideas, 95–96

revising, 96

sketching, 95–96

Proof Approval form, 111–113

proportions

golden ratio, 164–165

harmonic, 164–167

rule of thirds, 165–167

sequential, 163–164

Proxima Nova (font), 221

proximity unity, 149–150

purple, positive and negative connotations of, 204

## R

radial balance, 124–125

raster graphics

print technical requirements, 42

vector versus, 66–67, 72–73

rectangles (shape), 40–41, 132

red, green, blue (RGB) colors, 202

red, positive and negative connotations of, 204

repeat phase, 116–117

repetition

color, 154

conceptual, 160

emphasizing elements with, 142

grids and, 158–160

movement and, 172–173

overview, 153

pattern, 154

shape, 153

space, 156–158

texture, 154–156

unity, 149

resolution (printing), 42

responsive design (digital technical requirements), 43

responsive grids, 190–191

retainer agreements, 18

reverse brainstorming, 99

revising phase, 96, 110

RGB (red, green, blue) colors, 202

rhythm, 161–162

Roboto (font), 221

rule of thirds, 165–167

## S

sans-serif typefaces, 220–221

saturation

contrast of, 206

as key aspect of color contrast, 128

tool in Photoshop, 74

scale, 162–164

Scanner Pro app, 89

Scribus app, 87

secondary colors, 205

Selection tool (Photoshop), 75

sequential movement, 173

sequential proportion, 163–164

serif typefaces, 219–221

Shadow tool (Photoshop), 74

shapes

circles, 40, 132

contrast, 131–132

cultural associations and, 131–132

curves, 40, 74

hexagons, 132

organic, 40

ovals, 132

polygons, 132

rectangles, 40, 132

repeating, 153

spirals, 40, 132

squares, 40–41, 132

stars, 132

symmetrical, 40

interpretation of, 40–41

triangles, 40–41, 132

size contrast, 129–131

size hierarchy, 176–177

Sketchbook app, 89

sketching

benefits of, 60–62

collaborative, 102–103

combining, 104–105

iterative, 101–102

overview, 24–25, 100

porfolios and, 237

refining, 69–70

Index    257

sketching *(continued)*
  researching projects and, 95–96
  thumbnail, 61, 100–101
  visual metaphors, 103–104
space
  contrast and, 132–133
  creating unity with, 151
  repetition and, 156–158
specialization in graphic design
  AI and, 246
  branding, 9
  digital design, 9
  exhibition design, 10
  Illustration, 9
  logo design, 9
  motion graphics, 9
  overview, 9–10
  packaging design, 10
  print design, 9
  web design, 9
speculative work, 18–19
spirals (shape), 40, 132
squares (shape), 40–41, 132
stars (shape), 132
symbolism, 160
symmetry
  balance, 123–124
  Gestalt unity and, 146–147
  shapes, 40

# T

target audience. *See* audience
temperature (contrast), 128
tertiary colors, 205
text
  capabilities in InDesign, 83–84
  fonts, 42–43
  kerning, 229
  placeholder, 189
  space repetition and, 156–158

tools in Illustrator, 68–69
textural contrast, 129
texture repetition, 154–156
theme (conceptual repetition), 160
theme mapping, 99
thumbnail sketching, 61, 100–101
timelines, 93–94
Times New Roman (font), 219
tonal contrast, 128–129
tools for trend analysis, 38–39
top margins, 81, 183
trends
  audience perceptions, 36
  experimention, 39–41
  identifying gaps and opportunities, 36
  industry, 36
  influencers and leaders, following, 37–38
  iteration, 39–41
  overview, 36–41
  tools and platforms for analysis of, 38–39
  unique selling points, 36
triangles (shape), 40–41, 132
trim lines, 42, 194–195
typefaces
  avoiding similar, 151
  classic, 219–220
  limiting number of, 224–226
  pairing complementary, 225–226
  sans-serif, 220–221
  serif, 220–221
  trending, 220–221
  type families, 224–225
typography
  alignments, 228
  avoiding mistakes, 228–229
  capabilities in InDesign, 83–84

contrast, 133–134
emphasis, 139
fonts
  factors affecting contrast, 134
  hierarchy, 223
  importance of size, 226–227
  list of, 219–221
  print and digital technical requirements, 42–43
hierarchy and, 150, 222–224
impacting message, 216–219
kerning, 229
legibility, 221–222
licences and, 227–228
overview, 215–216
purpose, identifying, 216–219
as requirement, 43
text
  capabilities in InDesign, 83–84
  fonts, 42–43
  kerning, 229
  placeholder, 189
  space repetition and, 156–158
  tools in Illustrator, 68–69
texture repetition, 156
tone, identifying, 216–219
tools in Illustrator, 68–69
typefaces
  avoiding similar, 151
  limiting number of, 224–226
  overview, 219–220
  pairing complementary, 225–226
  sans-serif, 220–221
  serif, 219–221
  trending, 220–221
  type families, 224–225
unity, 150–151
x-height, 225

258 Graphic Design For Dummies

## U

unity
  color, 150
  conceptual, 151–152
  cultural, 152–153
  Gestalt, 144–148
  overview, 143–144
  proximity, 149–150
  repetition, 149
  spatial, 151
  typographic, 150–151
  visual, 148–149
Univers (font), 220

## V

vector graphics, 42, 66–68
Vectr app, 87
Verdana (font), 220
versioning, 110
vertical balance, 123–124

visual metaphors, 103–104, 160
visual unity, 148–149
visual weight, 175–176

## W

Wacom tablets, 63–64
Web Content Accessibility
  Guidelines (WCAG),
  210–211
web design
  accommodating content to
    various screens, 190–191
  adaptive design using AI, 245
  Gestalt unity, 148
  porfolios and, 236
  position hierarchy, 177–178
  preparing files, 114–116
  repetition and pattern
    emphasis, 142
  repetition unity, 149
  RGB colors, 202

shape contrast, 131
specialization in graphic
  design, 9
white, pos tive and negative
  connotations of, 205
whitespace, 140–141, 179,
  198–199
Williams, Robin, 179

## X

x-height (typography), 225

## Y

yellow, positive and negative
  connotations of, 204

## Z

Zapier Central, 242

# About the Author

**Ben Hannam** is an award-winning designer, educator, author, and small business owner recognized for his impactful contributions to the field of graphic design. In 2018, he authored *Oh @#$% I'm Graduating! A Student's Guide to Creating a Killer Portfolio,* published by Kendall Hunt Publishing, and previously published *A Graphic Design Student's Guide to Freelance: Practice Makes Perfect* in 2012 with Wiley Publishing.

Currently, Ben is an associate professor and department chair for the communication design program at Elon University's School of Communications. Ben brings extensive experience and passion to his role. He earned his Bachelor of Fine Arts in graphic design from Old Dominion University in 1996 and his Master of Fine Arts in visual communications from Virginia Commonwealth University in 2002.

Ben's global teaching experience includes instructing graphic design at Virginia Commonwealth University in Qatar. After three years abroad, he returned to the US to teach at Virginia Tech and later at Elon University. Known for his tactical approach to design and problem-solving, Ben believes that innovative solutions to everyday challenges underscore the value of graphic design and contribute to making the world a better place. For more about his work, visit his website at www.bhannam.com.

# Dedications

To my wife, Julie, whose support and encouragement have been a source of strength and affirmation. To my oldest child, Adam, I love you and thank you for proofreading chapters of this book and giving me your feedback. To my youngest child, Beckett, I love you, and thank you for your endless curiosity and joy in reminding me of the importance of creativity and imagination. I love you all.

# Author's Acknowledgments

I would like to extend my heartfelt thanks to the Dummies team for their incredible support. A special thank you to Jennifer Yee for inviting me to write this book and to Tim Gallan for guiding me through the Dummies writing process and helping me get started. My gratitude also goes to Kristie Pyles for her invaluable

assistance with images and permissions. I'd like to thank my colleague and technical editor, Rebecca Bagley, for all her insights and edits. And finally, a huge thank you to Rick Kughen, my editor, who kept me on track throughout this journey — I truly appreciate all of you.

I am also deeply grateful to the artists, graphic designers, and design students who generously shared their work, stories, and examples. Your contributions have enriched this book in countless ways. One of the things I admire most about our profession is the spirit of collaboration and support; you embody the best aspects of our discipline.

Finally, I would like to express my appreciation to Elon University for its unwavering support. I have had the unique pleasure of working with some of the most thoughtful and dedicated administrators, colleagues, and staff ever. Thank you for everything you do.

## Publisher's Acknowledgments

**Acquisitions Editor:** Jennifer Yee

**Development Editor:** Rick Kughen

**Copy Editor:** Rick Kughen

**Technical Editor:** Rebecca Bagley

**Proofreader:** Debbye Butler

**Production Editor:** Tamilmani Varadharaj

**Cover Image:** © artyway/Shutterstock